George Engleheart, 1750-1829, Miniature Painter To George Iii

Preserve this note my [illegible]

For the Avey coll'
 Print Room
make extra enly cd for [illegible]

George Engleheart.

THREE HUNDRED AND SIXTY COPIES
ONLY OF THIS EDITION HAVE BEEN
PRINTED, OF WHICH 350 ONLY ARE FOR
SALE.
THE BOOK WILL NOT BE REPRINTED.

LONDON: YORK ST., COVENT GARDEN.
CAMBRIDGE: DEIGHTON, BELL & CO.

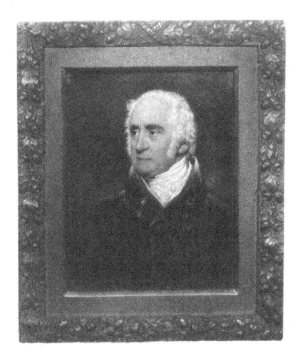

GEORGE ENGLEHEART.

BY HIS NEPHEW, J. C. D. ENGLEHEART.

George Engleheart

1750—1829

Miniature Painter to George III.

By

George C. Williamson, Litt.D.

and

Henry L. D. Engleheart, M.A.

Great Grandnephew of the Artist

London : George Bell & Sons

MDCCCCII

PREFACE.

GEORGE ENGLEHEART was one of the most important of the miniature-painters who adorned the eighteenth century, but he has not hitherto received the attention to which by the high merit of his work he is entitled. His best productions have often been confused with those of other artists, and thus he has not had the credit for the wonderful series of lifelike portraits which he produced.

The list of miniaturists made under the minute of the Privy Council for the exhibition in 1865 did not even include his name, and at the winter exhibitions at Burlington House, although a large number of miniatures have been shown, including many of his works, he has never been credited with the production of any of them. Even in the sale-rooms his works have been sold under other names, and he has been denied the fame which was his due. In the dictionaries of artists his name is but seldom mentioned, and where it is given it is too often confused with that of his nephew and pupil, and the biographies given of each person are full of errors and are very misleading.

It seemed, therefore, to the writers of this volume that the time had arrived when an authoritative and accurate account of the life and works of the artist should be presented, and they have striven in these pages to set forth clearly all that is known about him. They have worked together, inasmuch as for many years the great-grandnephew of the artist had been gathering up all the information which was available. The part which each writer has played in the production of the book cannot be accurately defined, for neither of them without the other could have written these pages; but there are certain portions of the work, such as the supplying of the information, especially as to the family history and

the compilation of the list of existing miniatures, and Chapter IX. relating
to Kew, which belong wholly to Mr. Engleheart, whilst other portions, as
Chapters IV., V., VI. and VIII., dealing with the Fee-Book, Pictures by
Reynolds, Palette and Appliances, and the Art and Place of Engleheart,
belong wholly to Dr. Williamson, whose pen is responsible for the whole
compilation.

The writers of the volume could not, however, have carried out their
pleasant task without the co-operation of the owners of the miniatures,
and to all who have so generously aided them in their work they express
their very hearty thanks.

Especially are they grateful to Sir J. Gardner D. Engleheart, K.C.B.,
who generously placed at their disposal all that he possessed relating to
George Engleheart and his nephew, not only miniatures, but also the
precious fee-book and many drawings, papers and documents. To all
other owners of miniatures who have allowed the writers to see, describe
and illustrate their treasures they are warmly grateful, and they trust that
the book which they present may be deemed a fitting memorial of the art
of the great miniaturist, and may serve to make his fame known, and
prevent it from ever again being obscured. They have thought fit to
give an account also of J. C. D. Engleheart, and to illustrate his work
fully, so that the two men so closely connected, and yet so different in
their style, may no longer be confused.

They have not been as successful as they could have wished in
compiling a list of the miniatures which can be traced as the work of
either artist, and they appeal to all persons to whom this volume may
come, to assist them in preparing a longer and fuller list of such works.
There are many hundreds of miniatures named in the fee-book which
they have been unable to find, and although they are aware that many
have perished, especially in certain notable fires, yet they are convinced
that there are still a large number belonging to private owners which
remain undescribed, and they will be grateful to any persons who own
such miniatures, or know of their existence, if they will kindly write and
give particulars of them.

The place and importance of miniatures are now so fully recognised
that it would be well for a complete list of the works of George Engle-

heart to be in existence, and such a list the writers could only supply by the assistance of the readers of this book.

To the owners of miniatures the authors would like to give one word of caution, begging that these treasures may be kept from sunlight, and may not be hung in positions where they are exposed to the extremes of heat or cold. The faded and damaged condition of so many of Engleheart's works has impressed the importance of thus urging that greater care should be taken of such lovely works of art in the future than has been afforded them in the past.

July, 1902.

COLLECTION OF THE LADY CURRIE.

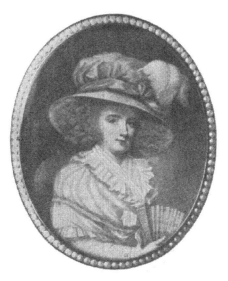

A LADY, UNKNOWN.

GEORGE BARING.

GEORGE P. BARCLAY, 1807.

CONTENTS.

b

COLLECTION OF SIR J. GARDNER D.
ENGLEHEART, K.C.B.

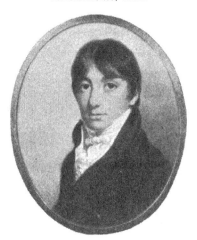

COLONEL GEORGE ENGLEHEART AS A LAD.

LIST OF ILLUSTRATIONS.

N.B.—The copyright and privilege of reproduction for *all* the illustrations in this volume are strictly retained by the Authors on behalf of the various owners of the miniatures, and are duly registered. The photographs, in every case specially made for this volume, have been taken and the collotypes and half-tone blocks have all been made by Mr. James H. L. Hyatt, of 70, Mortimer Street, London, W.

The book has been printed by Messrs. Billing and Sons, Limited, of Guildford. All the miniatures and drawings are the work of George Engleheart, except where the name of another artist is given. All the illustrations are from the very extensive collection in the possession of Sir J. Gardner D. Engleheart, of Curzon Street, except in the cases where other owners are mentioned.

Two pages of miniatures, all of unknown persons, in the possession of
Mr. Hodgkin, appear only in the large-paper edition of this book, and will be
found at p. 20 and p. 38.

COLLECTION OF MRS. FARRER.

LADY HAMILTON.
BY THOMAS RICHMOND.

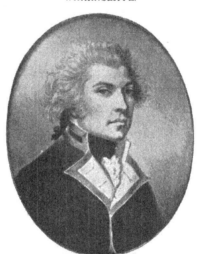

CAPTAIN FAULKNER.

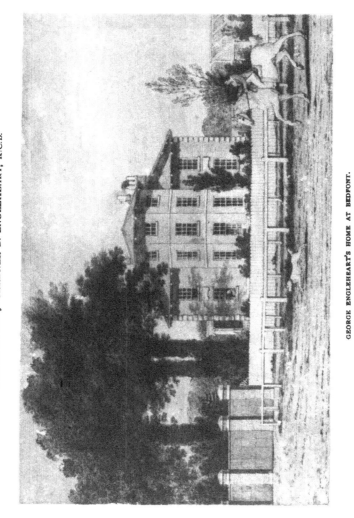

COLLECTION OF SIR J. GARDNER D. ENGLEHEART, K.C.B.

GEORGE ENGLEHEART'S HOME AT BEDFONT.

From a water-colour by him.

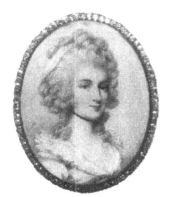 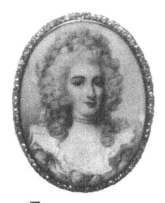

THE MISSES BERRY.

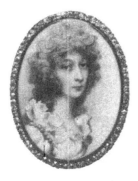 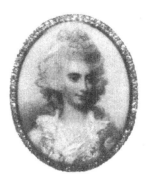

MISS SAINTHILL.

MRS. ROBINSON.

George Engleheart.

CHAPTER I.

THE ENGLEHEART FAMILY.

THE artistic genius which had its fullest development in the
miniature-painter who is the subject of the following pages
can be seen not only in the original ancestor of the family to
which George Engleheart belonged, but can be traced also in almost
every member of that family to a greater or less degree.

It had various phases, some members excelling in modelling, some
in sculpture, some in drawing, some in painting, and some in the kindred
arts of penmanship and pure design. Its origin must have been earlier
than we are able to trace, but it is to be found in Francis, the first
member of the family to settle in England, and from him as immediate
ancestor it passed on to receive its fullest achievements in the person
of George, his son.

The family is said to have come from Franconia, and Francis, born
in 1713, is believed to have sprung from an ancient Wendish family,
members of which were to be found scattered throughout Franconia. In
Upper Austria, between Ischl and Passau, there is a village called
Engelhart, and the name is still not an uncommon one in that same
district. An Engelharat (*sic*) is mentioned as the personal friend of
Charlemagne, and in the early Middle Ages many of the Engelharts rose
to distinction, while the name is not unknown to Continental fame in
more recent times.

It is not known why Francis Engelhart came to this country. He
is said to have arrived when quite a youth, brought by a compassionate
stranger, a fugitive from political reasons, and his earliest recollections,
which were of a very indistinct character, were connected with a great

commotion, a crowd of persons rushing over a bridge, the breaking down of the bridge and the loss in the waters of some of his nearest relations, and then a mysterious hiatus which he was never able to fill up.

A brother who is said to have come from the family home at the same time as Francis, was reported to have returned home again to Germany, and to have died leaving a considerable fortune to his widow, which she was anxious, it is said, to leave back again to the Engleheart family if they could but be found. This story was told many years later to Colonel Engleheart, the son of George the miniature-painter, when he was stopping at a house near to Cape Town enjoying the hospitality of a settler who knew the old lady referred to. He urged Colonel Engleheart to go at once to Worms, make friends with the rich widow, and secure the reversion of the estate ; but the Colonel's health at the time, and his unexpected decease soon after, prevented the adoption of this plan.

Another branch of this family seems to have settled in Russia, where Christine Engleheart married a Prince Potemkin, and had one daughter, who married her cousin Paul, and had in her turn a son Paul, who died quite recently at the age of eighty-two unmarried, and thus closed that line of the family.

Francis Englehart seems to have believed that he was from eight to ten years old when he reached England. At the age of twenty-one he was married. He had settled down in the royal domain of Kew, and it was the daughter of the Vicar of the parish, Anne Dawney, whom he married at that early age. He was by profession a modeller in plaster, and many of the ceilings at Hampton Court Palace owe their beauty to his handiwork.

The craft which Francis practised lost much of its repute until quite lately, and the demand for less expensive work—plain ceilings and machine-made cornices and mouldings—had caused the artistic side of the work of the plasterer to be ignored and overlooked. In the olden days, when elaborate ceilings were reckoned as important works of decoration necessary for the completion of the room, and when ornate strap-work and rich mouldings and ornaments were introduced into the ceilings of the reception-rooms in great houses, there was an important field for the exercise of artistic feeling, and for the execution of plaster work, which could take high position in the world of art.

By his profession, which was then in its palmy days, Francis

COLLECTION OF HENRY L. D. ENGLEHEART, ESQ.

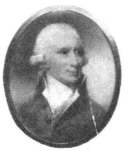

COLLECTION OF MISS KING.

GEORGE ENGLEHEART (?).
BY HIMSELF.

COLLECTION OF MISS KING.

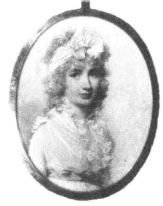

LADY COTTON.

COLLECTION OF
MRS. ENGLEHEART.

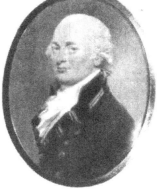

SIR C. COTTON.

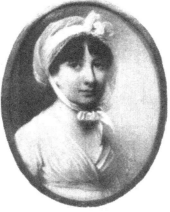

MARY PYE.

Engelhart appears to have made a fair independence, and to have wisely invested his savings in landed estate at Kew, and in the districts around London, which is still in the possession of his great grand-nephew.

It is believed that he was never naturalized, as real estate was devised to his wife, in his lifetime, by his brother-in-law, John Dillman, who had come from Dillingsburg in Nassau, and was naturalized by Act of Parliament (10 George II.). He, however, was able to acquire leasehold estate, and it included a house in Hertford Street, which he eventually bequeathed to his son Paul. He died in 1773, in the sixtieth year of his age, and was buried at Kew in what afterwards became the family vault, leaving his wife Anne and three sons out of a family of eight.

The Vicar of Kew had two other daughters beside the one whom Francis married. Of these, the second married the John Dillman just mentioned, who was styled Master Gardener to the Prince of Wales, and seems to have been responsible for the laying out of the original gardens of Kew Palace. He died in 1760, and by his will left to his nephew, the eldest son of Francis, considerable property both in Kew and in London, chiefly in and about Mayfair. He was evidently a very successful man, and was able to bequeath quite an extensive estate. The third daughter of the Vicar, Mary, married one John Bone, who does not appear to have been any relation to the well-known artist in enamel who attained to such celebrity. They had a daughter Anne, who married one Richmond, in or about 1737, and their son, Thomas Richmond, an artist, was the father of George Richmond, the well-known painter and the grandfather of the present Sir William Richmond, R.A., K.C.B.

Francis Engelhart appears to have always spelt his name in the Franconian fashion, and in a deed dated 1752 it so appears. In 1757 his son was admitted to copyhold, in the Manor of Kew, as John Dillman Inglehart; but in 1760 Mrs. Engleheart and her son were admitted as copyholders, under the name of Engleheart.

After his father's decease, George Engleheart was admitted as heir to his mother Anne, at a court held April 21, 1780, under the quaint tenure of Borough English, by which the youngest son succeeds. Queen Charlotte was at that time Lady of the Manor, and the name was spelt in the accepted manner, and has ever since been so spelt.

Of the family of Francis Engleheart, as for the sake of convenience it will be well in future to spell his name, there survived the three sons

John Dillman, Thomas, and George, five sons having died in infancy. Thomas, another son, left a son called Francis, after his grandparent, who became a line-engraver, and who will be mentioned later on. He, again, had two sons, Timothy Stansfeld Engleheart, who was a line-engraver, as was his father, and also was known for his powers of etching (he was born in 1803, and died in 1879), and Jonathan John, who also became an engraver. Francis had married twice, his second wife being Jane, daughter of Le Petit, the well-known engraver. Thomas was a sculptor by profession, and was noted for the beautiful work which he did in wax. His portraiture in that dainty medium was very popular, and year by year after 1773 he exhibited his models at the Royal Academy, twenty exhibits in all, as will be seen by the list in the Appendix to this work. One only of his portrait models is mentioned by name in the Academy catalogues, that which he sent in 1773, and which was a bust of Thomas Fuelling, of His Majesty's Board of Works. At that time the sculptor was residing in Little Carrington Street, Mayfair, in that part of London which the Englehearts appear to have made specially their own, and where they have always had important possessions. Two years later we find Thomas had moved his studio to 4, Old Bond Street, in 1779 he was at 28, St. James Street, and in 1786 his address is given as Richmond; and in that year he died, but it is not known where he was buried. He was a very religious man of enthusiastic Evangelical opinions. His talents from an early age were of a very high order, as he took the gold medal of the Royal Academy from John Flaxman and other competitors, the subject for competition being *Ulysses and Nausicaa*.

In a manuscript account of him, written by Nathaniel his nephew, and now in the possession of the Rev. G. H. Engleheart, there is the following passage: "Flaxman assured me that, when fellow-students at the Royal Academy, he had no rival whom he envied so much as Thomas Engleheart, and that such feelings assumed actual jealousy when the latter gained the Academy annual gold medal in a competition which lay only in point of fact between those two."

But little of Thomas Engleheart's work remains to be seen. Most of it was in the then fashionable, but very perishable, medium of wax, and has long since vanished. There is a medallion portrait of Edward, Duke of York, modelled in 1786, in the National Portrait Gallery, but it has been much damaged, and the only other works which we can definitely assign to him are the three beautiful portraits of

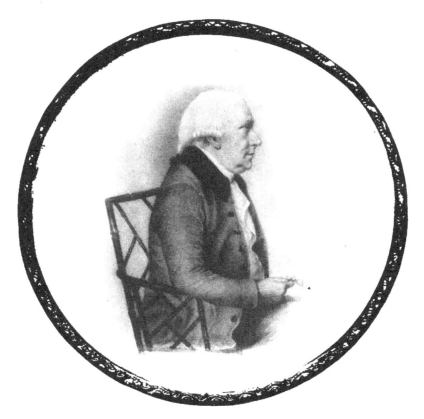

J. D. ENGLEHEART.

BY J. C. D. ENGLEHEART.

Signed.

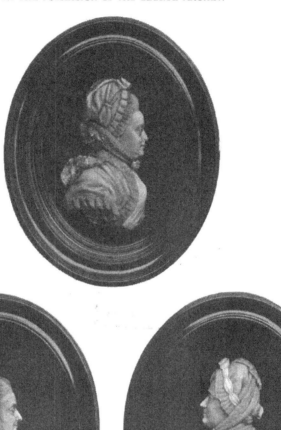

SCULPTURE IN WAX BY THOMAS ENGLEHEART, REPRESENTING
MARY WOOLLEY. HESTER WOOLLEY. ELIZABETH BROWN (*née* WOOLLEY).

COLLECTION OF SIR J. GARDNER D. ENGLEHEART, K.C.B.

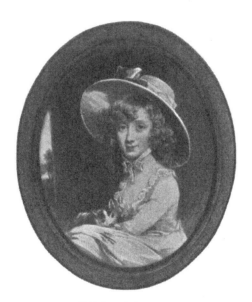

MELICENT ENGLEHEART.

members of the family illustrated in this volume. There are many examples of sculpture in wax at the Wallace Gallery, but they belong to an earlier period than the eighteenth century, and are mostly the production of Continental artists. Dr. Propert had some English wax sculpture in his collection, but nothing that was signed by Thomas Engleheart.

Another artist named Engleheart, and bearing the initial J., whose address is given as Foot Lane, Richmond, exhibited a portrait in wax at the Royal Academy in 1783; but this appears to have been his only exhibit of any sort, and who he was or what relation he was to his more celebrated namesake I have been unable to discover.

In the possession of Sir Gardner Engleheart there is a fine drawing by George representing a Greek bust which is believed to have been drawn from a work executed by his brother Thomas, and one for which it is said he obtained high credit and an important reward.

The drawing is a delightful one, full of dainty precision, and has every probability in its favour of having been executed from a bust. The tradition in the family to which it has ever belonged so regards it, and it therefore figures on page 7 as one more example of the work of the talented sculptor Thomas Engleheart.

Of Francis the engraver little need be said. He was born in 1775, and died at the age of seventy-four in 1849. He learned his art as an apprentice to Joseph Collier and as an assistant to James Heath. He was a member of the Society of British Artists. His earliest independent works were the illustrations to Akenside, after Thomas Stothard, whose "Canterbury Pilgrims" he had also a large share in engraving, and he also executed many of the illustrations to Homer, which were drawn by Richard Cook, R.A., the landscape artist, and works after Mulready.

He engraved many of Smirke's drawings for "Don Quixote," a portrait of Lord Byron after W. E. West, and many of the plates for the then popular "Literary Souvenir," "Amulet," "Gem," and other annuals. He is, however, best known by his engravings of Wilkie's *Duncan Gray* and the *Only Daughter*, and of Hilton's *Sir Calepine rescuing Serena*. Proofs of the Wilkie plates were sent by George Engleheart to his son when in India, and are mentioned in a letter which is quoted on p. 21.

Francis Engleheart exhibited his engravings at Suffolk Street

Gallery, not in the Academy, sending in 1824 twelve from " Don Quixote" and a portrait of a Mr. Robert Pope. In 1826 he showed a portrait of the Rev. J. Yates, and in 1828 his celebrated engraving of *Duncan Gray*, after Wilkie. During these years he appears from the catalogues to have been living at 2, Bayham Street, Camden Town.

Timothy Stansfeld Engleheart, the son of the engraver Francis just named, followed in the footsteps of his father. He was born in 1812, and died in 1879. He executed many of the plates for the " British Museum Marbles," and a number of illustrations for the " Forget-me-not," " Literary Souvenir," and other books of that class, some of which were quite remarkable for their merit and feeling. In about 1839 he left London and settled at Darmstadt, where amongst other works he produced a very fine engraving of the celebrated *Ecce Homo* by Guido Reni, which had a vast circulation at the time, and was esteemed by men of taste as a notable work.

The eldest son of the original Francis Engleheart must be mentioned ere we turn to the youngest, who is the subject of these pages. John Dillman Engleheart was born in 1735, and appears to have carried on for a time his late father's art in conjunction with his brother ; but by the will of his uncle John Dillman became possessed of so comfortable a fortune that he retired from active business and devoted himself to his family. He was twice married, his first wife being one Mary Webber, and the second, whom he married in 1770, one Jane Parker, whose family came from the North.

He resided in a house in Shepherd's Street (as it was then called), between Hanover Square and Bond Street, and abutting upon the mead through which passed the " great conduit," the site of the present Conduit Street. This appears to have been his favourite residence, as, after an enforced absence from London of twenty-four years owing to ill-health, he returned from Kew to live there. The house, which still belongs to the family, bears traces in its staircases and ceilings of having been a pretty and a comfortable residence.

He had ten children, but only three survived him : two daughters, Lucy, afterwards Mrs. W. Farnell Gardner ; Mary, afterwards Mrs. Pyne, whose portraits appear in this book ; and a son, John Cox Dillman Engleheart, who learned the profession of a miniaturist at the hands of his uncle George, followed it with success for some years, but relinquished it entirely in 1827, owing to ill-health.

To him further reference is made in Chapter VII., where his works, family, and career are more fully dealt with. From him, as will be seen in the genealogical table at the end of this book, descend the members of the family who now own the books and papers of George Engleheart, together with a very large number of his portraits.

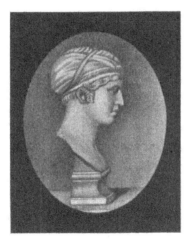

DRAWING BY GEORGE ENGLEHEART.
From a bust believed to have been executed by Thomas.
(Collection of Sir J. Gardner D. Engleheart, K.C.B.)

CHAPTER II.

THE LIFE OF GEORGE ENGLEHEART.

THE artistic tendencies of the talented family attained their fullest development in the person of George Engleheart, the youngest son of Francis. He was born at Kew in October, 1750, but of his youthful life little or nothing is known. We cannot even say where he was educated, and no stories of his early skill with pencil or brush have been handed down to his descendants.

It is, however, abundantly clear that his talent marked him out as an artist, and the signs of it were so evident that his family placed him as soon as he left school with a clever painter who could educate him in the art. He was sent to the studio of George Barret, R.A., when quite a lad, and under his tuition made some beautiful drawings of landscapes and cattle, taking up the branch of art which had gained for his master the premium at Dublin, and by which Barret had first become known in England.

Barret was at that time residing in Orchard Street, Portman Square, and it was there that George Engleheart was sent. His work was popular and in great demand. He represented English scenery in its true freshness and richness, excelling in the verdure peculiar to spring. He painted animals in a spirited manner with a firm characteristic touch, and had a certain amount of poetic imagination. It was in water-colour that he really excelled, and in that medium his tuition would be of special value to the young Engleheart; but it does not appear that the lad remained very long with his first master, and, leaving him, entered the studio of a far greater man, Sir Joshua Reynolds.

While in Barret's studio the young Engleheart seems to have first adopted water-colour as his favourite medium, but to have had no ideas as to its possibilities in portraiture. His efforts were confined, like those of his master, to landscapes and cattle, and very clever indeed were

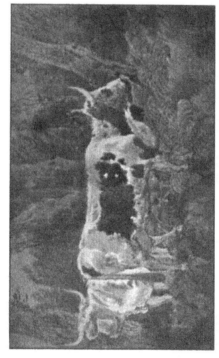

COLLECTION OF SIR J. GARDNER D. ENGLEHEART, K.C.B.

WATERCOLOUR SKETCH OF CATTLE DONE BY GEORGE ENGLEHEART WHEN IN THE
STUDIO OF GEORGE BARRET, R.A.

some of the latter. A large number of them are still in existence in the possession of Sir Gardner Engleheart, and one has been selected as a representative illustration of this period, in which the influence of Barret is specially well marked, and the tender fresh colouring of his master is imitated to perfection.

Barret was all his life in difficulties, and whilst in Orchard Street, although earning a considerable sum and having several clever pupils in his house, he managed to get into the Bankruptcy Court owing to his extravagance and carelessness. It was possibly at this time that Engleheart left him, but we are unable to say when he went into the studio of Sir Joshua or how long he remained with the President.

His first copies of the pictures painted by Sir Joshua were done in 1776, but at that time it appears that he was working for himself, as a year before that date he had commenced the series of entries in his fee-book, which are the chief source of our information. He exhibited for the first time in the Royal Academy in 1773, sending in on that occasion the only landscapes which he ever appears to have submitted to the judgment of that famous society. They were two in number, one called a *View of the Royal Villa, late the Princess Dowager's, at Kew*, and the other simply a *Landscape and a Castle*. With them he also sent in a miniature of a child, his first recorded portrait, and he described himself as living at " Kew Green, Surry."

In that year, on February 3, his father died, and perhaps in conse-quence George left Kew and came up to London to live, taking a studio in Shepherd Street, Hanover Square, probably in the house which belonged to his late father. This was his address for two years, but in 1776 he moved to Prince's Street, Hanover Square, and here it was, in all probability, that he first set up a home for himself, as the date is coincident with the opening part of his fee-book.

Perhaps during the three former years he was in attendance in Sir Joshua's studio in Leicester Square, only occasionally painting for himself; but in 1775 he comes forward as a professional man on his own account, and from the previous year down to the time when he retired he recorded with the most punctilious care the name of every one of his sitters, the amount which he received for each portrait, and the date upon which the payment was made. It is unfortunate that no records remain to tell us of his career in the great studio in Leicester Square, and that his name does not appear in any books which deal with Sir Joshua.

C

The President was, however, well known for his indifference to his pupils. Northcote said that "Reynolds was certainly very deficient in making scholars ; for although he had a great many under him who lived in his house with him for years, yet their names we never hear of, and he gave himself not the least trouble about them or their fate. It was his opinion that a genius could not be depressed, nor any instruction make a painter of a dunce. So he left them to chance and their own endeavours." In another place, in his entertaining work, Northcote describes his own experiences as a pupil in the house of Sir Joshua.

"The first day," he says, "I went there to paint, I saw one of Sir Joshua's pupils, and on conversing with him was much surprised to find that his scholars are absolute strangers to Sir Joshua's manner of working, and that he made use of colours and varnishes which they knew nothing of, and always painted in a room distant from them ; that they never saw him unless he wanted to paint a hand or a piece of drapery from them, and then they were always dismissed as soon as he had done with them."

"He has but two young gentlemen," continues Northcote, "with him at this time, and they both behave to me with great good-nature."

It is quite clear that Sir Joshua, as Sir Walter Armstrong has said, "would give a pupil the run of his house, would let him copy what he liked, and learn as much as he could, from his fellow-scholars ; he would even condescend now and then to require his assistance in a drapery or accessory ; but to lay down his own preoccupations and to put himself in the place of a young man wishing to penetrate the secrets of art was entirely outside his scheme of life."

In these circumstances it is small wonder that we know little or nothing of Engleheart's life in Leicester Square, although we cannot help regretting that he himself has left no records as to his dealings with the President, for whom he seems to have always entertained a high respect, and so many of whose paintings he copied so cleverly in miniature. To these copies we refer more fully in a succeeding chapter.

Whether he stayed a long or a short time with Reynolds, he appears to have started his professional life on his own account in 1775, and his first entry in his new fee-book is of a portrait painted on January 6 of that year, of a Mr. Belt of the Crown Office, for which he charged the sum of 4 guineas, and duly received the money on February 10 following. That 4 guineas was the only money which came in during those first two months, but in March he earned £37, and from that time forward there was no want of work.

COLLECTION OF SIR J. GARDNER D. ENGLEHEART, K.C.B.

MRS. GEORGE ENGLEHEART.

GEORGE ENGLEHEART.

In 1776 Engleheart married the daughter of a City merchant who lived at Isleworth, and brought his wife to the house which he had taken in Prince's Street, Hanover Square. His married life was, however, a very short one, for three years afterwards, to his great sorrow, his wife died, quite suddenly, on April 9, and, although he had been exhibiting at the Royal Academy year by year up to that date, yet in that year he sent in nothing, nor did he again exhibit till four years after, when, in 1783, he had again changed his place of residence. In that year he seems to have purchased the house in Hertford Street, No. 4, where he went to reside, and where he continued to dwell till he moved into the country.

This house had just been built on a piece of land belonging to the "old fair," which about that time assumed the garb of respectability, and was destined subsequently to become one of the centres of fashion. The neighbouring house was occupied by Dorothy Jordan, and No. 10, close at hand, was the residence of Sheridan, and had been previously inhabited by Lord Sandwich, famous for his musical parties, and after that by General John Burgoyne, the unsuccessful hero of the American War. Later on, in this same historic street, resided Trelawney, Lord Byron's companion, in whose arms the poet died ; Sir Charles Locock, the eminent accoucheur ; and Sir Alexander Cockburn, the Chief Justice of England.

Close to where Engleheart settled down had stood a hundred years before the celebrated inn called the Dog and Duck, with its gardens and pools, in which the fashionable diversion of duck-hunting by spaniels had been constantly practised. Later on it was superseded by pigeon-shooting, which took place near to a little pond "shaded by willow trees." The whole of the land in this neighbourhood had at one time belonged to a certain Mr. Sheppard, whose name was perpetuated in the street where Engleheart had before then been residing. Close by was a celebrated riding-school, and in a house very near at hand in the next street lived the notorious Kitty Fisher.

To the house in Hertford Street Engleheart brought his second wife, for in 1785 he had married again, one Ursula Sarah Browne, half-sister to Jane, the wife of his brother, John Dillman, and by her he had three sons and one daughter—George, Nathaniel, Emma, and Henry. George became a Colonel in the Honourable East India Company's Bengal Establishment, married Elizabeth Murray, and died without issue in 1833 in the forty-seventh year of his age, and was buried at Kew. Emma died single in 1863. Nathaniel, who was a Proctor in Doctors' Commons,

died in 1869, leaving a large family ; and Henry, the fourth child, a Clerk in Holy Orders, born in 1801, died unmarried on May 12, 1885.

Mrs. Engleheart predeceased her husband, dying in 1817 in the fifty-sixth year of her age, and was also buried in the family tomb at Kew. After his second marriage Engleheart seems to have continued steadily on with his profession, working very hard and very industriously, and producing such a large number of portraits as to be almost inconceivable had we not his written word attesting the fact. He gave himself few relaxations, especially during the earlier part of his career, spending almost all his time in his studio ; but amongst his friends there were a few whom he visited from time to time, and in whose houses he allowed himself a period of rest and quiet.

We hear of him visiting Hayley at Eartham for the first time in 1783, when he was invited to meet Flaxman and Meyer, Romney and Blake, and the change from the close work of the studio to the pretty Sussex home close to the sea where Hayley entertained his friends must have been pleasant and invigorating to the artist. His acquaintance with Hayley had been early begun, and was continued on the closest terms all his life. The two men had much in common, and entertained a very strong regard for each other. Hayley, whose clever portrait in Indian ink by the hand of his old friend adorns these pages, dedicated many of his poems to Engleheart, and they kept up a very constant correspondence, which extended over many years.

After Engleheart had retired from the active pursuit of his profession, he was able to see more of his old friend, and then it was that poetic effusions seemed to have passed frequently between the two friends, inspired, after the practice of Hayley, by the most trivial of events.

We find a record amongst the papers preserved by his son Henry, that on one occasion Engleheart left behind him at Felpham a silk handkerchief, which was returned to him by his friends with the following words worked on it in embroidery :

> " Blest be the pencil whose consoling power,
> Soothing soft friendship in her pensive hour,
> Dispels the cloud with melancholy fraught
> That absence throws upon her tender thought."

On two special occasions Hayley sent the following effusions to his friend by way of compliment.

On Friday, May 26, 1809, he thus writes :

> " Dear Engleheart, with more than magic grace,
> With heavenly aid, you exercise your art ;
> You paint my fair one's virtues in her face,
> A gracious Heaven impressed them on my heart.
>
> " For this may you, whatever ills are rife,
> See all you love of joyous health possest,
> And through a long and honourable life
> In your affections be supremely blest."

On March 10, 1811, he sent him the following lines :

> " Dear Artist, hast thou feared thy friend
> Could cease to love thee ? Never !
> Friendship with thee can never end—
> Once formed it lives for ever."

The ability to drift into verse upon every occasion, and to lavish poetic compliments in all directions, was very characteristic, not only of Hayley, but of the half-morbid, dreamy, poetic spirits with whom he loved to surround himself, and who flattered him and each other to their hearts' content.

The most truly poetic one amongst them was Cowper, for whose tomb Engleheart was asked to suggest a design, and for which he sent in to Hayley three alternative sketches, none of which, it must be confessed, were of more than ordinary merit. A scrap of paper on which Cowper had written some lines was given by Hayley to Engleheart as a precious memento. It bears on one side the following piece of rather hackneyed advice :

> " Teach freely what thou canst, nor in thy turn,
> If ignorant, account it shame to learn ;"

while on the back are the following adulatory lines dedicated to " Lady M. N. his patroness " :

> " Praise to deserve, yet never to desire,
> Is such high praise, that none can merit higher ;
> And this I give thee, with no base design
> To flatter thee, for it is duly thine."

The kind of letter which passed between Engleheart and Hayley may be fairly well judged by the following specimen—a note from Felpham dated September 6, 1818, when one of the sons of Engleheart was unwell :

" MY VERY DEAR FRIEND,

"I shall rejoice to see you, and still more to conduce to the restoration of your young student.

"Do not think of Bognor, but steer directly for Felpham. You will find two beds for you and your son in this hermitage, and there is a decent publick-house in the village where your equipage may be well taken care of.

"As I hasten to seize the returning post, I will only add that I beg to be most kindly remembered to every branch of your family, and most heartily wish you a pleasant and prosperous excursion to the Cell of your ever sincere and affectionate

" HERMIT."

Two views of the quaint house which Hayley called the " Cell " are given, and to one of them Engleheart, in his minute printing characters, has appended references as to the rooms in the house.

The likeness of the owner which Engleheart drew for his son shows a mild, benevolent person with a good deal of dry humour lurking in his features. It was his friendship for Cowper and his influence upon Romney which have immortalized his name. His own books, " The Triumphs of Temper " and the " Life of Cowper," are now but little known, especially the former, which had a great repute in its time ; but the ability which Hayley possessed of being able to gather around him the clever and strange men of genius of that time, to help and assist them with never-failing generosity, and to make their works better known to the world, have given to his name a personal value which far exceeds that which intrinsically it deserved.

Romney, whom Engleheart first met at Hayley's house, and with whom he afterwards became very friendly, gave to his fellow-artist some of his sketches, but these, unfortunately, were sold by some of the artist's descendants.

Blake, the visionary, a genius of marvellous ability and a poet of very high order, was also one of Hayley's and Engleheart's friends, and another one was Jeremiah Meyer, one of the earliest Royal Academicians, and himself a very clever painter of miniatures. One of the miniatures which Engleheart left behind him (see p. 22), has been believed to be the work of Meyer, and to represent *Lady Thomond*. A tracing of it, however, appears in Engleheart's note-book, and it was very probably therefore painted by him, in a manner resembling his friend's work, perhaps by way of experiment.

A the Upper Library (the end window the other windows on the side at .1.)

B.... Dining room

C.... Lower Library

D.... Harriet's room

E the Spare room when some Spirit will rest when it visits the Turret

F.... Mary's Boudoir

G.... round window in the turret

H at the kitchen door emblematical

I.... Arcade

J.... Porch

THE CELL, FELPHAM, FROM A WATERCOLOUR SKETCH, WITH REFERENCES, BY GEORGE ENGLEHEART.

To the British Museum there has recently been presented by
Mr. F. Haverfield a delightful book which was once the property of
Meyer, and contains tracings of many of the miniatures which he painted,
but, unluckily, they are not named. The only record which this little book
contains as to the artist is a bill for the purchase of ultramarine, in which
four " purces " of it are bought for £8. The colour was a very favourite
one on Meyer's palette, and, in fact, his work can often be identified by
the large amount of ultramarine which appears in the miniatures, not only
in the background, but elsewhere in the portraits. Meyer lived at Kew,
and therefore it is possible that the acquaintance began before the two
artists met at Felpham. It was continued to the descendants of Engle-
heart, as will be seen in Chapter VII., where J. C. D. Engleheart,
nephew of George, records his journey to Kew to copy the portrait of
Miss Meyer as Hebe, which Sir Joshua had painted, and which was still
in the possession of the artist's widow at Kew.

The two men, Meyer and Engleheart, had other sympathies in
common. Both were of foreign extraction, as Meyer had come from
Tübingen in Würtemberg. Both had been pupils of Sir Joshua, and
both were great admirers of the work of the President, and had copied
it on many occasions. Both came to England as lads, and had settled
down in the country, and both were expert painters of miniatures, on the
household of the King and Queen, and amongst the most fashionable
of the artists of the day. Meyer died in 1789, many years before his
friend, and was buried at Kew.

In the pretty Sussex home where these men met there must have
been many a delightful conversation, many an argument carried on with
vigour and enthusiasm, and very pleasant must have been the occasions
when, wearied by constant work in the studio, the friends gathered
together at Felpham and enjoyed one another's society in that agreeable
home. Romney, perhaps, was at that time painting at Petworth, and, as
Petworth House was not far off, we can fancy the visits which were paid
by the artists to the gallery of paintings, and the satisfaction which they
must have felt at the sight of the noble works which it contained.

It is probable that it was also at Felpham that Engleheart met Miss
Jane Porter, the author of "Thaddeus of Warsaw," "Scottish Chiefs,"
" Field of Forty Footsteps," and many other works, very popular in their
time. She kept up a constant correspondence with the artist, and when
in later years his son Henry was going abroad, she it was who gave him
letters of introduction to Madame Goldsmid and to Baron Humboldt,

which, as he records very gratefully, were of much assistance to him on the Continent.

With these exceptions, Engleheart seems to have had but few friends, and to have lived a very quiet and staid life. A good deal of his time was spent at his country house at Bedfont, whence he was able to ride or drive to Hertford Street for his professional work. He had purchased a small estate in this village in 1783, and built there a house decorated internally in the Adams style, and surrounded by pretty grounds and fine trees. The gorse-covered heathland of Hounslow then stretched up to these grounds, which it nearly surrounded, and even at that time the district, notorious for its danger in old times, was infested with highwaymen.

It was here that his two nieces, young girls of eighteen and nineteen, whom the King had called the Fair and Dark beauties of Kew, were stopped one night when returning in their carriage with their brother from spending the evening at Bedfont, and were despoiled by two masked and armed gentlemen of the road of all their valuables in the ancient and orthodox fashion. The portraits of these young ladies can be found in this book.

The village of Bedfont, which is said to derive its name from a well, still in use, which dates back to the time of the Venerable Bede, and is connected with the famous early historian, was a well-known one to all who had occasion to travel along the Western Road, for at one time no fewer than fifty coaches changed horses daily at the sign of the Black Dog on the village green, where the forerunner of the present Coaching Club, the celebrated association known as the Bedfont Driving Club, subsequently held its meetings. The passengers when entering upon the galloping stage to Egham had just time to notice the village green, with its picturesque church and the quaint yew-trees cut into the shape of peacocks, which are described by Hood in the following lines from his poem, *The Two Peacocks of Bedfont:*

> "Two sombre peacocks—Age, with sapient nod
> Marking the spot, still tarries to declare
> How they once lived, and wherefore they are there."

Two pencil sketches of Bedfont and a water-colour drawing of the village are given in this volume, as illustrative not only of the charm of the place, with its church and its yew-trees, but also as examples of the dainty grace which the artist was able to put into his pencil drawings,

COLLECTION OF SIR J. GARDNER D. ENGLEHEART, K.C.B.

PENCIL DRAWING OF THE VILLAGE OF BEDFONT BY GEORGE ENGLEHEART.

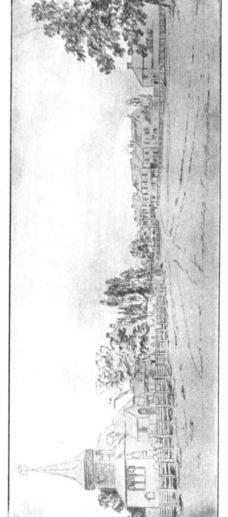

PENCIL SKETCH OF THE VILLAGE OF BEDFONT BY GEORGE ENGLEHEART.

and the satisfactory and pleasant effect of his water-colour landscapes.
In the second pencil sketch the inn with its swinging sign the Black Dog
is a very prominent object.

One of Engleheart's water-colour drawings of the house itself is also
given, and a member of the family is introduced riding on horseback near
by dressed in the curious costume of the period, whilst to complete the
series a photograph appears of the house in its present condition,

BEDFONT.

From a photograph.

very little having been done to it since it was erected by the artist. It
is still in the possession of the family, and has been used as the residence
of the great-grand-nephew of the artist till recent times.

Engleheart grew very fond of Bedfont, and was constantly there, and
always glad of an opportunity of riding down to his country home,
doing some of his work there, and introducing a view of the place into
the background of his pictures. He had, after many years of labour,
become a man of considerable means, and although his hand had not

D

lost its power and skill, yet he was often counselled by his friends to
relinquish miniature-painting, and spend the remaining years of his life
at his beloved home. Hayley was one of those who thus persuaded him,
and, being unable to resist so good an opportunity for his muse, thus
apostrophized the artist in poetic strain :

> " Be warned, dear artist, still of powers entire,
> Still firm of hand, still rich in mental fire,
> Dear Engleheart ; whom in thy zenith now
> Friendship salutes with many a kindly vow.
> List to her anxious monitory song,
> Toil not too eagerly, toil not too long,
> But in yourself prepare maturely sage
> The dignity that decks a green old age."

To the advice of his friends Engleheart appears to have given but
a very hesitating consent, as it was several years from the time when
the foregoing lines had been addressed to him before he finally withdrew
into private life. Still, little by little, he prepared himself for retirement
by accepting fewer commissions, and at length yielded altogether to the
advice of his old friends, and left Hertford Street in July, 1813, giving
up the active pursuit of his profession from that time.

It must not be thought, however, that he entirely relinquished his
art after that date. He certainly wrote no more entries in his famous
fee-book, and did not even complete the page upon which he had been at
work, or reckon up the figures which it contained, but he executed many
notable portraits, one of which, dated October, 1818, has been described
as the " ne plus ultra of miniature portraiture." Another of a lovely
boy appears in this volume, and bears the inscription " H. M." and
the date 1816, together with his old address in Hertford Street, where
he probably went to paint this very special portrait of an unknown lad.
From the public point of view the artist had, however, retired, and the
works which he executed after this date were probably those of his own
family or friends or of some very notable personages, who could not well
be refused, or would not accept such a refusal while the artist was yet alive.

In October, 1817, Mrs. Engleheart, the beloved partner of his life's
joys and sorrows, died at Bedfont, and was carried to Kew for burial in
the family tomb. It was to Hayley that Engleheart sent, after the death
of his wife, asking him to write an epitaph for the loved one's tomb, and
there is a letter still in existence in which the artist, while thanking his
friend for what he had sent him, ventures the opinion that the epitaph is
too long for the purpose, and begs that a shorter one may be composed.

WILLIAM HAYLEY.

From a pen and ink drawing by George Engleheart.

WILLIAM PITT.

From a pencil sketch.

LINES WRITTEN TO GEORGE ENGLEHEART BY HIS FRIEND, WILLIAM HAYLEY (OR HALEY), 1811.

Then Hayley wrote again, begging his old friend to come to Felpham, "as the sympathy," said he in his letter, "of a true fellow-mourner and a change of scene and air are, I am persuaded, the best lenitives for deep sorrow, and I cannot help wishing to persuade my good old friend to pass a little while with me in the Hermitage." This invitation was evidently accepted, as in a letter of Hayley's, dated "The Turret," November 4, he says: "He delighted us all with his society and with the various productions of his genius. I rejoice to find his pencil active and as powerful as ever."

Three years later the writer of this letter was no more. He left to Engleheart several of Romney's works, including a study for the character of Miranda in the "Tempest," describing it as "compassion personified in the form of beauty, which was the original design for Boydell's Shakespeare Gallery, and altered to suit the Alderman's taste," and also that masterpiece *Sensibility*, representing Lady Hamilton, painted at Hayley's suggestion, and obtained by him in part payment for a farm which he sold. But

> "Of all the legacies the dying leave,
> Remembrance of their virtues is the best."

The *Sensibility* by Romney remained in the possession of the Engleheart family for some considerable time, but was at length sold at Christie's by the three old ladies to whom it descended.

After his visit to Hayley, Engleheart returned to Bedfont, and there, with his daughter Emma, lived a life of quiet retirement for some years; but at length, finding that the trouble and bother of keeping up this establishment was considerable, and that his daughter, being in poor health, found it a serious burden, and realizing also that it was somewhat lonely after the busier life to which they had both of them been accustomed, he decided to let Bedfont and go and live with his son Nathaniel, who was settled in a large house at Blackheath.

The tenant obtained for the house was the Duchess of Manchester, who was in bad health and needed a place near London where she could have perfect quiet. Her husband had been away for eight years in Jamaica, where he was Governor. She appears to have been a very good tenant, and the new arrangement answered very well. The rent she paid was £262 10s., and Engleheart paid taxes, and so had a net return, he says, of £220 per annum.

There are three very interesting letters written by Engleheart to his son George when he was in India, dated 1827, in which the father describes his new life with Nathaniel at Blackheath. Major Engleheart was at that

time in the 2nd Regiment of Native Infantry at Barrackpore, Bengal, and
his father wrote out to tell him what plans he had made as to his property,
and what he had left him in his will.

He was anxious to impress upon his son the necessity for a substantial
income in England, and to make the matter perfectly clear he entered into
details as to his own expenditure at Bedfont during the preceding few
years, giving him some very instructive figures. His annual expenses,
he says, "for himself, Emma, and an occasional friend or two, with
expenses of three female servants (a cook, housemaid, and a girl to
attend to dear Emma) and two men servants (a gardener in the house
and a man to attend to the horses, cows, etc., out of the house), amounted
to not less than £544."

This he apportions as follows : Butcher, £80 ; baker, £20 ; grocer,
£31 10s. ; wine - merchant, £31 10s. ; coal - merchant, £35 ; tallow-
chandler, £20 ; washing (paid quarterly), £30 ; servants' wages, £105 ;
corn, hay, and straw for two horses, £60 ; taxes (various)—for horses,
carriage, servants, windows, etc., £53 ; subscriptions — school, £2 :
coals, £5 : lying-in women, £2 : etc., £6 : total, £15 ; tailor, £30 ;
linen-draper, £20 ; shoemaker, £10 ; hatter, £3 ; total, £544. Butcher
and baker, he adds, were paid weekly, and all this expenditure was
" independent of medical advice and pleasureable expenses, and living in
the house furnished as it now is rent free."

In concluding this interesting letter, in which he tells his son that he
has left the Bedfont property to him with its furniture and other contents,
he adds : "You cannot possibly live in England under £800 a year,
making no allowance for buying horses, carriage, and other accidental
and pleasurable expenses."

The figures which he gives are of great interest for comparison with
those which would be needed in the present day, in order to live com-
fortably in the style to which the old artist had been accustomed, and
they also enable us to see what a successful man he had been, and how
the habits of scrupulous care, neatness, and attention to various small
details, which are all exemplified in his fee-book, were carried out by
him throughout all the affairs of his life.

In another letter he explains to his son that he is now "paying
Nathaniel very satisfactorily for our board for myself, dear Emma, and
her little maid, and dear Henry, who occasionally visits us, perhaps once
in five or six weeks." He speaks of Nathaniel as "very busy at Doctors'
Commons," of Henry as "a bookish man who will soon be obliged to go

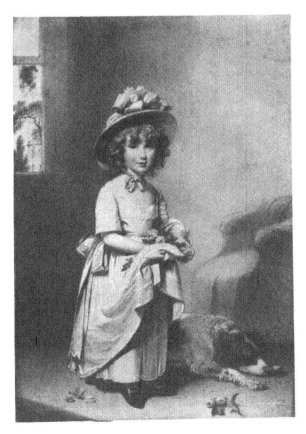

LUCY ENGLEHEART (AFTERWARDS MRS. GARDNER).

to his clerical duties In Kent at Sevenoaks, and who had suffered much
in health from ague, which he had four times during his long curacy in
Romney Marsh"; and he expresses great pleasure at the thought that
when at Sevenoaks his son would not be so far from him, and would be
able to ride over to Blackheath and see his father very often.

The artist's affection for his children was most marked. He lived
and worked for them, and was anxious to behave with perfect justice
towards them, and to do his utmost to make them happy.

He was of a bright, happy, and very religious disposition, and in one
letter he writes that his friends say that he is "the most cheerful old
person whom they have ever met." His own explanation of the fact is
contained in a clause in another letter, in which he states that "never
willingly or knowingly have I done an unjust act, and would not hurt
any living creature upon earth."

He seems to have taken infinite pains with his will to make it as
fair and as just as possible.

His expression as to the division of his property is as follows : " I
hope I have divided my little property as equally as I could to all your
mutual advantages and to the best of my abilities, and I trust God will
bless all my intentions."

In May, 1827, he describes the new chaise which he had purchased,
and a clever little sketch, here reproduced, is attached to the letter.

may 25 1827.

It was light, he says, and "painted dark green and had drab-colour
cushions, and he had bought with it a mare thirteen hands high."

In December he writes again to George, to tell him of the serious
accident which he had with this very chaise at Blackheath, in which he
and his daughter were thrown out and much bruised, and he informs him
that he had been twelve weeks in bed since the accident. At that time
he sent to George in India a proof on "sattin paper" of his cousin
Francis's engraving of *Duncan Gray*, which he says was very highly
appreciated in England, and he explains that the proofs, such as he was

sending, were practically unprocurable. It was always a feature of this family that they had a sound appreciation for the genius of other members of the same household, and were ever ready to understand and to praise the fruits of that genius, however expressed.

The severe shaking and bruising which the artist underwent at the time of this carriage accident accelerated his death. He was never quite the same man after it as he had been before. He lived to see his favourite son George return from India, and died at Blackheath in his seventy-eighth year on March 21, 1829, surrounded by the various members of his family. He was buried at Kew, his son Henry taking the burial office, and his remains were deposited in the family vault where so many of his relations had been buried, and where, later, his son George and his daughter-in-law Mary, the wife of Nathaniel, were to be placed. Close by his monument can be found those which have been erected to his friend Jeremiah Meyer, and his contemporaries and acquaintances, Gainsborough and Zoffany.

Nathaniel records the fact that when his father died in 1829 a raven took up his position on the top of an elm-tree in the garden and kept up his melancholy croak during the last few hours of George Engleheart's life. It remained there till after the funeral, and would not move till the body had left, and never before nor since had a raven been seen in that garden, although the family had then resided there for some eight years, and lived there for a long time after George Engleheart's decease.

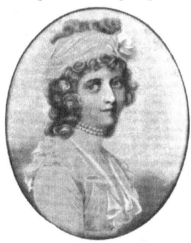

*Collection of Sir
J. Gardner
D. Engleheart,
K.C.B.*

MINIATURE
BELIEVED TO
REPRESENT LADY
THOMOND.
(See page 14.)

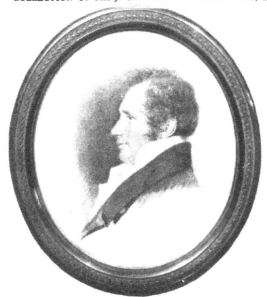

J. C. D. ENGLEHEART.

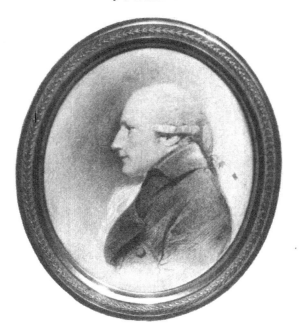

PELTRO TOMPKINS.

CHAPTER III.

YEAR BY YEAR IN THE STUDIO.

AS we have already seen, the entries in Engleheart's fee-book commence on January 1, 1775. Many of his commissions in that year, and for some few years which succeeded it, were for drawings, but for miniatures his chief patron in his first year was Lady Townshend, of whom he painted six portraits in one month. Lords Lyttleton, Valentia, and Borrowdale (the latter probably intended for Berriedale, and the son of the Earl of Caithness), were also painted by him. The noted Lady Banks, wife of Sir Joseph Banks, and the still more remarkable Miss Sophia Banks, were amongst his patrons in his very first year of work.

In 1776 we find the name of Lord Ferrers, as painted both whole-length and also in ordinary form; Lady Albemarle, for whom a portrait of her son, Lord Albemarle, appears in the following year; the Adairs, one of whom commissioned in that year what is entered as "a drawing for the Pope," and which it would be interesting to know more of; Count Brahe; and a large number of portraits of the Chambers family including no fewer than five of Sir William himself, and portraits of Lady Chambers and six other members of the family. The Duke of Gordon, well known as a friend of Pitt; several members of the Drummond family; Sir Edward Swinburne, evidently the Baronet of Capheaton; and the well-known names of Strutt, Tyrconnel, and Walpole, are also to be found in that year; and Sir Thomas Clarges, whose name survives in Clarges Street, Piccadilly.

Three times in that same year appears the name of the King, who thus early in the young artist's career, before he was twenty-five, became his patron, and gave him the honour of sittings on many occasions. Engleheart seems to have painted George III. twenty-five times in all.

One example of his portraiture of the King which is here illustrated was a present from His Majesty to the artist. It was suitably mounted and adorned with good ormolu work, and was intended as a mark of the appreciation which his royal patron had for the industrious and clever miniature-painter. That second year of work was a very busy one, no less than 180 portraits being recorded, a number which fell to 98 in the following year, and was not again reached till 1781.

In his third year of work the King's name again appears many times, and amongst other notable patrons are Lady Day, Lady F. Leslie, Lord and Lady Winterton, and members of the Colebrook, Chisholm, Haverfield, Pennington, and Compton families. Lord Borriedale (*sic*) appears again in that year with his name more correctly spelt, and the year is also notable for the work done by the artist in copying the portraits by Sir Joshua which are mentioned in Chapter IV.

Early in 1779 come the names of some members of the Dering family, of Surrenden Dering. These miniatures, which were of the great-grandparents of the present Baronet and his family, seem to have been removed from the family seat by the second wife of the sixth Baronet, Deborah, the daughter of Mr. J. Winchester, who cleared the house of every ornament and jewel for the benefit of her own children. Lady Cadogan, Lady Caroline Dawson, Lord F. Campbell (afterwards Lord Clerk Register), and the noted Kitty Fisher, are recorded in that year's work. The number of commissions was slowly creeping up. It was 139 in 1779, and it rose to 151, 181, 175, and 208 in the following years.

One of the very few of the works of Engleheart which have been engraved was painted in the following year—the portrait of the singer Mrs. Mills, who was so noted for her acting in the part of Polly in the "Beggar's Opera." This portrait is one of those of which we give an illustration from the series of tracings of portraits which Engleheart kept for reference, very few of which, however, he named; and we also reproduce the scarce mezzotint of the same lady which was published in colours, was the work of J. R. Smith, and had a great vogue at the time.

Several of the Knatchbull family, from whom later on sprang Lord Brabourne, appear in this year; also Lord Fauconberg; the two quaint old Essex brothers, Moses and Thomas Yeldham of Yeldham, whom Russell painted; members of the Quarington, Kincaid, and Drummond families; and several children of the Bromley family. Charles Morris, of the

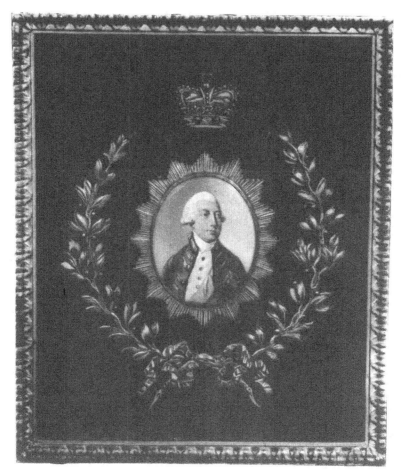

HIS MAJESTY KING GEORGE III.
BY GEORGE ENGLEHEART.
A GIFT FROM THE KING TO THE ARTIST.

A LADY UNKNOWN.

A LADY UNKNOWN.

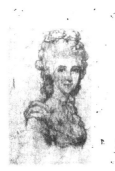

A LADY UNKNOWN.

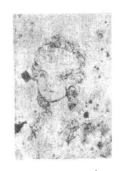

MRS. PAYNE GALLWEY.

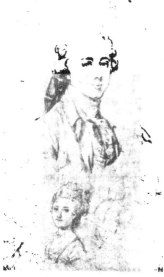

UNKNOWN PERSON.

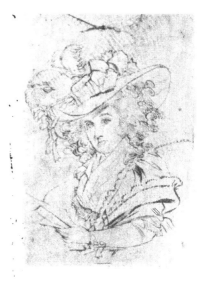

MRS. MILLS.

SOME OF THE TRACINGS OF MINIATURES FROM GEORGE ENGLEHEART'S TRACING BOOK.

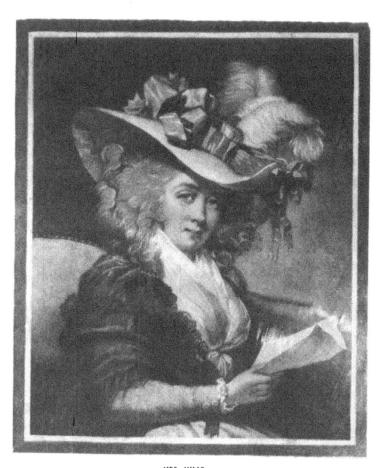

MRS. MILLS.
From the coloured mezzotint.

"Sublime Society of Beefsteaks," also appears in 1780, and Alderman Harley (afterwards Lord Mayor of London) and his family.

In 1781 Captain Rodney (afterwards Admiral Sir George) sat to our artist, having that very year relieved Gibraltar and captured the Dutch East India Islands. The dramatist Sir Lumley Skeffington also sat at that time, and several members of the Skeffington family. It was a busy year, with its harvest of 181 portraits, and amongst the long lists of names appear those of Cadogan and Townshend, Walpole, Fowlis and Hilliard, Whitefoord, Moyle, Harvey, Nicholas, and Nares.

In 1782 we find recorded the names of Lady Payne, several of the Petres and Bedingfelds, who increased Engleheart's already large Roman Catholic connection ; and Sir William Chambers, whose name that year was so familiar by reason of his erection of Somerset House. Lady Paget, Lady Cunliffe, and Lady Brooke, also sat to Engleheart, and the first of a long series of the Setons, who, with the Blunts, Imhofs, and Dents, their relations, made up quite a respectable proportion of Engleheart's sitters at about that time. This same year saw the completion of the portrait of Sir Joshua Reynolds, and the painting of some charming pictures of the Bramley and Belford children ; also Colonel and Mrs. Williamson ; the Princess Dowager of Wales, to be given to a Mrs. Leslie ; Lord and Lady Cadogan ; Mrs. Payne-Gallwey, whom Reynolds immortalized in *Pick-a-Pack;* members of the Mathias, Churchill, and Fitzgerald families ; and a celebrated clergyman, Dr. James, Headmaster of Rugby.

The next year was the biggest in commissions which Engleheart had so far seen, and very heavy years of work these few were. The average of pictures exceeded 200 in the year, more than one for every other day, and in some cases three are entered to the same day.

The speed with which the artist must have worked is simply extraordinary, and in one month—that of May in this very year—he executed no less than twenty-seven pictures, giving one for each day incessantly, excluding Sundays. There are three entered to the 6th of the month, two to the 7th, two to the 8th, two to the 9th, one on the 10th, three on the 12th, two on the 13th, one on the 14th, 16th, 19th, and 22nd, two on the 23rd, two on the 26th, and three on the 29th of this busy month. The King appears several times in this year, and there are also the names to be seen of Lord Caithness, whose son Engleheart had already painted ; Mrs. Yates, the noted actress ; his constant patrons

E

the Townshends ; Lord Feilding ; the Braddyls, who patronized Sir Joshua ; and several members of the Drummond family.

The very first entry in 1784 is that of Miss Elizabeth Young, a famous actress whose countenance, when shown at the Burlington Fine Arts Club Exhibition, was declared to bear a very striking resemblance to the unknown sitter who was painted by Romney, and has gone under the name of the *Parson's Daughter.*

Another famous beauty, a Miss Rumbold, appears a few months later. In this same year Lady L. Manners sat to Engleheart. She afterwards became Countess of Dysart, but search in the famous room full of miniatures at Ham House has not proved successful in finding this portrait of a delightful woman. Mr. Graves, afterwards Lord Graves, and the Rev. Mr. Madan, a well-known preacher of the time, were amongst the sitters in this same year.

The year 1785 opens with more of the ladies of the Blunt family, that famous family of lovely daughters, all of whom were painted by Engleheart, and all of whom made such notable marriages. Mrs. Spencer Stanhope appears in that year. She was the wife of the owner of Cannons Hall, Yorkshire, and an ancestress of the pre-Raphaelite painter of the present day. Sergeant Adair, who nominated Fox as candidate for Westminster, also sat in 1785. Mrs. Clive, the comic actress who charmed both Walpole and Johnson, was also painted in the same year.

Lord Northington's portrait by Reynolds was copied in 1786, and there are entries that year of the portraits of Sir James Lowther, the Trelawneys, Hamiltons, Drummonds, and Lees, as well as those of Lady Maynard, Lady Blunt, Lady Windsor, Lady Forbes, and Dr. James of Rugby. The most notable visitor, however, of the year must have been the famous Duchess of Devonshire, whose name appears twice at that time in the fee - book. She herself was painted in large size on September 5, and just before that, perhaps as a trial of the artist's power before the notable beauty would herself consent to sit, there is an entry under August 7 which reads : "A child for the Duchess of Devonshire." The Duke also sat to Engleheart, and Mr. John Townshend, the satirist, in that year.

In 1787 we find that two important families come upon the scene, the Berties and the Blighs, of whom he painted several portraits. Mrs. Robinson, whose name is also to be found, was the winsome Mary Robinson whose beauty, skill, and charm, together with the

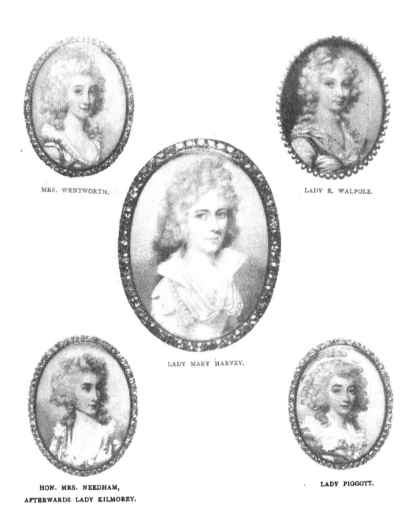

MRS. WENTWORTH.

LADY E. WALPOLE.

LADY MARY HARVEY.

HON. MRS. NEEDHAM,
AFTERWARDS LADY KILMOREY.

LADY PIGGOTT.

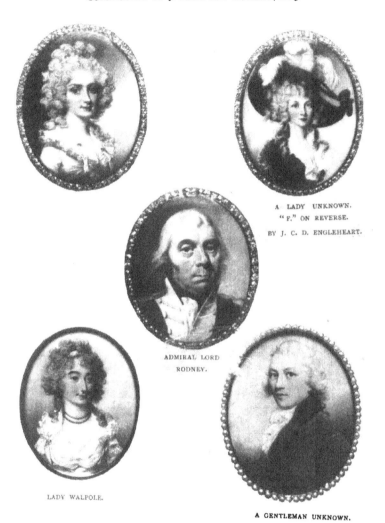

A LADY UNKNOWN.
"F." ON REVERSE.

BY J. C. D. ENGLEHEART.

ADMIRAL LORD
RODNEY.

LADY WALPOLE.

A GENTLEMAN UNKNOWN.

devotion which she received for a time from a fickle Prince, serve to keep alive the memory of her name. The Lady E. Forster (*sic*), whose name is so recorded, is almost certainly the great friend of the Duchess of Devonshire, Lady Elizabeth Foster, who became the second wife of the Duke of Devonshire ; Mr. Dundas we may take to be the one who afterwards became Lord Melville; Mr. Dymock represents the family of the King's Champion, one of the oldest and noblest in the country, one of the untitled aristocracy of England ; Miss Bromley was the actress ; Lord Compton, the son of Lord Northampton ; Mr. R. Grosvenor became afterwards the first Marquis of Westminster; and the Stapletons, Goslings, Claverings, and Kings were amongst the other names which are to be found in this fashionable year.

Dorothy Jordan, the actress, and Mrs. Billington, the great singer, are amongst the persons of note who sat to our artist in 1788 ; and in July there are the names again to be found of the Duchess of Devonshire, and also of Lady E. Foster. Another great name is that of Lady West- moreland, whose portrait is in this volume ; and the fine minature of Lord Robert Fitzgerald, which was recently sold at Christie's, and is, by permission of the owners, to be found amongst our illustrations, dates from this year. Other eminent names are those of several of the Douglas family, the Hutchinsons, the Howards, Hoares, and Vansittarts.

Amongst the clergy that year we see the Bishop of Hereford, Dr. Harley, whose son became fifth Earl of Oxford, and the Rev. Mr. Howard, Rev. Mr. Greathead, Rev. Dr. Carter, and Rev. Mr. Newton.

Lord Apsley, the President of the Board of Trade, Secretary of War, and afterwards third Earl Bathurst, heads the year 1789. His wife is also to be found on the same page, and with them, in good com- pany, are the names of Lord Tollemache ; Captain Hutchinson, Com- mander-in-Chief in Egypt ; Lord Daer, son of the Earl of Selkirk ; Lady E. Bellasis ; and Lady J. Long. There are also Cholmondelys, Talbots, Gordons, Fitzroys, Duncombs, and Biddulphs.

The year 1790 was the one in which the artist was able to proudly record himself as Miniature-Painter to His Majesty the King, and his name appeared with this addition in style in the catalogues of the Royal Academy at that time, Jeremiah Meyer, who had held the same office, having just died. He sent only one miniature to the exhibition that year, and by a curious coincidence we are able to tell whose it was, as although the entry in the catalogue is merely "A Gentleman," according to the tiresome custom of that period, yet on the catalogue in the Royal

Academy Library some unknown person has marked the words "Mr. Bate Dudley," and on turning to the fee-book we find that Engleheart did twice paint a portrait of this very person on January 26. In the fee-book he is first recorded as the Rev. Dudley Bate, and then, in the second entry, correctly as Bate Dudley. He was afterwards Sir Henry Bate Dudley, and Gainsborough painted his wife, Lady Bate Dudley—a fine portrait, which now belongs to Lord Burton.

A member of a Royal Family appears this year who is not named by the artist in the list given at the end of the fee-book of the portraits which he did of the royalties. The entry reads, "Prince Edward. C.," and it is probable refers to the Duke of Kent (father of Queen Victoria), and the C implies that the miniature was "Copied" from another work. It was painted on March 16.

Mrs. Fitzherbert sat to Engleheart in that year on March 25, and was painted large size. It was probably a very charming portrait, as this much-to-be-pitied lady, so noble in her character and so devotedly attached to the Prince, over whom her influence was ever for good, was just at that time in the very heyday of her beauty.

Sir John Leicester, afterwards Lord de Tabley; Lady E. Fane, the daughter of Lord Westmoreland, and her mother, the Dowager Lady Westmoreland; Lord Oxford, the fourth Earl, who died in that very year; Lady Salisbury; Lady Milner; and Lady Carolina Price, are to be found in this year, as well as the Thelussons, Bosanquets, Evelyns, Mansfields, Lindseys, Caves, and Rollestons.

There are the names of two notable beauties in 1791, Mary and Catherine Horneck, the Plymouth beauties, the "Jessamy Bride" and "Comedy Face" of Goldsmith's characters. There are two fine miniatures of sisters which now belong to Sir G. Engleheart, and to which the portraits of these two ladies bear a strong resemblance. They are not named, but we are disposed to think that the two which we illustrate at pp. 30 and 35 represent these notable sisters. Other important personages who sat in 1791 were Earl Glencairn, the fifteenth and last Earl, who died in 1796, when the honours became dormant; Sir Nelson Rycroft; Sir Robert Gerrard; Miss Pelham, the daughter, probably, of the Charles Pelham who afterwards became Lord Yarborough; Lady C. Bertie, daughter of the Earl of Lindsey; Lord A. Hamilton, son of the Duke of Hamilton; Lady Tweeddale, who is mentioned on p. 39; Lord R. Fitzgerald, sitting for a second time; Baron Amfelt; Madame St. Julian, a well-known and popular beauty; Mr. Dillon, the eldest son of Viscount

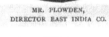

MR. PLOWDEN,
DIRECTOR EAST INDIA CO.

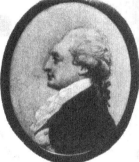

A LADY UNKNOWN.

MRS. STEWART, 1731.

MR. STEWART, 1731.

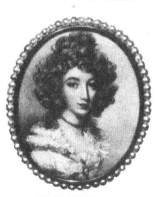

ELIZABETH ENGLEHEART.

Dillon; Nelly Farren, the actress; and several lads of the Woodford and Reed families.

In 1793 we see the names of Mr. and Mrs. Wedgwood, who are in all probability the famous potter and his wife. Josiah Wedgwood was just then a very noted man, and his pottery, started in the Staffordshire village of Etruria, was producing some of the most notable works which have ever been made from clay in this country, and was delighting all who saw them by their refinement of taste, their classic beauty, and their charm of colour. Flaxman, who was the great friend of Thomas Engleheart, was then working for Wedgwood, and many of the finest designs which came from the factory were his. It has been said that George Engleheart was sometimes associated with him in his drawings and designs, but in all probability a confusion has arisen between the names of the two brothers, and Thomas, the sculptor, is meant, as very possibly he was able to assist Flaxman in some of his work. All this, however, is conjecture, as nothing definitely is known.

Sir James Baird; Sir Richard Sutton; Lady Egmont, daughter of Sir Thomas Spencer Wilson, and wife of the Earl of Egmont; Lord Heathfield, of the Dragoon Guards, the only son of the brave defender of Gibraltar, whom Reynolds had painted, and who was himself the second and last Baron Heathfield; Lord Charles Murray; Lady Matilda Wynyard; and Lord Leicester, also sat in this year, and there are many entries relating to the Blunts, the Setons, and the Dents, who were all closely connected, and almost every member of whose families appears to have sat to this artist.

Lord Breadalbane starts the next year; Dr. Warren, Bishop of Bangor, was painted in August; General Dundas, who was about to start for the West Indies, was at Hertford Street in September; Lady Helena King, Sir John Ord, Mr. Bagot, Mr. Elphinstone, and General Stopford, may also be mentioned; but the year was a somewhat smaller one than usual with regard to work, and only 100 miniatures are recorded.

In the next two years, however, the total creeps up again, amounting to 138 in 1795 and to 152 in 1796.

In the former year we find the names of Lord Torphichen; Lord Sackville; Lord Westmoreland; Governor Hornby; the Honourable Mr. York, a fine miniature, which now belongs to Mr. Greville Douglas, and by his kindness is illustrated in this volume; Mr. Grey, the Leader of the House, afterwards Lord Howick, and then second Earl Grey; Sir H. Vane Tempest, who married the Countess of Antrim, and whose

daughter became the Marchioness of Londonderry ; Admiral Christian, together with Pagets, Tennants, and Torrianos.

In the following year there is the entry of a picture for Lady Cremorne ; there is a sitting recorded to the great preacher of the day, Mr. Romaine ; and there are entries to a Lord Homefield, Lord Ashbrook, Lord Andover, Sir William Erskine (who went with the Duke of York to Flanders), Mrs. Garrick (the widow of the famous David), and many another well-known name.

Engleheart is said to have painted Garrick himself, and the miniature was exhibited at the Burlington Fine Arts Club in 1889. It was probably painted before the artist commenced his fee-book, as the year after that book was commenced was the last in which Garrick played, and three years later he was dead. The portrait was a very fine one, and appeared to have every reason in its favour for attribution to Engleheart. If it was his work, as seems more than probable, it is evident that from the very earliest part of his career the talent he displayed was very considerable, and his power of painting a fine portrait quite remarkable for so young a man.

The list of eminent names continues on year after year ; all the chief persons who were known in town for beauty, genius, estate, position, or quality, seem to have sat to Engleheart.

When we open the pages on which the tale for 1797 is recorded, we find the names of Lord Cassalis, son of the Marquis of Ailsa ; Lord Broome (sic) ; Sir Thomas Hesketh ; Mr. Peltro Tompkins, the well-known engraver who engraved so many of the works of Bartolozzi ; and in the next year, 1798, those of Lady Macdonald ; Lord Lorne, the son of the Duke of Argyll ; and such familiar names as Cardwell, Marjoribanks, Delme, Fuller, Grote, and Paget.

In 1799 Admiral Christian, who sat in 1795, came again to be painted in his new honours, and appears as Admiral Sir H. Christian.

We now come to a new century, and in 1800 some of the chief names are those of Lady Swinburne, Lady Delme—which the artist carefully records was painted " by description "—Sir Richard Worsley, Sir Brook Bridges, Richard Sheridan, Lord Uxbridge, and Lady Clayton.

The portrait of Sheridan is a remarkable one, and reveals the good-nature, the genial qualities, and the weaknesses of his character to a striking extent. Mrs. Sheridan was also painted by Engleheart, and he was perhaps more successful in delineating her face than he was with the more complex features of her clever husband. Pitt he never seems to

COLLECTION OF SIR J. GARDNER D. ENGLEHEART, K.C.B.

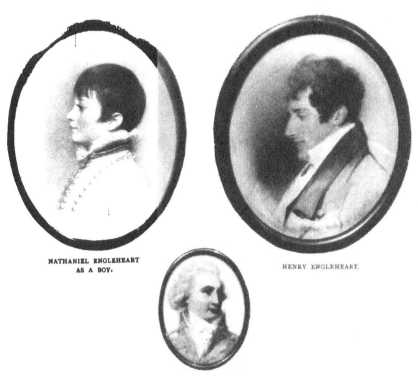

NATHANIEL ENGLEHEART
AS A BOY.

A GENTLEMAN UNKNOWN.

HENRY ENGLEHEART.

MISS MARY WOOLLEY, 1806.

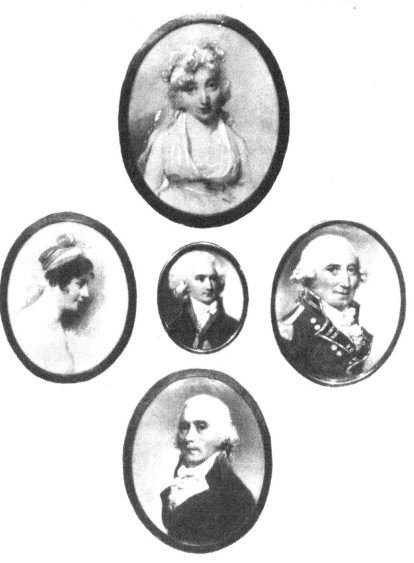

ALL UNKNOWN PERSONS.

have painted, but a rough pencil sketch of the great statesman is in existence, and was perhaps intended as a foundation for a miniature to be painted subsequently. It is of importance as revealing what Engleheart considered the salient points of the countenance, and is therefore reproduced in this work.

The opening year of the nineteenth century starts with a very notable name, as the entry for January 3 reads : " Bonaparti finisht."

It is a most perplexing entry. For whom did Engleheart paint this miniature if it was a commission? The family record is that it was, but that a replica of the portrait was done by the artist for himself, and retained by him. The entry does not bear the mark (referred to on p. 36) which showed that it was "paid for," but neither does it bear the cross which denoted that the portrait was done for the artist himself, and therefore the tradition as to two copies may be a true one. The miniature which the artist kept is now in the possession of Sir Gardner Engleheart, and is reproduced here. It shows a face in profile to the right, the complexion sallow, the hair and whiskers dark brown. Bonaparte is dressed in a blue coat which has a deep embroidered collar.

The portrait must have been a copy from some other picture, but the question arises, Which? It is inconceivable that it was done from life, as there is no space in the entries in the fee-book which could be filled in with a journey to France ; and although it is certain that at that time the First Consul was in Paris, as on December 24 he had narrowly escaped death by an infernal machine, and on January 4 he signed a decree banishing 129 persons on suspicion, yet the conqueror who had so lately crossed the Alps by the Great St. Bernard and defeated Melas at Marengo was not in the mood to give a sitting to an English artist, even if one had been commissioned from Engleheart at that time. It would be of the greatest interest to know more of this miniature, and to be able to tell for whom it was done, from what portrait it was copied, and why.

After Napoleon, all the entries under this year seem to take an unimportant place. There is Lady W. Russell to be recorded, Captain Paget, Admiral Braithwaite, Lord A. Hamilton, and others, all in 1801. The following year was a very aristocratic one, and boasts the names of Lord Tamworth, son of Earl Ferrers ; Lady Thompson ; Count Byland ; Lord and Lady Kensington ; H.R.H. the Duke of Cambridge ; Sir H. Hoskins ; Sir G. Abercrombie ; Lord Henry Fitzroy ; Sir Clement Cotterel,

the Master of Ceremonies at the Court; H.R.H. the Duchess of
Würtemberg, painted for the Duke of Sussex, and, unfortunately, as
Engleheart naïvely records, "never paid for"; H.R.H. the Prince of
Wales, done for Princess Augusta; and several other notable persons.
It may be considered as Engleheart's great Court year.

It is curious that during these few years, from 1799 to 1806, Engle-
heart never sent any exhibits to the Royal Academy. Whether he was
too busy with commissions to be able to do so, or whether he had some
quarrel with the authorities, can never be known; but for seven years
there is no mention of our artist in the catalogues of the society.

In 1806 he returned to the Academy, and from that time till 1812
sent in year by year some of his famous miniatures. A few of them were
of notable persons. Admiral Hamilton appeared in 1806; Mr. Plowden,
a Director of the East India Company, in 1807, together with three
brothers of the name of Barwell—Messrs. F., H., and C. Barwell. Lord
Henry Petty, the youthful Chancellor of the Exchequer, and afterwards
Marquis of Lansdowne; Lord Aboyne, afterwards Marquis of Huntley;
the Hon. E. S. Cowper, M.P.; and a well-known clergyman, a Mr.
Dallaway, were exhibited in 1808. Lord Erskine, the Chancellor; Sir
Christopher Robinson; Vice-Admiral Campbell, M.P.; and the Hon.
Mr. Quin, M.P., were sent in 1811; and amongst those exhibited in 1812
is the name of the King's Jeweller, Mr. Rundell.

The year 1803 is the last of what we may call the big years for
Engleheart. It records 103 pictures, and after that there is a drop, for in
1804 only 74 were done, and the artist never again reached the high-
water mark in point of numbers, 84 being the largest number which he
painted in any of the succeeding years, and the average for the nine
complete years during which he still worked only reaching 74. It must
be remembered that Engleheart was now fifty-two years old, and had
been working all his life at his art, and that it was at about this time that
his friends tried to persuade him to retire from the profession and take
more rest. He seems to have let his commissions come in more slowly,
and to have selected those which he liked; and it must also be re-
membered that the sizes of the miniatures had gone on increasing as
well as the amount of detail which they contained, and that the work,
therefore, on those accounts would take him longer to execute. His
position in the world of fashion as a favourite painter seems to have
continued up to the very end.

It is in 1803 and 1804 that the fashion of having the eye painted

COLLECTION OF SIR J. GARDNER D. ENGLEHEART, K.C.B.

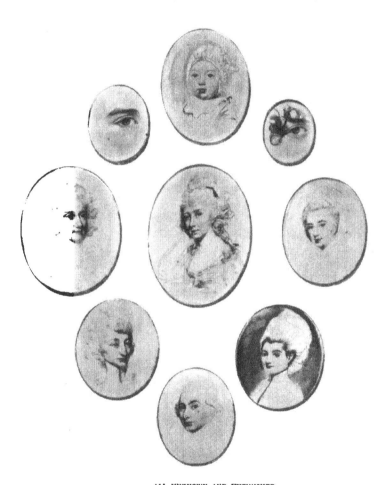

ALL UNKNOWN AND UNFINISHED.

The baby at the top is believed to represent Princess Charlotte.

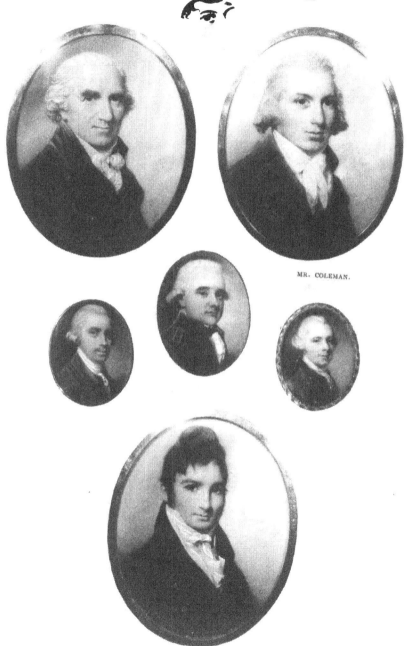

MR. COLEMAN.

ALL UNKNOWN PERSONS SAVE ONE.

seems to have attained to its zenith. It was a curious fad to have the eye alone painted, and in some cases to have each eye the subject of a separate miniature. In the case of the Beauchamp family it was carried out to its logical conclusion, as all the members of the family seem to have had miniature portraits done of their right eyes, and one of them of the left eye also.

We read in the fee-book of Captain R. Beauchamp's eye, and also of his left eye; Mr. R. Beauchamp's eye; Mr. T. Beauchamp's eye; Miss Beauchamp's eye; Lady Beauchamp's eye; Sir Thomas Beauchamp's eye. And we also find entries of the eye of Captain O. Paget, the eye of Mr. Newman, the eye of Mr. Nesbitt, and the eye of Colonel Paget.

In the Beauchamp family there must be quite a collection of eyes, but we have not been able yet to hear of them. We illustrate a miniature of an eye which now belongs to Mr. Jeffrey Whitehead, and two from Sir Gardner Engleheart's collection. They are most carefully painted with exquisite accuracy, and with all the transparent quality so desirable in such work.

Another interesting entry in 1803 records the portraits of the artist's two sons and one of himself, to replace those which had been "lost," and fancy will at once begin to weave a story as to the loss of these precious miniatures, and who lost them, and where, and also whether they were ever found.

The notable persons who sat to the painter at this time were: Sir James Blackwood, Captain Cochrane, Hon. Colonel Paget, several of the Baring family, Mrs. MacDonald of Staffa, Lady Rumbold, Lord John Stewart (son of the Marquis of Londonderry), Lady Hoskins, Lord Graves, Lord Darlington (afterwards Duke of Cleveland), Mr. Twining the banker, Lord Arbuthnot (Lord Rector of King's College, Aberdeen), and members of the Murray, Montgomery, Dundas, and Paget families.

In the next couple of years, 1805 and 1806, we find recorded the names of the three brothers Barwell, already mentioned; Lords Paget, Hutchinson, and Nesbitt (sic), Lord Hutchinson, the Commander-in-Chief for Egypt at that time; Lady Fraser; Sir Lawrence Parsons; Lord William Leslie; and many of the Plowdens and Barings.

The writing for the year 1807 is done with a different ink from that used in any other part of the fee-book. It has retained its colour better than the rest, but it also shows signs of shakiness, and it is our opinion that in this year the artist was not in his usual good health, and that this

F

condition lasted the whole of the year, more or less, varying from time to time.

He opened the year with several members of the Plowden family, and he continued busy throughout most of the year, doing, however, very little in September, October, or November, only four miniatures being entered for September, three for October, and four for November ; but in December again he is busier and able to do his usual number. He earned that year, despite the fewer works executed, over £1,000. Only one titled person sat to him in that year, a Lady Fraser, and it may therefore be contrasted with the year which we have called his aristocratic one, in which there were Princes and Princesses, and noblemen and noblewomen galore.

In the next two years Engleheart seems to have taken more rest during the hotter months, and very probably went into the country at that time. There were but three portraits done in August, three in September, and one in October, during 1808 ; and in 1809 July had but three, August four, and September only two.

Lord Henry Petty sat again in 1808, also Lord Elphinston, Lord Aboyne, Lord Rosslyn, Lord Lauderdale, Lady Brisbane of Brighton (a well-known society entertainer), Sir Abraham Hume, and many others. The most notable person, however, who was painted by Engleheart at that time was, perhaps, Ferdinand VII. the unacknowledged King of Spain, who had been compelled by Napoleon in the previous year to renounce his rights, and had resided mainly at Bayonne. He was restored to his kingdom in 1814. There are two entries respecting him —one on April 1, 1809, and the other on August 26 of the same year.

In 1810 Engleheart painted the Queen, the miniature being intended for the Persian Ambassador, and for it he received, in the following month, the sum of 20 guineas. This is his only record of any portrait of Queen Charlotte. Sir William Wiseman, Admiral Campbell, and many members of the Perkins family, were done that year.

The year 1811 was a busier one, and the earnings, which had dropped to just below £1,000 in 1810, now mounted up to nearly £1,400.

Lord Erskine was painted again, also Mr. Quin, Lady Bristow (as to whom the artist, with very particular care, inserted the address " Crofton Hall, Cumberland "), Sir Henry Smyth, Sir Richard Lavinge, Captain and Mrs. Kneller, Mrs. Cavendish, Sir Nathaniel Duckingfield, and many others.

Lord and Lady Rendlesham were painted in 1812, also Lord

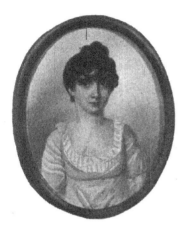

MISS ELIZABETH JANE PRITCHARD.
BY GEORGE ENGLEHEART.

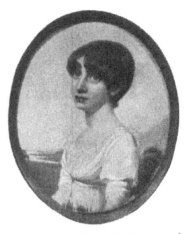

MISS ANN PRITCHARD.
BY GEORGE ENGLEHEART.

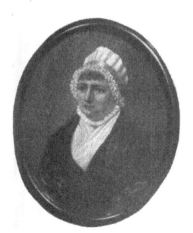

MRS. VENNER, 1803.
BY J. C. D. ENGLEHEART.

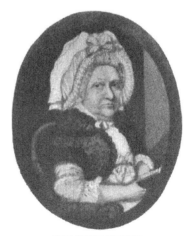

MISS HESTER WOOLLEY.
Born, 1723; died, unmarried, 1793.
BY GEORGE ENGLEHEART.

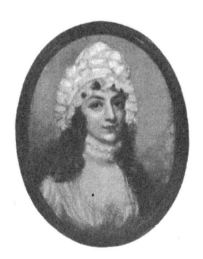

A GIRL UNKNOWN.

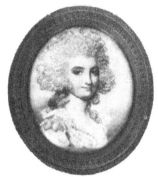

A LADY, BELIEVED TO BE
MISS HORNECK.

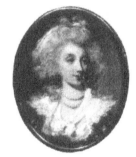

A LADY UNKNOWN.

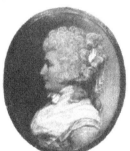

MRS. J. D. ENGLEHEART.

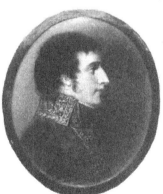

NAPOLEON.

and Lady Warton (*sic*), who were, I suppose, claimants to the dormant barony of Wharton; Lord Oxford, the fifth Earl; the Marquis of Huntley, in extra large size; Sir Thomas Cochrane, afterwards Earl of Dundonald; Mr. Twyrritt (*sic*) Drake; some Knellers, Macdonalds, and Verekers; and Captain Jervis, afterwards Earl St. Vincent.

The artist's earnings for that year showed him to be still full of activity and power, as he painted seventy portraits and earned £1,300.

The last year in the book is 1813, and the record only goes down to July, when, as already mentioned, Engleheart retired to Bedfont and gave up the actual pursuit of his profession.

There are but few names in that half-year's record, and they include some of his old patrons and such names as Ricketts, Thomas, Curtis, Masters, Gregorie, Wilbraham Bootle, Constable, and Rucker, the last being the final entry in the book, dated July 20.

At that time Engleheart was getting 20 guineas for a portrait, and when that sum is compared with the much higher cost of living, of food, of rent, and of expenses, it will be seen that it was not at all a high price for the very lovely portraits which he used to produce. In considering his prices, attention must be given to the alteration which has taken place since his time in all costs, and it will then be found that our grandparents got their portraits painted for them by these notable miniaturists at a very moderate cost indeed, with the added charm of receiving a fine picture, thoroughly worthy of being called a work of art, and one that would ever be a joy and delight to contemplate.

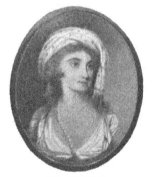 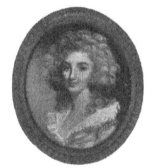

LADY UNKNOWN.

LADY UNKNOWN.
(Possibly Miss Horneck, see p. 28.)

(*In the Collection of Sir J. Gardner D. Engleheart, K.C.B.*)

CHAPTER IV.

THE FEE-BOOK.

THE fee-book, to which reference has already been made, is the most important record of Engleheart which we possess, and from it we gather almost all the information which exists as to his work.

It is a small quarto volume, bound in vellum, and contains 101 pages of accounts, followed by 15 pages of index and 11 blank pages.

On the exterior it is inscribed " Pictures, etc., etc.," and on the first page is a memorandum explaining the use of two signs which the writer has adopted in keeping his accounts :

> ✓ he says, stands for " paid " ;
> + for " painted for self or presents."

Then follows his list of works, preceded by a summary of the pictures which he painted in each year, giving the astonishing total of 4,853 works in all.

The list is as follows :

PICTURES PAINTED BY GEORGE ENGLEHEART.

Year			Pictures	Year			Pictures
1775	89 pictures	1784	152 pictures
1776	180 „	1785	168 „
1777	98 „	1786	208 „
1778	114 „	1787	212 „
1779	138 „	1788	228 „
1780	151 „	1789	161 „
1781	181 „	1790	192 „
1782	175 „	1791	138 „
1783	208 „	1792	85 „

PAGE OF THE FEE BOOK FOR 1802, SHOWING THE ANNUAL SUMMARY MADE BY THE ARTIST.

PICTURES PAINTED BY GEORGE ENGLEHEART—*continued.*

1793	131 pictures	1804	74	pictures
1794	100 ,,	1805	81	,,
1795	138 ,,	1806	84	,,
1796	152 ,,	1807	75	,,
1797	97 ,,	1808	76	,,
1798	131 ,,	1809	84	,,
1799	91 ,,	1810	74	,,
1800	101 ,,	1811	79	,,
1801	104 ,,	1812	70	,,
1802	100 ,,	1813	30	,,
1803	103 ,,				
					4,853	

The pages which follow this summary of the work are all arranged in the same way. At the top of each is the date of the year, and below it the page is divided into two columns, headed respectively " Pictures painted " and " Cash received."

Each page is carefully reckoned up, and the result carried over to the next, and at the end of each year a total is obtained in each column of the pictures painted and of the cash received, and the date of the year is repeated, as will be seen by the facsimile pages given in this volume.

The addition of the miniatures painted is made at the side of each page, in groups of five, each set of five figures being neatly written in.

A complete list of all the names given in the first columns of this book has been prepared by the authors, and will be found as an appendix to the volume. It was at first thought that all that would be necessary would be a copy of the index which the artist had himself prepared, and which followed his accounts, but after that had been made it was dis-covered that, carefully as the artist had made his index, it was yet full of errors, names having been omitted, credited to the wrong years, or repeated, and therefore the book has been gone over, page by page, and a complete list has been made afresh, which includes every name which appears in Engleheart's Fee-Book.

This appendix will therefore give in print, for the first time, the names of every person whom the artist painted, where he has himself recorded the fact, and as an authentic record its value can hardly be overstated.

Only one reference, however, to each name in a year has been given,

as where the same person was painted many times in the same year it would only have encumbered the list to repeat the names over and over again. In some cases the artist has noted how many times he painted the same person, but he has not done this in all cases, and therefore these numbers have not been repeated in the list. It is manifestly impossible to make up for this deficiency, as there are many persons whose names, although spelt differently in different places in the book, may have been the same person, and others, where the same name occurs more than once, may refer to different persons bearing the same name, and only the artist himself, conversant as he was with his sitters, could set these difficulties straight. In the early part of his career many of the works which he did, appear as drawings, but as the years went on these entries disappear, and it is taken for granted that all the works which are not marked as drawings were miniatures. The letter L applied to many of them no doubt means "Large," and where it is underscored the work in question was probably of an unusually large size.

The words "Copy" or "Copied" which occur in places in the list are taken to mean that a work of the artist's has been recopied by him for the person whose name is attached to the entry, but they may refer to copies made by Engleheart of the work of other artists. It is believed, however, that this is not the case in any of the entries in question, as in other entries where Engleheart copied the works of Sir Joshua, for example, either for himself or as commissions for other people, the fact is carefully recorded that these were copies of the work of Reynolds. The words just named may therefore be taken to mean that the artist was employed to make a copy of a work which he had previously carried out, and which had given satisfaction as a portrait.

There is a regular progression in the scale of prices which the artist obtained for his work. It started, as has already been noted, at the sum of 3 guineas per portrait, but for this sum only drawings appear to have been supplied, a rather higher sum—4 guineas—having been his starting price for miniatures. Year by year he increased his prices, slowly rising as he became better known and appreciated, and eventually reaching an important figure.

In 1775, as we have said, his prices were from 3 guineas to 4, in 1776 from 4 to 5; in 1777 His Majesty was charged 10 guineas, some other persons 6, and the remainder as before. In 1780 his scale was from 5 to 6 guineas, in 1785 from 6 to 8, and occasionally 9, in 1788 from 8 to 10, in 1795 from 10 to 12, and occasionally 15 for specially

PAGE OF THE FEE BOOK FOR 1812.

important works, and in 1800 his usual price, below which he hardly ever went, was 12 guineas.

In 1803 he got from 12 to 15, in 1809 from 15 to 17, in 1811 from 18 to 19, and in the last two years of his work from 18 to 20 guineas, and upon occasion 25 guineas for a portrait.

His earnings, therefore, for each of the years moved in the same progression, varying slightly year by year, according to the number of sitters whom he had, but keeping up to an average of about £1,200 a year, rising in his best year, 1788, to £2,241 11s. 6d., and falling in the worst of those thirty years to £796 19s.

This average is taken from 1782, when he had attained to his position, and closes in 1812 as the final year of work. The year 1813 was not a complete one, and he seems to have done but little work in it, and not to have desired more commissions.

A complete list of his earnings will be found at the end of this chapter, taken from the careful reckonings at the end of each successive year's work.

The column of the book which contains an account of the cash which the artist received for his work does not always agree in its items with the opposite column. Occasionally there are names in it which cannot be found in the opposite column, and the divergence may be thus explained : In the first column Engleheart put down the miniature or drawing under the name of the person who was depicted. In the second column, the entry is under the name, sometimes of the person who was depicted, and sometimes of the person who paid the account, and therefore there are cases in which another member of a family paid for the work—a person whose portrait had not been painted by the artist. There are other reasons for this divergence, as in a few cases the person had changed his or her name since the portrait had been completed, and appears under one name in one column and under another in the other. The Marquis Tweeddale appears as having paid for two miniatures, but his name does not appear in the portraiture column, although that of Lady Tweeddale is to be found. The name also of the Hon. Mr. H. Pelham does not appear in the portraiture column, although a payment of 5 guineas is credited to him, and he probably paid for a miniature of some member of his family. There are several anonymous entries in which the artist either did not know the name of his fair sitter, or was requested not to record it, the former probably the case, as it is clear from the careful way in which the

accounts are kept that the artist preferred entering the name of each
sitter in his book. In most of these anonymous entries there is the
name of the person who paid for the portrait ; thus, there are entries of
a lady for Mr. R. Oliver, for Mr. Agassiz, for Mr. Pattison, for Mr.
Redhead, for Mr. Kirkman, for Mr. Russell, for Mr. Leake, and Mrs.
Carter for Sir George Methuen, Miss Lloyd for Mr. G. Coleman, and
Miss Holford for Mr. Binyon, are recorded, as well as " Madame " for
Lord A. Hamilton and Mrs. Douglas for Lord R. Fitzgerald.

There is no need to condemn these entries wholesale, as it is possible
that in some cases fair cousins or other relations were the ladies in
question, brought by their admirers to the artist ; but as a rule surmise
may conjecture that there were reasons for keeping the names of the
ladies out of the book, and the gentlemen in question were not anxious
that it should be known that they commissioned portraits of the anonymous
damsels.

There are three or four cases where the names of gentlemen are not
recorded, but in these instances the artist has been gallant enough not
to record the names of the ladies who commissioned the pictures, so that
neither name can now be discovered from the book.

The cash column also records several entries for repairs to miniatures
and portraits, alteration in some cases simply to the coat or the wig, for
which the sum of a guinea is usually charged, but occasionally extending
further and referring, it is possible, to accidents which may have happened
to the miniature, either by a fall or by water or fire.

Lord Ashbrook and Mr. Fuller are charged 2 guineas each for such
repairs, while Mr. Manby's work was still more extensive, and needed
the sum of 3 guineas to discharge it ; and Lieutenant-Colonel Wheatley
is charged as much as 4 guineas for what must have been serious repairs
to a miniature which two years before had cost its owner 15 guineas.

There are one or two mysterious entries which cannot be explained,
as in 1801 an anonymous gentleman pays 30 guineas for miniatures, and
under the entry is another one reading, " A present from the same
by a Lady fifteen pounds."

Whether this means that a lady gave Engleheart a gift of the money
in question, or gave it to the gentleman, or gave her portrait worth this
sum to him, cannot now be told, and the entry must remain in its original
mystery. Another odd entry reads, " Lord Harvey for the Duchess of
Devonshire " in 1806, and, as Lord Harvey was painted in 1796, it can
only be conjectured that the Duchess desired a copy of this picture and

COLLECTION OF SIR J. GARDNER D. ENGLEHEART, K.C.B.

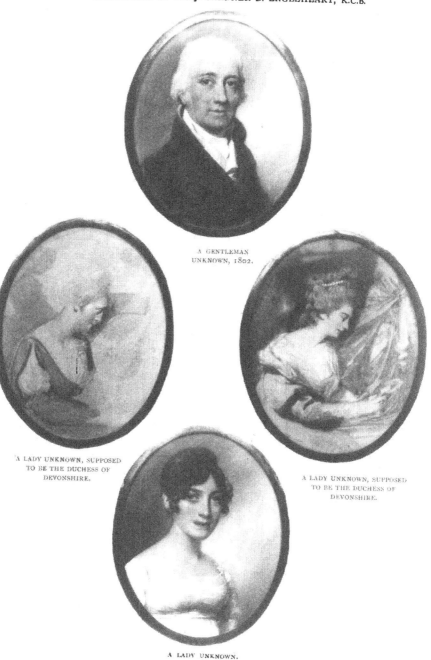

A GENTLEMAN
UNKNOWN, 1802.

A LADY UNKNOWN, SUPPOSED
TO BE THE DUCHESS OF
DEVONSHIRE.

A LADY UNKNOWN, SUPPOSED
TO BE THE DUCHESS OF
DEVONSHIRE.

A LADY UNKNOWN.

paid for it to be done. Another entry relating to the same Duchess is to be found in 1788, where is noted the fact that "A child" was painted for the "Dutchess (*sic*) of Devonshire."

This same Duchess was one of the very few persons to whom Engleheart appears to have given any lengthy credit. As a rule, all the miniatures which he painted were paid for within a few weeks of their completion, but naturally there are exceptions to the rule.

A Mrs. Mahon paid in 1784 a part of her account, 10 guineas, a further 8 guineas in 1787, and the completion "in full" in 1788, which amounted to 8 guineas more. In 1785 Mr. T. Hardwick paid for the miniatures which were painted in 1783, and Mr. H. Drummond paid for the portraits which he had commissioned in that same year, both of them having had two years' credit. Captain Bowatre paid part of his account, £10, in the early part of 1786, and in the June succeeding cleared off the remainder by a remittance of 6 guineas.

The Duchess had a larger bill to pay, and she is recorded as having sent £20 in 1786, and the balance of £35 5s. "in full" in the following year. Mrs. Whitehead did not pay for the miniatures which she had painted in 1807 until 1810; Mr. Walpole paid in 1798 for those which were painted six years before; but a certain Doctor, whose name it is not easy to decipher, but which looks like "Babuine," made his first payment of £3 9s. for a portrait of his wife, or "Lady," as she is styled, and did not complete the arrangement for seven years, when the final payment of £10 6s. 2½d. is carefully recorded as the "balance."

We wonder whether this was for the portrait of his wife, after all, or whether the Doctor desired the portrait of some other lady, and then had to be threatened before he would pay for it. Perhaps the explanation is a far simpler one, and want of means prevented the payment, and then, like an honourable man, when later on the money came in, the good Doctor sent the debt to Engleheart up to the halfpenny which is so carefully entered. Who can tell what the story was?

There are a few cases where this cash column enables us to identify the sitters in the other column. In the case of Mr. Home, the addition is made in brackets in the cash column of "Sir Everard," and in the case of Miss Johnson the cash column records in brackets "Mrs. Kneller," proving that a marriage had taken place in the interval.

It would be strange indeed if such an entry was the means of setting at rest the question of a doubtful marriage or one where the record is

G

missing, but stranger things than this have happened, and many a romance has turned upon a trivial entry such as this.

A Mr. Murray in the portrait column becomes the Hon. Mr. Murray, M.A., in the cash column, and so is the easier identified, and in a few cases the address is added when the money is paid. Thus, in 1798 we have an entry of Mr. Seton "of Harley Street."

There appear only two entries of enamel work. One is in 1778, and is of an anonymous lady, and the other in the cash column of the following year, 1779. "Lady Thomas, an enamel, £10 10s.," probably explains who the unknown lady was who was painted in 1778. There is no entry of a miniature painted of any Lady Thomas.

It will be noted also that this cash column records the sale to a Mrs. Clay, of the fancy subject which the artist called *Adam and Eve*, and which he exhibited at the Royal Academy in 1778, and that the price she paid him for it was £26 6s.

One entry cannot be in any way explained. It is under 1808, and appears to read "A Lady from a Shadow."

It is possible that the portrait was done from another picture, which, in the expressive words used by artists, had faded to a shadow, or that a silhouette may be meant, or something of that kind used as a model for the picture. There is plenty of room for surmise and conjecture in this curious entry.

A few entries in the fee-book seem to allude to portraits painted after death. In some few cases it would appear that the artist was begged to paint a portrait of some loved one who had passed away before the counterfeit presentment had been made, and the artist has against these entries put the word "Dead," and in one case the phrase "After death."

In another case he records the fact that the portrait was painted by description, as perhaps the lady was too ill to come to him or for him to go to her, or too far off to be reached, and the artist had to make a description supplemented, perhaps, by a drawing by someone else, suffice him for his purpose.

The account for the last year has never been completed or reckoned up. It finishes in the portrait column with an entry recording the portrait of a Mrs. H. J. Rucker, done on July 20, and for which, as well as for a portrait done, on May 12, of a Mrs. Constable, there is no entry of payment. The final entry in the cash column is one in the name of Captain Salmond for a payment of £63 for three miniatures,

COLLECTION OF SIR J. GARDNER D. ENGLEHEART, K.C.B.

PAGE OF THE FEE BOOK, GIVING THE LIST OF PORTRAITS PAINTED FOR THE KING AND ROYAL
FAMILY, AND OF COPIES MADE FROM PICTURES BY SIR JOSHUA REYNOLDS.

which were those of Mrs. Salmond, her son, and a third one which cannot be identified, as no other member of the family appears in the list.

There the accounts end, and the money received in that half-year when added up is found to come to the sum of £563 7s. 6d.

Following that entry comes the index, which was probably done after that date, unless by a very curious chance the artist left exactly the right number of pages in which to record his life's work when he started the Index. By the look of the writing, however, it is probable that when he relinquished the active pursuit of his profession he set to work to index the fee-book, and, being an old man, was not able to do it as accurately as it would have been done had he commenced years before and continued it regularly year by year.

It is on the whole, however, a remarkable and careful piece of work, and its compilation must have taken him a very long time.

At the end of the fifteen pages which it fills are some special lists. The first records the times when he painted the King. It is headed " His Majesty."

To it we have added the prices which he obtained for the miniatures in question, showing that for this royal work there was not much increase in price over ordinary charges, and it is probable that the King was in the habit of paying a certain fixed price for miniature portraits, and did not care to exceed it, and that therefore the artists who desired to have the honour of his patronage had to keep to the price which the King was willing to pay.

June 8, July 11, August 2, 1766: These three were charged at £10 10s. each. January 25, 1777; January 6, January 20, and February 10, 1778; October 3, October 6, October 27, October 30, and also November 4 and 10, 1783: The cash entry which seems to refer to this series is for six miniatures £75 12s., and for two small ones £21.

In 1784 the same price was obtained, and the King was painted on May 29, and in the following year, 1785, there are four entries—November 25, November 27, December 4, and December 7.

In 1786 there is a payment recorded for three miniatures £37 18s., which appear to have been painted on November 21, December 4, and December 14 of that year.

Five more times the name of the King appears in this list—thrice in 1787, on March 6, August 17, and August 31; and twice in the following year, on February 1 and on July 3; and all of the miniatures then painted were paid for at 12 guineas apiece.

G 2

Following the records of the miniatures painted of the King comes a separate list of those of the Royal Family, which is as follows : " Princess Dowager of Wales, July 23, 1782." This was done for a Mrs. Leslie, and is noted as " copied," and as the price paid for it was only 6 guineas, it is possible that the miniature was a copy of one which had already been painted by some other artist, although it is more probable that it was an original work.

" The Duke of Cambridge, May 3, 1802." For this the artist was paid 15 guineas. " The Prince of Wales, for Princess Augusta, September 14, 1802." The payment for this was also 1·5 guineas, made to the artist in the following January. " The Queen, for the Persian Ambassador, May 16, 1810." This was paid for within a month, the entry on June 12 reading : " The Queen, 21 pounds." " The Duchess of Wertemberg (sic), for the Duke of Sussex, October 11, 1802," with the note " Never paid for." The Duke of Kent (see page 28) does not appear in this list.

A little lower down in the page is the entry of the other royal personage whom the artist painted, " Ferdinando Septimo," who was painted " August 26, 1809," for which the artist received in the following September the sum of 32 guineas.

On the whole, his list of royal patrons is an important one, but the financial receipts from them do not come up to the average of the money which he had from less notable personages.

The last record in this index relates to the pictures by Sir Joshua Reynolds which the artist copied, and to this entry a reference is made in another chapter of this volume.

The artist's nephew appears to have looked through the index rather carefully, as a note in pencil appears at the end of the book, as follows : " *Note.*—Six B's omitted from the alphabetical index under year 1789, and all B's from 1800 to 1809 inclusive.—J. C. D. E."

Unfortunately for the authors of this volume, these were by no means the only errors in this index, and with all its delightful minuteness there were many omissions from it and wrong dates given to the work ; but the list which appears at the end of our volume is the result of a careful checking of each page, and will, it is hoped, be found far more accurate and complete than the list made by the artist himself.

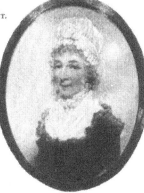

LADY BURRELL BLUNT.

LADY BLUNT.

A LADY UNKNOWN,

A MEMBER OF THE PARRY-
HODGES' FAMILY.

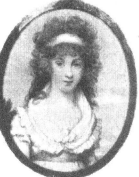

LADY COCKERELL.

The following is a list of the earnings of Engleheart year by year, as mentioned at page 39, the figures being extracted from each annual entry in the Fee-Book :

		£	s.	d.			£	s.	d.
1775	...	278	15	0	1795	...	1,440	5	0
1776	...	645	9	0	1796	...	1,756	18	6
1777	...	521	16	0	1797	...	1,134	8	0
1778	...	599	11	0	1798	...	1,188	19	6
1779	...	690	13	6	1799	...	1,262	19	0
1780	...	817	16	0	1800	...	1,119	9	6
1781	...	861	11	0	1801	...	1,262	7	0
1782	...	1.021	3	0	1802	...	1,291	5	0
1783	...	1,200	3	0	1803	...	1,396	16	0
1784	...	1,075	13	6	1804	...	796	19	0
1785	...	1,266	19	0	1805	...	1,143	5	0
1786	...	1,673	13	0	1806	...	951	8	6
1787	...	1,787	5	0	1807	...	1,006	17	0
1788	...	2,241	11	6	1808	...	1,282	5	8
1789	...	1,586	19	0	1809	...	1,225	12	6
1790	...	1,747	16	0	1810	...	959	11	0
1791	...	1,495	10	0	1811	...	1,396	3	0
1792	...	881	7	0	1812	...	1,298	14	0
1793	...	1,426	8	6	1813	...	503	7	6
1794	...	986	19	6					

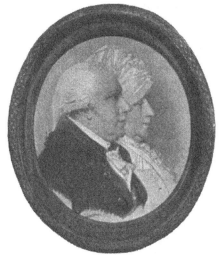

J. D. ENGLEHEART AND HIS WIFE.
(In the Collection of Sir J. Gardner D. Engleheart, K.C.B.)

CHAPTER V.

PICTURES BY SIR JOSHUA REYNOLDS.

ONE of the most interesting circumstances in the work of George Engleheart is the fact that he made careful copies in miniature of many of the famous paintings executed by his great master, Sir Joshua Reynolds. In his fee-book he recorded, with scrupulous care, the dates when he made these copies, and, as will be seen, these dates are of no slight importance to the student of the work of the President, for they enable him to come to definite conclusions as to when certain pictures were painted, and give other information as to these paintings which is of the greatest interest.

So important did the artist consider these miniature copies, which it is clear he executed with the utmost precision and care, that he had all of them framed with suitable frames, and retained them in his own house as some of his chief treasures, and then left them by will specially to various members of his family, naming each one specifically and the person to whom it was to go.

Not only did he record in the proper page of his fee-book the fact of his making these copies, but again at the end of the book, as we have already seen, after he had made its index, he repeated the information in a separate column, so that there should be no question about the extent to which, by the permission of Sir Joshua, he had been able to copy his paintings in this miniature form.

There is very little doubt that the work was actually done in the studio of the President, as it must have taken some considerable time to execute, and perhaps was painted under the very eye of Sir Joshua himself.

Very many of these interesting copies are still in existence, most of them now belonging to Sir Gardner Engleheart, and it may be desirable

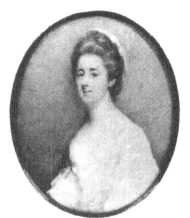

A LADY, SAID TO BE MISS PALMER.

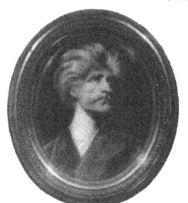

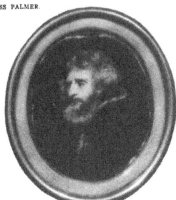

POPE PAVARIUS.

UGOLINO.

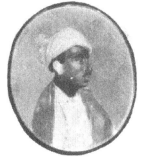

THE NEGRO.

COPIES OF PICTURES BY SIR J. REYNOLDS.

to deal with these works seriatim, and to give such information regarding them as can be obtained.

In these details it is with the utmost pleasure that we record the very kind and constant assistance of Mr. Algernon Graves, who is *par excellence* the authority in Europe on the works of the President, and who has not only been much interested in the discovery of these copies and the entries respecting them, but has placed at the disposal of the authors all his stores of information, not only as contained in his famous work,* but also in manuscript at his own home, and the result of his most recent investigations since his last volume was issued.

The actual records from the fee-book are as follows :

1776. March 21.—*Miss Palmer*, from Sir J. Reynolds.
 November 1.—*Miss Ridge*, from Sir J. Reynolds.
1777. October 25.—*Little Thief,* from Sir J. Reynolds.
 October 27.—*Link Boy,* from Sir J. Reynolds, for Mr. Scawen.
1778. April 30.—*Cupid,* from Sir J. Reynolds.
 June 1.—*Old Head,* from Sir J. Reynolds.
 June 7.—*Another Old Head.*
 June 21.—*Samuel,* from Sir J. Reynolds.
 September 7.—*Schoolboy,* from Sir J. Reynolds.
 September 22.—*Boy at Study,* Sir J. Reynolds.
 October 23.—*Pensive Girl,* Sir J. Reynolds.
 December 5.—*Laughing Boy,* Sir J. Reynolds.
1781. January 8.—*Madame Scheldlering* (*sic*), from Sir J. Reynolds.
1782. September 3.—*Laughing Girl,* Sir J. Reynolds.
 September 12.—Finished Sir J. Reynolds.
1786. August 18.—*Lord Northington,* from Sir Joshua.

The list at the end of the fee-book is not quite the same as the entries to which it refers. It does not include either Miss Palmer or Miss Ridge of 1776, or Lord Northington of 1786, and as it is headed " Copies for Self," it is quite possible that these three omitted ones were commissions, and were done for some of his numerous patrons.

It, however, includes three others, Mrs. Palmer of 1782, Miss Palmer of 1793, and Baretti of 1793, which are not recorded in the fee-book, and which shows us that this wonderful book does not include every miniature which the artist painted, although it is a mystery how he could possibly have found time to do more than are entered in it.

This list at the end of the book, which we may call the index-list,

* " A History of the Works of Sir Joshua Reynolds," by Graves and Cronin. Privately printed by subscription, 1899. 3 vols. 4th volume, 1901.

possesses one which is not in the fee-book, and that the most puzzling of all, a miniature called *Pope Pavarius*, to which we will refer in due course.

The list is as follows :

Little Thief, 1777.	*Pensive Girl*, 1778.
Link Boy, 1777.	*Laughing Boy*, 1778.
Cupid, 1778.	*Madame Schilder* (*sic*), 1778.
Two Old Heads, 1778.	*Laughing Girl*, 1781.
Pope Pavarius, 1778.	*Sir Joshua himself*, 1782.
Samuel, 1778.	*Mrs. Palmer*, 1782.
Schoolboy, 1778.	*Miss Palmer*, 1793.
Boy at Study, 1778.	*Baretti*, 1793.

We now come to the third list, which appears as a codicil to the will of the artist, and which may be termed the will-list.

In it will be found many divergences from the two previous lists. *The Three Miss Montgomerys* and *Hugolino* (*sic*), which are not in either the fee-book list or the index-list, appear here.

The *Old Heads* which are in the fee-book list are not in this list, unless *Hugolino* takes the place of one of them under its new name, as it was certainly the head of an old man.

Miss Palmer appears twice, once under her maiden name, in which the miniature painted in 1776 is probably meant, and once under her married name, in which reference is probably intended to the one painted in 1793. *Link Boy* is in this list called *Young Hymen*.

The entire list is as follows, but it includes some works which are not copies of *Sir Joshua*:

"To my dear son George: *Lady with Sparrow, Miss Palmer, Boy with Book, Laughing Girl, Pensive Girl, Mr. Baretti, Lady Thomond, Studious Boy*.

"To my daughter Emma: *Mrs. Gardner, Milicent Engleheart, Eliza, Major Engleheart, Young Cupid, Laughing Boy*.

"To my son Nathaniel: *Mrs. Biggs, Little Thief, Young Hymen, Mrs. Robinson, Madame Schindleim* (*sic*), *The Three Miss Montgomerys*.

"To my son Henry: *Reubens* (*sic*), *Sir Joshua Reynolds, King George the Third, Samuel, Hugolino, Pope Bavarius* (*sic*)."

We now have the three lists of these miniatures before us. Those left to Nathaniel have passed to remote members of the family, and cannot now be traced; the rest, mentioned in the will-list, are still in existence, and figure in this volume.

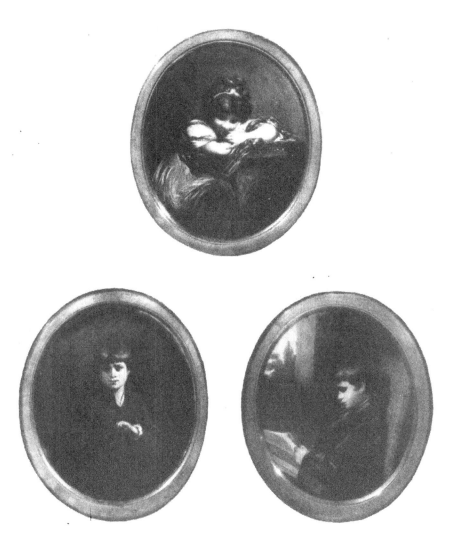

To deal with them according to their date, we start with the one which has been called *Miss Palmer*, 1776, in the fee-book.

This miniature, if correctly named, is not in the least like Miss Theophila Palmer, who has a decided turn-up nose. She was born in 1756, and would therefore be only twenty when the picture was done. It is in Mr. Graves' opinion more like Miss Mary Palmer, who was born in 1750, and would therefore be more the age of the girl in the miniature. The dates of the sitting of these ladies would not necessarily be stated in the fee-book, as, living in the same house with Sir Joshua, they would always be available.

The *Miss Ridge* of the same year (1776) was a daughter of Counsellor Ridge, of the Irish Bar, a friend and favourite of Sir Joshua, and mentioned by Goldsmith in "The Retaliation." She sat to the artist in December, 1773, and is represented seated, her left arm resting upon a table. She is in white dress trimmed with gold, the bodice tied in front with a blue bow, blue sash, and a blue ribbon in her hair, and has a black velvet band around her neck. The background is a landscape. The picture belongs to Sir Charles Tennant, and an unfinished sketch for it to Dr. Hamilton.

The miniature copy by Engleheart mentioned in the fee-book cannot be found. It was probably done on commission.

The *Little Thief*, of 1777, is the picture usually called *Mercury as a Pickpocket*, and it is not known for certain when it was painted. It was engraved in 1777 by J. Dean, who seems to have engraved many of the pictures which took Engleheart's fancy and which he copied, and it is probable that the two men were friends, and possible, even, that some of Engleheart's copies were made when the pictures in question were at Dean's studio for the purpose of being engraved. *Mercury as a Pickpocket* now belongs to Mr. Alexander Henderson. It seems to have originally belonged to the Duchess of Dorset, and was sold by Lord Sackville to its present owner through Messrs. Agnew. It was evidently painted before October 25, 1777, as Engleheart's book proves.

Cupid as a Link Boy was the companion picture to it, and belonged to the same owner, passing through Messrs. Agnew to the same owner, Mr. Henderson. It was engraved by Dean in the very year in which Engleheart copied it, and is the picture called by Malone *Covent Garden Cupid*. Armstrong in his celebrated book says that this picture was painted "1778," but it is quite evident that he puts the date too late. Engleheart copied it on October 27, 1777, Dean

H

engraved it in the same year, but a miniature copy of it, discovered by Dr. Williamson, and described by him in the *Magazine of Art* for February, 1902, p. 189, as the work of Frances Reynolds, bears the date 1776.

It is probable, therefore, that this delightful picture was painted in 1776, and it was possibly entered in the missing diary for that year, although Reynolds is not known to have entered his fancy subject pictures in his diaries at all.

The year 1776, to which this picture must now be ascribed, was a very famous one for pictures of children, including as it did *The Infant Samuel, St. John, Master Crewe as Henry VIII.*, and *Master Herbert as Bacchus*, making with the *Link Boy* as fine a collection of children's pictures as could exist.

It is possible that Sir Joshua altered this picture from his first conception of it, or else, as Mr. Graves now suggests, he painted two pictures of similar subjects, one of which is still unknown, as the face in Frances Reynolds' copy is quite different from that in the oil-painting, and the vest in the latter is dark in colour, whereas Frances Reynolds gives it as white in her copy. The Engleheart copy is unfortunately missing, or the colouring of that would help to settle this interesting question. It is called *Young Hymen* in the will-list.

There are many copies credited to the busy year 1778.

Cupid, copied April 30, is the *Cupid sleeping in the Clouds*, resting on his left arm, with an arrow in his right and a quiver with arrows to his left.

It was exhibited at the Royal Academy in 1777 as *Cupid asleep* (293 ; *vide* Graves and Cronin, 1141), and belongs to the Earl of Carnarvon. It also was engraved by Dean in 1779.

There are two *Old Heads* entered in that year, one on June 1 and the other on June 7. One of these still exists in the family, but is marked as *Hugolino* (*sic*), and under that name appears in the will-list.

It is not, however, *Ugolino*, but a beggar man called *A Study from Nature*, under which name it was engraved both by J. R. Smith and S. W. Reynolds (*vide* Graves and Cronin, 1217). The old man is supposed to have been the same model as the *Ugolino* was painted from, but, in the opinion of Mr. Graves, is not the same face. Another picture painted by Reynolds, called *Resignation*, is the same face as *Ugolino ;* but that was exhibited at the Royal Academy in 1771, whereas the *Ugolino* did not appear till 1773.

The second *Old Man* whom Engleheart copied is, perhaps, the one of the *Banished Lord* which the family possess, but more probably is the one (*vide* Graves and Cronin, 1124) called an *Old Man reading a Scroll*, engraved by Okey in 1777, and copied by Engleheart a year later.

The note in Messrs. Graves and Cronin's book as to its having been exhibited in 1771 at the Royal Academy is a misprint, and refers to the picture called *Resignation*, mentioned in that same volume on p. 1192.

Samuel was copied by Engleheart on June 21, 1778, and is evidently the National Gallery picture described by Messrs. Graves and Cronin on p. 1201, as there is a bed in front of the rays and a column behind the figure, neither of which were in the picture paid for in 1776 by Lord Granby, exhibited at the Royal Academy in 1777, and destroyed at Belvoir in 1816.

The National Gallery picture was therefore painted before June, 1778, a fact which it has not been possible before this to state with any accuracy. It was not engraved till 1822, and then by Thomas Lupton, and it is not known when it was exhibited at the Royal Academy, if ever it did appear in that gallery at all. It was lent to the British institution by the Hon. Charles Long in 1813, and passed to the National Gallery by bequest of Lord Farnborough in 1838. Engleheart's copy now enables us to date it.

The *Schoolboy* which Engleheart copied on September 7, 1778, is the picture (*vide* Graves and Cronin, 1203) now belonging to the Earl of Warwick. It was paid for in March, 1779, but Dean had engraved it in 1777, and Engleheart copied it in the following year.

The lad stands full-face, and carries a large volume under his arm. The painting has never passed out of the possession of the family, who originally purchased it from Sir Joshua. The miniature copy is mentioned in the will-list as *A Boy with a Book*, and left to George Engleheart.

In the same month we find, under date September 23, a picture called in the fee-book *Boy at Study*, and in the will-list *Studious Boy*. This was copied from the picture now belonging to Mr. Sidebotham, bought in 1778 (the year in which Engleheart copied it), by Judge Harding for £42, and exhibited at the Royal Academy in 1784 as *A Boy reading*. It at one time belonged to Sir J. F. Leicester, and is etched in outline in the description of the Leicester gallery.

The *Pensive Girl*, copied on October 23, is one of the studies for *Lesbia*, with a dead bird in her lap, but in this case there appear neither

the cage nor the dead bird which are in the picture belonging to Sir R. Proctor-Beauchamp.

In the fourth volume of Messrs. Graves and Cronin's book there is at p. 1456 a statement that *Lesbia* was a portrait of Miss Theophila Gwatkin, but that is now entirely disproved, as she was not born till 1782, and this picture was copied by Engleheart four years before.

In Sir R. Proctor-Beauchamp's picture Lesbia is seated to the right; in Sir Charles Tennant's she is to the left, and this is the case with Engleheart's copy, which therefore was taken from the Tennant picture, and not from the Beauchamp one. For the Tennant painting we have not hitherto had a definite date, but that missing fact Engleheart's copy supplies.

The *Laughing Boy*, copied on December 5, is a very interesting picture, as it explains for the first time a mysterious entry. In 1781 (*vide* Graves and Cronin, 1112) there was exhibited at the Royal Academy a boy laughing, while in the same year there is an entry in the diary of the sale to Mr. Brummell for £50, "a boy laughing praying."

The entry seems to be a contradictory one, but a sight of Engleheart's copy proves that it was not so, as the boy is both laughing and praying at the same moment.

The original picture is missing; it was said to have been sent to France. It was never engraved, and therefore Engleheart's copy of it is the only evidence we possess of what it was like, and his entry tells us that it was painted before December, 1778, although not sold till three years after.

It is also quite clear from an examination of this picture that it must have been one of the studies for the *Samuel*, but, being a successful picture, was probably sold as it was, and another face painted for the *Samuel* with a more devotional aspect, and without the amusing smile which is breaking out upon the merry face in question.

Madame Schindlerin, whose name seems to have been a puzzle to Engleheart, as he spells it in three different ways, was copied in 1781, on January 8. The painting was paid for in 1776 by the Duke of Dorset, and cost him £36 15s.

The lady was a singer or dancer at the opera, and is represented full-face with a mob-cap on her head. The original was sold at Christie's in the spring of 1902. The copy by Engleheart is not known. The original is probably entered in Sir Joshua's missing pocket-book of 1775.

There are two miniatures to describe copied in 1782. The first, which was done on September 3, is called the *Laughing Girl* (*vide* Graves

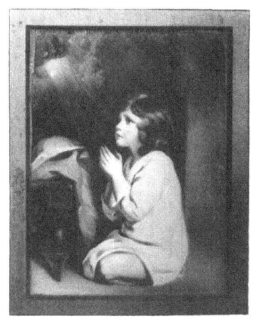

THE INFANT SAMUEL.

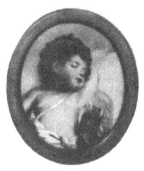

CUPID.

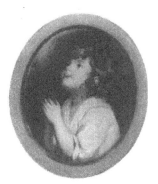

THE LAUGHING BOY.

COPIES OF PICTURES BY SIR JOSHUA REYNOLDS.

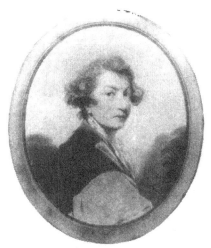

SIR JOSHUA REYNOLDS.

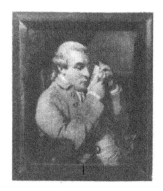

BARETTI.

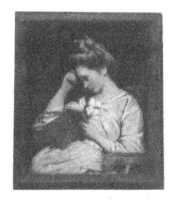

THE STUDIOUS GIRL.

and Cronin, 1166). The painting was bought by Lord Palmerston, who was himself one of Engleheart's sitters. It was painted in 1785, according to Messrs. Graves and Cronin, but must have been done long before that, as Engleheart copied it in 1782. The date of Lord Palmerston's purchase is not known, and the first record of its belonging to the Viscount is its exhibition under his name at the British Institution in 1813. The picture passed to Mr. Evelyn Ashley by will, and was sold by him through Messrs. Agnew to the Earl of Rosebery, to whom it now belongs.

The copy by Engleheart fixes its date definitely for the first time. The index-list, it will be noticed, gives it as 1781, but the fee-book as September, 1782. This may be an error on the part of Engleheart in making out the index-list, or it may mean that the artist commenced to copy the picture in 1781 and finished it in 1782. We incline to the former opinion by reason of the errors which have already been found in the index, which Engleheart made to his book when his strength was failing, and when he was not as accurate as he had been at the beginning of his career.

Nine days afterwards he records finishing his portrait of *Sir Joshua* —*i.e.*, September 12, 1782. This was a copy of the painting in which the President was in his D.C.L. robes, which once belonged to North-cote the painter, and is now in the possession of Earl Spencer. It was painted in 1773, and must therefore have remained for some time in Sir Joshua's studio till it was given to Northcote, unless Engleheart copied it when it was in the possession of Northcote, and not when it stood in Sir Joshua's studio.

The last copy named in the fee-book list is the one of Lord Northington. Reynolds painted several portraits of him in 1782 and in 1784. The chief one was exhibited at the Royal Academy in 1785, and was probably the one which Engleheart copied in the following year. This miniature copy is not known, but is probably of a short, apoplectic-looking person represented full-face.

There are two portraits in the index-list which are not in the fee-book list. These are the portrait of Baretti and the one which is called *Pope Pavarius* in the index-list, *Pope Bavarius* in the will-list, and on a paper *Pope Bavarino*.

Baretti was painted in 1774, and the picture is now at Holland House in the possession of the Earl of Ilchester. Engleheart appears to have copied it in 1793, nineteen years after it was painted, and four years after the death of Baretti. The picture was originally painted for Mr. Thrale, for his house at Streatham, and it would be interesting to

know where it was that Engleheart copied it, perhaps at Streatham, or whether it was sent up to London for repair or exhibition in a private gallery in the year after Sir Joshua had died.

The mysterious copy called *Pavarius* it is not easy to identify, and the name given to it but adds to the puzzle which it presents.

There is no Pope whose name in the very least resembles the one borne by this picture ; nor is it possible to identify the features with any picture of any Pontiff which Sir Joshua could have seen, and to which this name could have been given.

Our explanation of the mystery is that the person so named is intended for George White, the pavior, an Irishman, "once a pavior and then a beggar," as Tom Taylor says, whom Sir Joshua converted into a professional model.

Our impression is that the name Pavarius was a Latinized form of the word "pavior," and that as an Irishman, and therefore probably a Catholic, the man was in the habit of speaking of the Pope, or identified in studio talk as a follower of His Holiness, and given a name in dog-Latin, or that his fatherly appearance gave him the name of Pope.

There is a portrait of this man White, now at Crewe Hall, as a captain of banditti, painted in 1772, and the grimy, haggard features bear a close resemblance to the miniature in question, which Engleheart painted in 1778. Whoever it was, he was well known by the name which Engleheart gives him, and the portrait is of a rough, grimy man, evidently a model, and we are disposed, therefore, to think that our suggestion offers the most likely explanation of the puzzling name.

The *Mrs. Palmer* copied, according to the index-list, in 1782, which is missing, must represent an old lady, as she was born in 1715 and died in 1787. She would therefore be sixty-seven when the miniature which Engleheart records was painted, if he copied one recently done by Sir J. Reynolds, and not one which had been a long time in his studio.

There is now another miniature to mention which appears in the index-list as *Miss Palmer*, 1793, but which has always been called by the family *The Studious Girl* (*vide* Graves and Cronin, 724). It is a copy of the painting of Miss Theophila Palmer reading " Clarissa Harlowe," and for this reason was also called *Clarissa*.

This was exhibited in 1771, when the fair damsel was twelve years old, on which occasion, according to Cotton, the young person, seeing the

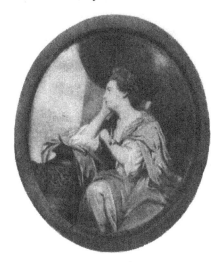

LADY MARY O'BRIEN.

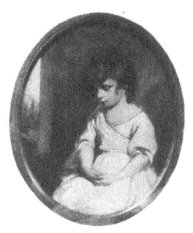

THE PENSIVE GIRL.

description of the picture as "A Girl reading," stated that in her opinion it ought to have been styled "A Young Lady reading."

The picture belonged to John Gwatkin, and afterwards passed into the hands of Mr. John Heugh, who sold it in 1872, but since that time it has been lost sight of.

It was evidently copied by Engleheart after the death of Sir Joshua, and is a particularly charming picture.

One more miniature copy does not appear in either list, but has always remained in the possession of the family, who did not know whom it represented. It is marked at the back in the handwriting of the artist as a copy from a work by Sir Joshua. It is an oval portrait, and undoubtedly represents *Lady Mary O'Brien*, daughter of the Marquis of Thomond and the Countess of Orkney, his wife, and who afterwards became Countess of Orkney in her own right.

The painting was exhibited constantly as that of *Nelly O'Brien*, but must not be confused with the better-known frail beauty who bore that name. When it was painted is not known, but it was engraved by Dixon in 1774.

The last of these curious copies which claims attention is the *Head of a Negro*, which is not in either of the three lists, and but for its being marked by the artist "a copy of a head by Sir Joshua" would not merit any notice. It appears to be a sketch for the negro who is holding the horse in the picture of the Marquis of Granby in the possession of the Crown, and which hangs at St. James's Palace. It was painted in 1766, when the Marquis was Commander-in-Chief.

We have not only to consider George Engleheart as an expert copyist of the paintings by Sir Joshua, but a few words must be added as to his nephew, J. C. D. Engleheart, who in this respect followed in the footsteps of his uncle.

In his record of work executed will be found several entries of pictures copied from Sir Joshua, and two of them deserve special attention.

On October 19, 1799, John C. D. Engleheart mentions that he made a miniature copy of "*Miss Mary Mayer as Hebe* from a full-length picture painted by Sir Joshua Reynolds, and in the possession of Mrs. Meyers at Kew." The statement is quite correct, as in 1799 the well-known picture (51 in. × 39 in.) was in the possession of Mrs. Meyers, as her name was spelt in the catalogue of the day, when she exhibited it at the British Institution in 1813.

The picture now belongs to Mr. Leopold de Rothschild, and we illustrate the pencil drawing which John C. D. Engleheart made of it for his miniature copy.

On March 9, 1799, he mentions that he copied the *Weeping Girl* from Sir Joshua, and that he did it in London.

This entry is very interesting, as the original picture has entirely disappeared since 1833. It was a companion picture to the *Laughing Girl*, which the same artist copied nine days afterwards; but it is not known when it was painted nor to whom it belonged. It was exhibited at the British Institution in 1813, and again in 1833; but since then nothing is known of it, and, as it was never engraved, no description can be given of it. The miniature copy made by J. C. D. Engleheart, which is also missing, would be very interesting, as it would give the desired information as to this picture, its subject, and its colouring. All the others which John C. D. Engleheart copied are the same as those which had been previously copied by his uncle, and very possibly were not so much copies of the originals as of the miniatures already done from the oil paintings by George Engleheart.

Engleheart's affection for the memory of his old master is shown by the care in which he preserved several mementoes of his days in the studio. He had replicas, or perhaps Sir Joshua's own copies, of *Charity*, for which Mrs. Sheridan sat, and which was designed for one of the compartments of the New College windows, and of *Hebe*, for which Miss Meyer sat, represented as climbing the rainbow path, guided by the eagle of Jove. He also treasured one of the peculiar spade-like palettes which Sir Joshua used, and the pictures and palette are still in the possession of Sir Gardner Engleheart.

The various items of information afforded us by these miniatures may seem to the ordinary reader of small importance, and to have received more attention than they deserve; but students of English eighteenth-century painting will value them highly, and understand the exceptional importance which they possess as definite data enabling us to clear up certain difficult questions as to the works of Sir Joshua Reynolds.

COLLECTION OF S. E. KENNEDY, ESQ.

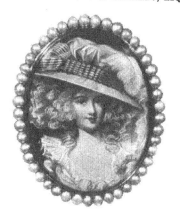

A LADY UNKNOWN.

N.B.—*Lady Currie has in her collection (see another plate) a miniature almost exactly resembling this one, possibly a replica of it, but both are genuine works by George Engleheart.*

CHAPTER VI.

ENGLEHEART'S PALETTE AND APPLIANCES.

I T is always interesting to know what colours were used by any noted
artist, and to examine his appliances and tools.

In the case of Engleheart the task of explaining how his palette
was " set " is at the same time one of ease and of difficulty.

It is easy because all of his colours appear to have been preserved.
It is difficult because he tried several methods of working, and it is not
quite clear which colours he used for each.

He not only painted in water-colour on ivory, by which work he
gained his great reputation, but he also dabbled in oil, worked a good
deal in enamel, and, it is believed, tried glass-painting, even if he did not
still further try experiments with painting on porcelain, and all the
colours used for these various works are together in one cabinet.

The wonderful neatness which characterized the man, and extended
to every detail of his life, is well shown by the illustrations which we give
of his palette, colour-boxes, and brush-rest.

Ivory with an enamel tablet on lid
7/8" high 7/8 diameter top, 12/16 diameter base

His enamel colours are all put up in tiny ivory boxes, each carefully
turned and each possessing on the lid, set into the ivory, a small plate of
enamel on which the colour which the box contained is shown. The

little boxes are of exactly the same size, and many of them, as seen in the drawing, were kept together in the drawers of a cabinet. In some cases the lids bear not only a splash of the colour, but an identifying number, but there is no list by which the colours can be identified, nor have any of the colours their names given to them, the number only appearing.*
From experiment we are disposed to think that they were not prepared in England, but that the artist obtained them in Switzerland. With them Engleheart seems to have used oil of spike lavender as a diluent.

There are many trials of enamel in this same cabinet, oval tablets of white enamel on copper covered with splashes of various colours, many of them marked with numbers corresponding to those on the boxes. Of actual works in this medium there are but few which remain certified as the work of Engleheart. Two are on p. 59, one being a delightful

7³/₈″ long 3½″ wide 1⅝″ deep

Sir-Joshua-like head of a lady resting her head against her hand and seated near a large vase of classic design, and the other representing a woman and a cherub, which are faintly drawn in pink colour on the corner of one of the trial plates.

There is but one entry in the fee-book as to an enamel, and that is under date December 10, 1778, "A Lady copied in enamel." By looking down the column which records the payments for each work, this entry is seen to refer to a payment made March 27, 1779, when the name of the lady is given as Lady Thomas.

* These colours were long considered as tints for use in miniature-painting; but we have tried experiments with many of them, and find that they fuse readily at a moderate heat into globules of enamel of about the same hues as they present in the form of powder. It is evident that they were tinted to resemble the hues they would acquire in the kiln.

COLLECTION OF THE HON. GERALD
PONSONBY.

LORD BEAUCHAMP.

COLLECTION OF THE REV. G. H.
ENGLEHEART.

NATHANIEL ENGLEHEART.

COLLECTION OF J. WHITEHEAD, ESQ.

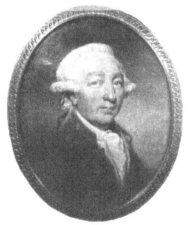

AN OFFICER UNKNOWN.

COLLECTION OF GREVILLE DOUGLAS. ESQ.

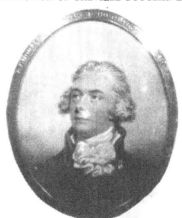

RIGHT HON. CHARLES YORKE.

ALL UNFINISHED AND UNKNOWN.

Judging, however, from the quantity of enamel colours which the artist possessed, and by the extreme care which was taken of them and the number of trial plates which remain, Engleheart must have done a good many enamel portraits, and it is strange that so few of them certified as his work now remain, as in this medium more than in any other it was the custom of all workers to sign their productions, and the name is usually to be seen burnt into the back of the portrait.

There is but one miniature in enamel amongst all those which belong to the family. It is in the possession of Sir Gardner Engleheart, and is enclosed in a gold locket which bears the coronet of a Duke with an intertwined monogram of the letters.

His nephew, J. C. D. Engleheart, shared in his uncle's fondness for

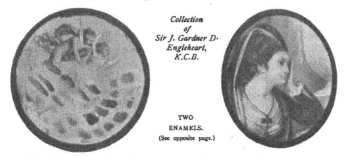

*Collection
of
Sir J. Gardner D.
Engleheart,
K.C.B.*

TWO
ENAMELS.
(See opposite page.)

enamel, and did several works in that medium, notably one copy of Sir Joshua's picture of Miss Meyer as Hebe.

Some of the other colours which the artist left behind him are in paper packets and some are in bottles.

Amongst those in packets are a whole series called " Blooms," which are somewhat puzzling. They are body colours, and appear to have been used in enamelling or in china-painting, and it seems probable that Engleheart tried experiments in this latter branch of art.

Professor Church, the greatest living authority upon the chemistry of paints, and the author of the well-known handbook on that subject,* tells us that these blooms are " very useful when applied over the surface of a deeper or more transparent colour, already burnt in by a passage through the enamelling kiln. A second firing fixes them, and the bloom on the

* " The Chemistry of Paints and Painting," 1901.

I 2

cheeks, and the haze in the distant landscape may thus be realized." He adds that "the opacity or semi-opacity which they impart is due to the presence of stannic oxide (SnO_2) in varying proportions."

One or two other packets of colour bear well-known names. There is, for example, "Turner's blue," which appears to be genuine ultramarine of very fine quality.

"Mr. Warde's China vermillion very fine" is Mercuric sulphide, crystalline and of remarkable purity, and apparently prepared by the dry process.

Mr. Meyer's name appears on two packets, one of which is "Smalt," a very favourite colour with the artist, but one now almost superseded, its place being taken by cobalt blue, which naturally does not appear at all on the artist's palette, and by artificial ultramarine. The other colour bearing Mr. Meyer's name has also that of a Mr. Griffith on it, and the packet reads "Mr. Meyer's and Mr. Griffith's scarlet." The pigment contained is an enamel colour.

A packet labelled "Spencer's colours" very likely refers to the name of a colourman of the period, but the little parcel labelled "Chinese colours given me by Mr. Taylor" was probably a present from the artist known as Old Taylor, who was an original member of the Incorporated Society of Artists, and the survivor of them all, and who has been called the father of English artists, as he lived on till 1838, dying at the advanced age of ninety-nine, and well on in his hundredth year. Mr. Taylor at one time resided in Queen Street, and the name of this street appears on the inside of the packet. The colours which it contains are three, each wrapped in Chinese paper, and are, ultramarine of lovely quality, vermilion (very fine), and Indian lake, a very little of each remaining.

The name of Samuel Cotes, the miniature painter, appears on a packet of very fine Chinese White.

There is a large packet of verditer in the cabinet, marked "Verditer —very fine B. L.," and the use of this pigment, Chessylite, a copper mineral, accounts for the fact that in some of Engleheart's miniatures the blues have become very green, as this untrustworthy pigment is apt, by exposure to sunlight or a moderate amount of heat, to become greenish. It is now discarded by artists, as it is not a permanent colour.

"Silver Yellow," a small packet of which appears in the cabinet, is, I am told by Professor Church, to whose kindness and to the references in his book I am indebted for much of my information and for many directions, "an enamel colour the standard silver stain for glass-painting,"

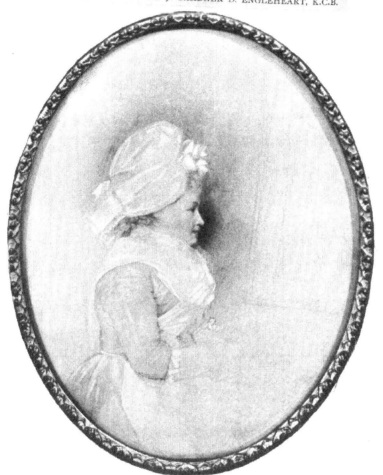

MRS. J. D. ENGLEHEART.

and from the presence of that colour, mulberry oxide, and a curious bismuth, it is clear that the artist busied himself at some stage in his history with experiments in glass-painting.

There is a large bottle full of that terribly poisonous pigment called Scheele's green, which Engleheart calls " Parrot green." It is an arsenite of copper with an excess of copper oxide, and is not permanent as a water-colour pigment, although it can be locked up in oil. It was only discovered in 1778, and was thought at that time to be a very important colour, and likely to be very popular, but it has now been altogether relinquished by workers in water-colour.

Very many, in fact, of Engleheart's colours would now be discarded, such as French Lake, Green Vermilion, Scheele's Green, Blue Verditer, Yellow Lake, Antwerp Blue, Amorphous Cinnabar, and Indigo, as none of them can be considered as permanent colours, and their presence accounts for the ruined condition of some of Engleheart's early miniatures which I have seen, and which have been exposed to the full effect of the sunlight.

There are certain colours in the cabinet which are prepared for work in oil, notably one which is labelled " Prussian Blue, prepared for Oyl." Possibly also the Ochres, Siennas, Red Lead, Lakes, and Carmines were used for oil-painting, but it is not easy, as stated in the first sentence of this chapter, to separate the colours used for each process from each other.

To " set " the artist's palette, however, we may take out from his cabinet the following colours :

Whites: We find " Fine White," " Flake White," and " French White."

Yellows: " Naples Yellow "—a terrible colour, which blackens rapidly ; " Yellow ochre "—an excellent permanent colour ; " Yellow Lake "—a beautiful but most unreliable pigment, which alters in colour very quickly.

Reds: " Carmine "—unreliable ; " Red brown earth "—probably a red ochre, and quite permanent ; " Garnet red "—which appears to be what we call Indian Red or Indian Lake, a very fair colour for permanence ; " Scarlet "—already mentioned ; and " Vermilion."

Greens: " China Green "—which is Green Verditer or Malachite green ; " Verdigris "—a most untrustworthy pigment ; and " Scheele's Green "—to which I have already made reference.

Blues: " Ultramarine " ; " Smalt " ; " Prussian Blue " ; " Indigo "; " Old Light Blue "—which appears to have been a species of artificial

ultramarine; "Velvet Blue"—a preparation of oxide of tin with nitrate of cobalt, now known as Cœruleum; "Antwerp Blue."

Browns and Blacks: "Burnt Sienna"; "Red Brown Ochre"; "Iron Brown"; "My own Black"—a species of lampblack; "Old Light Brown"; "Ivory Black"; "Light Chocolate"—a sort of Sienna, it appears, mingled with Sepia; "Blue Black."

It is curious to note that no Gamboge appears, although that colour was in extensive use in Engleheart's time, but has been proved in later times to be untrustworthy.

Probably the pigments most in use out of all these were Yellow Ochre, Yellow Lake, Indian Red, Scheele's Green, Carmine, Ultramarine, Smalt, the Sienna earths, and Black.

Very little of the green tints in Engleheart's miniatures have remained, and this is, of course, by reason of the use of Scheele's Green. The Carnations also have often fled, owing to the untrustworthy character of the Carmine, Scarlet, or Indian Lake, although the last-named is not so much affected by light as is Carmine. Where the Carnations have stood, the miniature has been kept from the light, or the colour used has been Indian Red Ochre.

It is interesting to contrast this list with the palette of water-colours as used to-day by the President of the Royal Academy, Sir E. J. Poynter.

His colours are, he says, as follows: Burnt Sienna, Indian Red, Light Red, Chinese Vermilion, Brown Madder, Purple Madder, Crimson Madder, Cobalt Blue, Cyanine Blue, Burnt Umber, Raw Umber, Vandyck Brown, Sepia, Raw Sienna, Yellow Ochre, Cobalt Yellow (*aureoline*), Oxide of Chromium (*viridian*), Chinese White, Lemon Yellow, Cadmium, Oxide of Chromium (*opaque*), French Ultramarine.

It is interesting also to compare the palette with that of the leading miniature-painter of the day, Mr. Alyn Williams, who has sent me the following notes as to the colours with which he "sets" his palette for work.

For flesh tints he says he uses Orange Cadmium and Rose Madder, the latter being not quite a stable colour—"not absolutely permanent," as Professor Church says—and the former a sound colour, far better than the Lemon variety, which no doubt Mr. Williams avoids. For shadows in the flesh he uses Brown Madder and Cobalt, the latter of which was unknown to Engleheart. For Carnations in lips and cheeks he uses Rose Madder and Vermilion. In the flesh he uses that wonderful colour Viridian, quite new since the time of Engleheart,

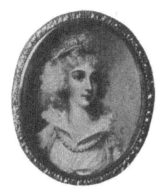

MRS. FISHER.

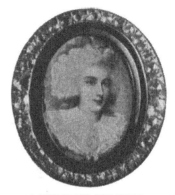

A LADY OF THE ABDY FAMILY.
Abdy arms on the reverse.

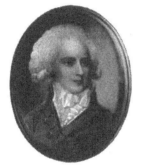

LORD MOUNTJOY.

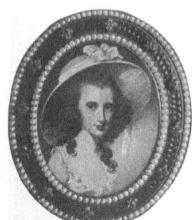

LADY HEADLEY (*née* BLENNERHASSET).

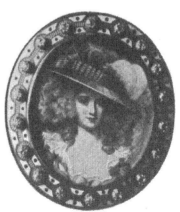

A LADY UNKNOWN.

having only been discovered in connection with the experiments which Professor Church says were commenced in 1838 by Pannetier and Binet in treating oxide of chromium. It is a wonderfully lovely colour, quite " unaffected by sunlight and sulphuretted hydrogen, and it has no action on other pigments."*

Mr. Williams also uses Raw Umber and Cobalt in the flesh, and could not well use a more valuable and sound colour than the former.

For hair—if brown, he uses Brown Madder, Sepia, and Rose Madder with Cobalt—if golden, he uses Brown Madder and Cobalt Roman Ochre and Rose Madder with Cobalt—if black, Brown Madder, a little Cobalt for darkest shadows, Black in half-tones, and Cobalt for the highest lights ; and for his cloud backgrounds he uses Prussian Blue and Cobalt with Vermilion, and sometimes a touch of pure Vermilion on the light edges of clouds. As a rule, he says, he tries to avoid the use of either Vermilion, Indian Red, or Light Red, using transparent colours alone, if possible, and Brown Madder rather than Black, which was used by Engleheart, for the first laying-in.

In the early part of Chapter IV. we mentioned that some of the first works which Engleheart did were styled " drawings " in his fee-book, and these were actually drawings in pencil, with colour applied to portions of them, such as the features and the costume, and other parts left in the plain black and white of the pencil and paper. When the artist adopted ivory he did not relinquish his affection for this class of work, and to the end of his life was fond of doing likenesses on paper and applying his colour to them with the same dexterity which he used when working on ivory. Some of our illustrations are of such work on paper, notably that on p. 45.

In working on ivory he used ox-gall and gum-water as a medium. A favourite mucilage was isinglass, boiled until it lost its gelatinous texture, and if colours were to lie flat, and not bear out with gloss, he used a cold solution of borax with gum tragacanth.

Contrary to the usual practice, Engleheart adopted circular palettes, and not the kind which were carried on the thumb. His were made of ivory, and were of such a size that they could easily be held between the thumb and first finger. They were provided with a slight rim, and were probably made specially for him, as they are extremely neat in appearance.

With them he appears to have used a set of mixing basins, cut out

* Church, p. 195

of a thicker piece of ivory, three inches square and five-sixteenths of an inch deep, in which were twelve small circular pits for the purpose of

2¾ inches diameter - ¼" thick
reversible.

mixing colours. This set of mixing basins was flat, and probably stood on the desk at his side.

As a rest for his brushes he had a special series of half-circles

3" square 5/16" deep 11/16 diameter of
12 mixing basons. Ivory.

cut in a slip of ivory, very neatly made, as were all the other appliances, and capable of holding nine brushes at a time.

Drawings of all these appear on this page.

4 inches long, 3/8" high, ½" wide

His brushes had very long handles, and were of sable, camel hair, and hog hair, the latter being the very smallest. I do not find that any of them were made of squirrel tail, such as Cosway expressed a great preference for.

COLLECTION OF MISS ENGLEHEART.

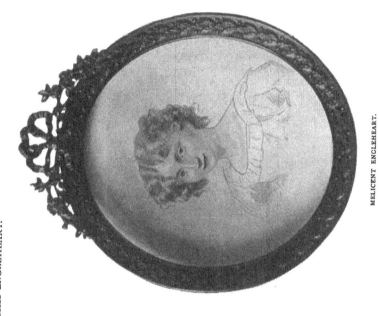

MELICENT ENGLEHEART.

MARY ENGLEHEART.

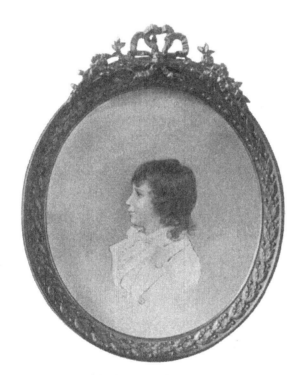

J. C. D. ENGLEHEART AT THE AGE OF TWELVE.

Many of the brushes are still in existence, and show signs of having been used with the utmost care.

He worked at a sloping desk which was covered with green baize, set upon a cabinet or table, in the drawers of which his colours and tools were arranged, and had everything he needed close within reach, so that his work could go steadily forward without any delay. This cabinet and desk still belong to his great-grandnephew.

It contains 70 drawers, in which were, amongst other things, 86 ivories, large and small, 100 enamel trial plates, 85 ivory boxes of enamel colours, 150 packets of colours, 60 bottles of colours, palettes, saucers, cover glasses, plates for enamel work, gum, gold leaf, Indian ink, and other things which the artist needed in his work.

His signatures to his miniatures usually took the form of a single letter E as on the one below, but in some cases (as in this very same instance), he also signed his best works at the back, adding the date and his address. Many of his works are signed G. E. and dated, and this form of signature he seems to have specially adopted after his nephew began to exhibit miniatures, probably in order to guard against confusion between the two artists.

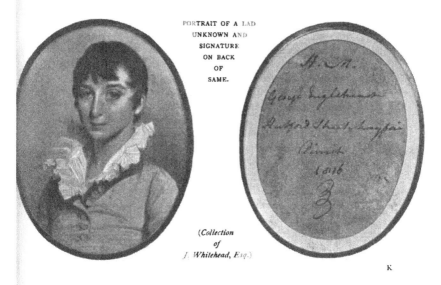

PORTRAIT OF A LAD UNKNOWN AND SIGNATURE ON BACK OF SAME.

(*Collection of J. Whitehead, Esq.*)

K

CHAPTER VII.

ENGLEHEART'S PUPILS.

THE only pupils of George Engleheart who deserve much attention in these pages are his nephew, John Cox Dillman Engleheart, and his distant connection, Thomas Richmond.

The former, who has already been mentioned several times, appears to have gone to his uncle's studio in 1798, when he was but fourteen years of age, and to have been under his care and tuition for a considerable time.

In the list of his works extracted from the very scanty records which remain of his painting-books, and which will be found at the end of this volume, is the entry of the "Pictures since I first went to my uncle's in Hertford Street," commencing with the note of his earliest work, copying two heads in Indian ink from plaster, representing Seneca and Sappho, very possibly the creation of his other uncle, Thomas, and also a head from a portrait by Romney.

From this initial entry the list continues of the work done by the nephew down to 1802. It includes the first miniature done by John Engleheart, which he proudly records on September 7, 1799, only a year after he had entered the studio. A Mr. Morgan it was whose portrait was the earliest original work of the young artist, who up to that time had evidently only copied his uncle's works and drawings, which were given him as studies.

The earlier subjects which were set him were pictures by Sir Joshua, and he relates that he copied the *Weeping Girl*, the *Laughing Girl*, *An Old Head*, another *Old Head*, and *Samuel*, the same pictures which so attracted his uncle's attention and which he had himself copied, as narrated in Chapter V.

A little later we find records of other of Sir Joshua's pictures copied. *Miss Mary Meyer as Hebe, a miniature from a full-length picture painted*

COLLECTION OF SIR J. GARDNER D. ENGLEHEART, K.C.B.

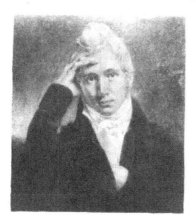

J. C. D. ENGLEHEART.

BY HIMSELF.

MRS. CHARLES BARKER AND HER BABY.

BY J. C. D. ENGLEHEART.

TWO PORTRAITS BY J. C. D. ENGLEHEART IN THE POSSESSION OF MISS ENGLEHEART.

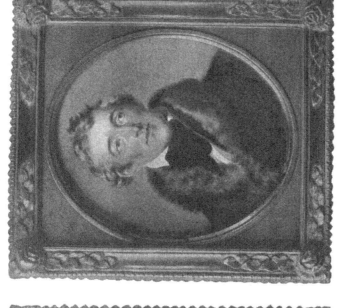

THE DUKE OF WELLINGTON.

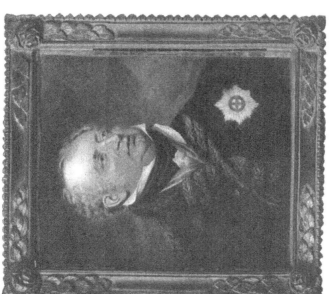

THE DUKE OF YORK.

by Sir Joshua, and in the possession of Mrs. Mayers (*sic*) *at Kew*, was copied by young John Engleheart in 1799, and in 1800 there are entries of copies made by him from the *Sleeping Cupid*, the *Sleeping Boy*, the *Boy with a Portfolio under his Arm*, and the *Reading Boy*, all works by the President, but in these cases not copied directly from the original paintings, but from the miniature copies previously made by George Engleheart. This same saucy Mary Meyer was also painted by George Engleheart in a white dress with dead-leaf yellow drapery set against a dark brown background, which set off her brilliant colouring delightfully. She was a wayward damsel, and on one occasion, being reproved for some fault, she ran away from home, and arrived at Hammersmith at midnight, where she was accidently found by George Engleheart on his way down to Kew, and by him taken back to her mother.

It appears as if on several occasions the lad was sent out of town to execute some commissions which, perhaps, he had himself obtained, or which his uncle was unable to attend to. The entries of October 7, 1799, relating to a drawing of Mrs. Cooper, to which the word " Pentonville " is attached ; those of October 24 and 25, 1800, of miniatures of Anne and William Paterson, which are marked " Condery Farm " ; the drawing and the miniature of Mrs. Haverfield, which are marked " Kew "; the miniature of Mrs. Paterson, which is also marked " Kew "; the ones of Mrs. Fulling and of Mrs. Wooley, with the same word ; and, finally, the drawing of Mrs. Roberts, which is marked in the list as done at " Eton on November 14, 1800," are probably all of them commissions which John executed at the houses of the sitters, and which reveal him as already an artist whose work was in demand, or at least as a satisfactory substitute for his uncle when the work of the greater man could not be given to the task.

For the most part, however, the records of these earlier years are not so much of original work as of copies executed for his uncle, and of backgrounds to the miniature portraits done by the older artist which he employed his nephew to execute.

The second list, taken from another book kept by John Engleheart, which commences at 1801, appears to refer solely to these copies and backgrounds, and is perhaps for that reason kept apart from the former one, which included John's own work.

In this second list there appear several entries of copies made by John from finished portraits by his uncle, whether for the persons who had commissioned the originals or for his own practice is not clear ; but his

K 2

ability in original work at that time can be proved by the fact that it was in 1801 that he first exhibited at the Royal Academy, and that in the following year he appears to have had a studio at his father's house, as he gave his address in the Academy list as 13, Shepherd Street, Hanover Square.

Six years afterwards he had a studio of his own, and his address was given as 88, Newman Street, Oxford Street—a street in which Cosway and Meyer had both lived, and which was a very favourite place of residence at that time for artists. There he resided till 1821, when he removed to 70, Berners Street.

In 1825 he moved into 65, Upper Berkeley Street, Portman Square, and in 1828 his address is given as 7, Mortimer Street, Cavendish Square, on the last miniature which he exhibited at the Academy.

Altogether he sent in to the Royal Academy a very long list of pictures, some 157 works in all, exhibiting in some years as many as eight at a time.

He also exhibited twice at the British Institution when he was residing at Newman Street, sending in 1809 what is simply called *A Study in Miniature*, and in the following year "a miniature" measuring 12 inches by 9, entitled *Cheerfulness*.

He married in 1811 Mary Barker of Edgbaston, and by her he had four daughters—Mrs. John Hennen, Mrs. Fulling Turner, and two unmarried ladies who are still living, Miss Lucy and Miss Melicent Engleheart, all of whose portraits appear in this work; and one son, the present Sir John Gardner Engleheart, K.C.B., who is the owner of the fee-book and most of the remaining records relating to the family, and who still resides in the family home in Curzon Street, Mayfair.

When the artist was forty-four years of age, his health, never very strong, entirely broke up, and he was obliged to relinquish the active pursuit of his profession. He went away to the Continent, and, finding that his health was thereby improved, he left England for four years in 1830, taking with him his family and travelling in Switzerland and South Italy. Two winters he spent on the shores of the Bay of Naples, and two in Rome, returning to this country in 1834 rich, as has been pleasantly said by one of his descendants, "not only in varied associations of foreign travel, but also in the acquisition of many valued friends whom his gentle presence and cultured taste had attracted towards him." On his return he resided at East Acton until 1852, in which year he established himself at Beechholm, Tunbridge Wells, where in

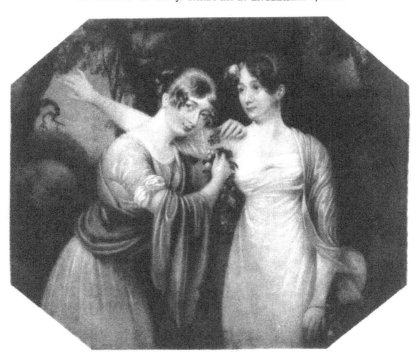

MRS. J. C. D. ENGLEHEART AND HER SISTER, MISS JANE BARKER (AFTERWARDS MRS. MYLNE).
BY J. C. D. ENGLEHEART.

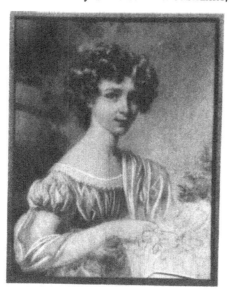

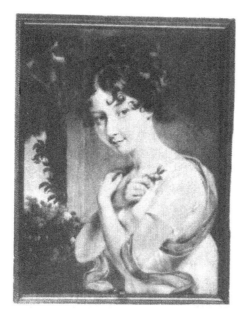

MARY ENGLEHEART, AFTERWARDS MRS. HENNEN.

BOTH BY J. C. D. ENGLEHEART.

1862 he died at the age of seventy-eight. His widow continued to reside in the same house until her death, in her ninetieth year, in 1878, and they were both buried in the cemetery of Trinity Church, Tunbridge Wells.

As will be seen by the list of pictures which he exhibited at the Royal Academy, he was a very popular artist, but he laboured under the disadvantage common to all the men who worked at that time—the changes of fashion in the way of costume and coiffure.

The advantages of charming costume which belonged to the men of the earlier day, and the charm of manner in which the hair was dressed, were rapidly passing away when John Engleheart was at the zenith of his reputation, and they were being superseded by costume and coiffure which were far more difficult to make picturesque, or even pleasing.

In his earliest days he so closely adopted the manner, and even the colouring, of his uncle that it is not easy at times to distinguish their work, and, in fact, one of our illustrations, that of his own father, John Dillman Engleheart, would most certainly be taken, as we ourselves at once took it, as the work of George Engleheart, were it not for the unmistakable signature and date which it bears.

His colouring, however, as he advanced in life became far hotter and less refined than his uncle's ever was, and his drawing was done with a heavier hand and lacks the dainty lightness which George Engleheart possessed in so remarkable a degree.

He always aimed, as was the custom of his period, to bring in accessories to his portraits—flowers, trees, landscapes, vases, wood, and symbolical objects—and so destroyed the unity of the portrait and prevented its obtaining the success which it deserved. Another fault, and one also which belonged to most of his contemporaries, was a striving to express emotion, to suggest romance and classical allusion, in the pictures, and by such means he removed from the portrait much of its simplicity.

At times, however, he could paint a simple straightforward portrait thoroughly well, but even then the gorgeous backgrounds which were so popular at the time, and which were always dark and rich in colouring, even if not actually hot, injured the effect of the picture. There was a straining after the effect of oil-painting in the miniatures of his day, and for that reason they are not nearly so pleasing as are the earlier and far simpler portraits of those who preceded him.

The portrait of his uncle George is one of the best miniatures which

John ever painted, and a light and very graceful work is the portrait of his daughter Mary, afterwards the wife of John Hennen, Esq., M.D.

His wife and her sister Jane he painted in a large miniature standing in a somewhat affected pose, and the quaint conceit of Pick-a-Back, originated by Sir Joshua in his famous picture of Mrs. Payne Gallwey and her child, was adopted by this artist in his miniature of Mrs. Charles Barker and her baby, but without any great success or sense of reality. There is an affected simper in it, although the conception is pleasing. The drawing of the hands is not good, while the colouring is too hot to be satisfactory.

One of his most graceful conceptions is called *Past, Present, and Future*, and represents three female figures in symbolical positions. Even in this the drawing is not without reproach, and the draperies are heavy, but there is a charm in the picture and a beauty in the face and form which redeem it from being commonplace, and give it a higher position than many of these more ambitious works can claim.

In his portrait of himself the artist is well depicted as a quiet, studious man, not strong in bodily health, refined, cultured and thoughtful, but lacking, it is clear, the power of forcefulness, quickness, and nervous tension which characterized his uncle.

It was in his simplest portraits that he excelled, in cases where he did not strive after pictorial effect but confined himself to a just delineation of the person under consideration.

In many of such portraits he was successful, bringing to his task a discrimination and an insight into character which were of great value. He was, however, too much disposed to sentiment, too poetical, too romantic, to often allow himself the simpler aim of a straightforward portrait, which should reveal the sitter exactly as he or she was, but perhaps part of the very secret of his popularity for some years was this romantic and semi-classical feeling, which accorded with the sympathies of that artificial age.

Such a work as the one which he exhibited in 1809, and which he called a portrait of Miss J. Cramer in the character of *Cheerfulness*, from Collins' " Ode to the Passions," was just the sort of thing to rouse his enthusiasm and to attract attention at the Academy.

Another one of the same kind would be the picture of *April and May*, containing portraits of his wife and sister, etc., painted to illustrate the words in Cowper's " Invitation to the Country," which was exhibited in 1813, and for such works he had a great repute.

COLLECTION OF SIR J. GARDNER D. ENGLEHEART, K.C.B.

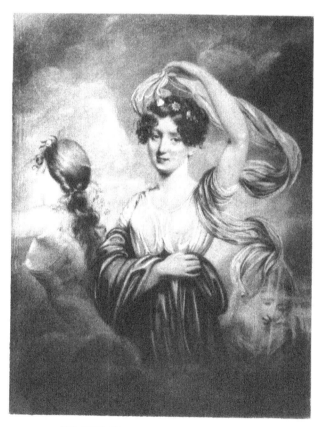

MISS DALLY AS PAST, PRESENT, AND FUTURE.

BY J. C. D. ENGLEHEART.

IN THE POSSESSION OF MESSRS. E. PARSONS AND SONS.

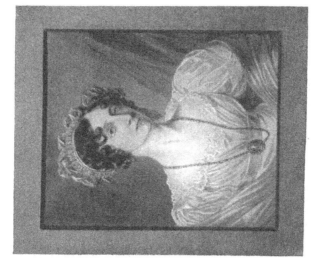

TWO LADIES UNKNOWN.

BY J. C. D. ENGLEHEART.

It is, however, by his portraits alone that his name will live, and not by these fanciful works, which had but an ephemeral interest and very little real artistic merit.

Of portraits he painted a vast number, and one which we illustrate on p. 73 of Richard Brinsley Sheridan shows him at his very best.

It is impossible to speak too highly of the power and force, the brilliance and characterization, of this portrait. It is a masterpiece, and if John Engleheart had done no other work than this he would have deserved ample recognition as an artist of great achievement. There is no attempt in this portrait at strained sentiment, no desire to cumber the work with a landscape background or with accessories which would but detract from the face. There is just the likeness of the man, well modelled and adequately expressed, thoughtful, brilliant, full of humour and intellectual force, coupled with indecision, and we need no other portrait of the orator, statesman, and dramatist to bring before us an excellent idea of what sort of a man he was.

John Engleheart was not only a clever, capable painter, but excelled in his pencil-drawing, and no notice of his work would be complete did it not refer to the dainty grace of the drawings which he has left behind him, and one example of which we illustrate.

The very lightness and grace which mark them seem to have left him when he took in hand his brush, and it was but seldom that he allowed himself to execute in his painting the fine and more dainty work which he could so well have done.

Beyond the two records which we print, and some drawings and tracings which are unfortunately not named, he has left behind him very few writings or papers.

A vast quantity of his colours, however, remain in the possession of his family, and many of his brushes and trials of work, and to these there is a reference in the chapter on the colours used by his uncle, as he seems in his esteem for that relative's name and importance to have gone on using the colours which had been prepared by him, and the value and use of which he had learnt when he entered the studio in Hertford Street in 1798.

Thomas Richmond, who, as already mentioned, was connected by marriage with Engleheart, was born at Kew in 1771. He appears to have worked for a short time in the artist's studio, and then he went to the St. Martin's Lane Academy. He exhibited at the Royal Academy

between 1795 and 1825, and was held in great repute, but was excelled by his sons, who followed him in the same profession, Thomas Richmond the younger and George Richmond, R.A. Richmond died in 1837. One of his miniatures figures in these pages.

Although not a pupil to his father in the ordinary sense, the work of one of his sons, Henry, deserves attention.

Henry was in many ways a remarkable person, and it is mainly to his forethought that the preservation of such of his father's drawings and papers as have come down to the present day is due.

He mounted many of the drawings and tracings with infinite care, bestowing upon them the utmost attention. He was a well-educated man, had been at Caius College, Cambridge, where he was a pupil of Whewell and the best man of his year, but owing to an unfortunate breakdown in health only took an ordinary degree. He travelled a great deal on the Continent before he took Orders, and acquired the intimacy with, and the love for, Italian and German art which characterized him all his life.

In 1883 Henry took up his residence at Bedfont (left to him by his father's will, subject to his brother's life interest), and there he made a home for his sister Emma and his widowed sister-in-law, the wife of his brother, Colonel George Engleheart.

From time to time he resumed his travels, and brought home with him many a portfolio full of fine drawings, mainly architectural subjects, which rival those of Prout and Edridge.

He was an omnivorous reader, and his house at Bedfont was full of books and pictures from attic to cellar. Botany, conchology, and natural history also engaged much of his attention, and he had the power of being an admirable raconteur, charming in his conversation and full of desire to instruct, interest, and amuse those about him. Unfortunately, he committed nothing to writing of all his recollections of the artists whom he met or the places which he visited.

After the death of his two sisters he became more and more a recluse, only coming up to London to visit some art exhibition, and to return to Bedfont laden with spoils of art and literature.

He was a tall man, of handsome, striking appearance, and a great walker, and his figure was well known in the neighbourhood of the place where he lived. Overmodest and unselfish to a remarkable degree, he unfortunately neglected opportunities in his life which would have been of great advantage to himself and to others, and with his great natural

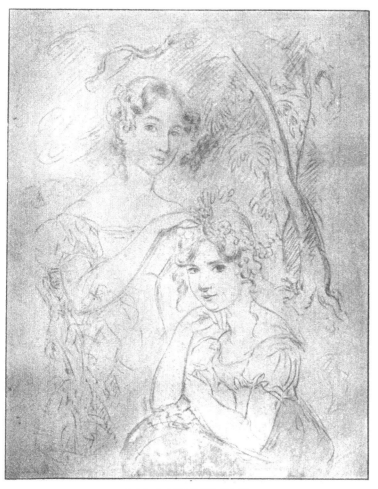

PENCIL SKETCH OF TWO SISTERS.

BY J. C. D. ENGLEHEART.

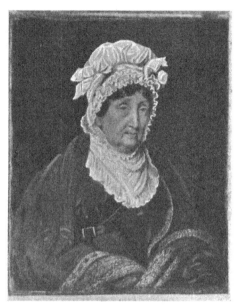

MRS. J. C. ENGLEHEART.
BY J. C. D. ENGLEHEART.
Painted before 1815.

TWO EXAMPLES OF THE SIGNATURE OF J. C. D. ENGLEHEART, FROM TWO MINIATURES, PROVING THAT
SOMETIMES HE OMITTED HIS SECOND INITIAL FROM HIS SIGNATURE.

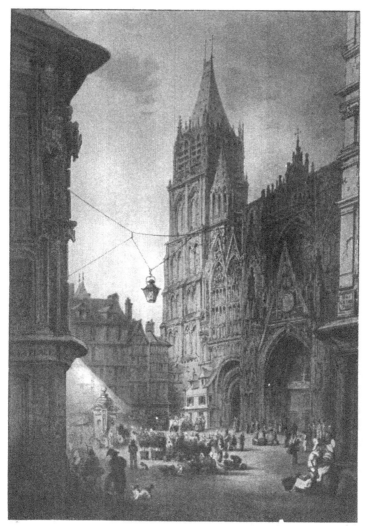

WATERCOLOUR OF THE CATHEDRAL OF ROUEN.

BY HENRY ENGLEHEART.

YPON.

YPONOMEUTA:
Padella.

The Common Ermine.
The Small Ermine.

7273.

TORT.

ORTHOTÆNIA:
Turionana.

ARGYROLEPIA:
Turionella

The Orange-spotted.

7121.

TORT.

XANTHOSETIA:
Zoegana:

Zoegana.
Clouded Straw.

7148.

YPON.

Anacampsis:

Domestica.

7198.

MOTHS PAINTED BY NATHANIEL AND GEORGE ENGLEHEART, GRANDSONS OF
GEORGE ENGLEHEART.

The names and numbers of the moths also were done with the brush.

powers of intellect and deep and extensive reading he yet added nothing to the world's storehouse of knowledge. Our main cause of gratitude to him with regard to this volume is the care with which he preserved such of his father's treasures as came into his hands.

He died in 1885, in the eighty-fourth year of his age, and was buried at Bedfont.

Finally, we must refer to the work of two of the artist's grandsons, Nathaniel and George, sons of the elder Nathaniel.

Some examples of their dainty work in delineating the forms of English moths are given in these pages, but it is unfortunately impossible to present them in adequate form by photography.

They are of the most exquisite refinement, coloured to perfection, and perfectly accurate in all their details, and yet, although life-size, are of such extreme minuteness as almost to defy illustration.

So facile were the two brothers with the brush that they have even painted the names of the moths with that appliance rather than with a pen, and have done them with wonderful accuracy and regularity. This work of delineating moths, which fills many pages of a substantial book, was their occupation during spare evenings at home, and was done without the use of glasses.

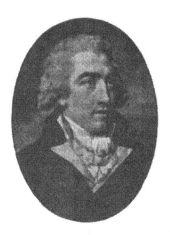

RICHARD BRINSLEY SHERIDAN.

(*Collection of Henry Yates Thompson, Esq.*)

L

CHAPTER VIII.

THE ART AND PLACE OF GEORGE ENGLEHEART.

IN person George Engleheart was a man of medium height, with pleasing and good features and very gentle manners. He was of a bright, cheerful disposition, full of benevolence—so his children said—and of consideration for others. He was also a very modest and retiring man, and, as has been shown by his letters, a man of decided religious opinions.

His position as Miniature-painter to the King made him, to a great extent, a rival of Cosway, who was so closely attached to Carlton House and the establishment of the Prince of Wales, afterwards the Prince Regent. Between them they divided the fashionable world, and those who went to Cosway did not come to the studio of Engleheart as a rule, and the reverse also was the case. Engleheart's sitters were really the more precise, staid persons, while Cosway was the favourite with the brilliant persons of fashion—the gay ones of that busy world. There is almost the same contrast between their work.

There is a brilliant flippancy about the work of Cosway, a display of talent, a verve, show, and glitter—all very different from the quiet refinement, simplicity, and tender dignity of the work of Engleheart. Cosway's portraits had all the softness of Italian work, Engleheart's all the strength which betokened the English character.

There is a dignity and impressiveness, with the charm of grace and the flutter of life, about the work of Engleheart which that of his great rival does not possess, but at the same time Engleheart cannot pretend to compete with the dash and lightness of touch, with the daintiness and luminous quality, of the work of Cosway.

The complaint has often been made as to the miniatures by Cosway, that, with all their beauty, there is a certain monotony about them. His fair ladies were all too much alike—too idealized, too near to the

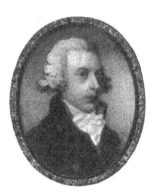

A GENTLEMAN UNKNOWN.

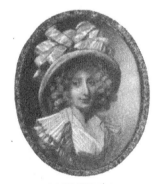

A LADY UNKNOWN.

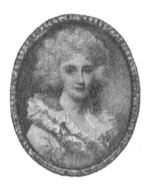

A LADY UNKNOWN.

ideal which Cosway had set, and which he made them come up to in his portraits. His men were too much like the Prince Regent, his ladies too similar one to another. They were all very lovely, the grace and the charm of their beauty was entrancing; but the question often arose, Were they really as lovely as they are painted, or do we owe much of their exquisite charm to the ideality of the artist? This question seldom arises when we consider the miniatures of Engleheart, as there is a truth, a force, a directness about them which tells its own tale, and in gazing at them one is convinced that what is seen is a real likeness of the person depicted.

We would not be supposed for one moment to gainsay the exquisite loveliness of the work of Cosway. It is supreme. Its delicacy no one could equal, its charm is complete, and in the painting of the hair and in the wonderful suggestion of costume—the touch which gave all the impression which was needed—there is no one who can come near to the Painter to the Prince Regent. Engleheart was not his equal where daintiness and grace were considered; his touch was a far heavier one, and he had not the sparkle and glitter of his rival. When truth, however, is considered, and when accuracy of drawing are taken into account, then Engleheart forges far ahead of Cosway. Cosway was notoriously careless in his drawing. He was weak in that respect, and he covered up his defects, as all weak persons try to do, with colour, glamour, and show. Engleheart was a far better draughtsman, not irreproachable in all respects, but generally far more correct than Cosway would have been, and often absolutely accurate. His colour was stronger than Cosway's, and it lacked the luminous transparent quality of the work of Cosway, but there was a straightforwardness about it, an honesty—in a word, a truth—which redeemed all faults.

On careful study his work will be found the more satisfying and the more pleasant to examine. It is not mystifying, as is Cosway's. One does not wonder, as a rival said of Cosway, 'How the d——l does the fellow gets his effects?' There is no such puzzle; all is clear and above-board. The colours are laid on evenly and surely with a steady hand, and the effect of the finished work is a satisfactory, well-composed, truthful portrait, with a charm which is all its own.

Engleheart never worries the observer. It is easy to say what his colours were, why they have stood, or why some of them have faded, why they were used, and whether there was any glazing, or hatching, or stippling. With Cosway the case is different, as the more one looks the more wonderful does the marvel grow as to how the dainty charm is

L 2

realized, how the subtle modelling is obtained, and how the suggestion is
given where hardly a line and a touch only can be seen.

In the painting of the hair the two men differ completely, as the hair
of Cosway is always treated in masses, while that of Engleheart is
painted in lines, sometimes hatched and cross-hatched, but with a clear
distinctness not always to the advantage of the portrait when mere beauty
is required.

He comes nearer in that respect to the work of the brothers Plimer
—Andrew and Nathaniel—especially Nathaniel, pupils of Cosway, but
their treatment of the hair is harder than is Engleheart's, and his takes a
middle position between that of Cosway and that of Plimer.

One feature he has very clearly set forth, and by it his miniatures
may readily be identified. The eyes are defined with an almost piercing
directness. They are generally a little too clear and a little too large.
They are luminous, transparent, and with all the liquid quality which is so
lovely in the living eye.

They are seldom velvety, although instances could be given of this
quality also, but there is a brilliance about them, a fulness, which is a very
marked characteristic of this master's work. The carnations of the
features have what is called a juiciness about them, a freshness and vigour
of colour not always quite convincing, and occasionally a little too full of
flush, but honest and agreeable and bearing the direct impress of truth.

He was accused, as were all the artists of that day, and as all artists
have ever been and will ever be accused, of idealizing and of flattering,
but to few men does the charge so little belong.

He painted several persons who were quite plain, some even who
cannot but be considered as ugly, and he softened no asperity, indulged
in no imagination, and presented them as they were in actual life.

It is impossible for any true artist to rid himself of his artistic
perception, to refuse to ignore all the features which tend to plainness
and to gladly amplify those which have the opposite tendency. We
would not wish that it should be otherwise, but that is not flattery.
There are circumstances, lights, poses, or expressions, in which the
plainest of faces will look agreeable and pleasant, but at the same
time to those who look for them the plainer features will be at once
apparent. It is the skill of the artist so to put his sitter, so to arrange
the light, and so to try to form the expression, as to make the portrait,
while thoroughly lifelike and honestly true, as pleasing as possible. This
is the case with the work of Engleheart. He always found out the

BOTH IN THE COLLECTION OF THE HON. SIR SPENCER
C. B. PONSONBY-FANE, K.C.B.

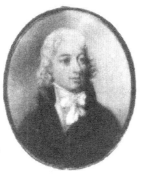

IN THE POSSESSION OF
MESSRS. DUVEEN.

COLLECTION OF
MRS. STRACEY-CLITHEROE.

LORD WESTMORELAND.

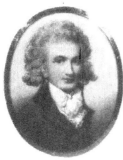

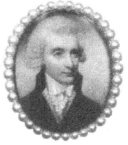

LORD ROBERT FITZGERALD.

LORD UXBRIDGE.

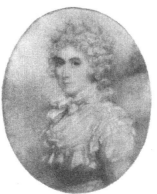

LADY WESTMORELAND.

charm which a face possessed, and he made the best of it, and even with its plainest features it is quite clear that he had devoted much attention to making the best of things, and yet at the same time preserved the actual likeness without exaggeration or injury.

There is always expression in Engleheart's faces. There is never that vapid, overcomplacent look which betokens self-satisfaction, the smirk of a foolish mind, the vacancy of a weak and trivial attention.

With the poorest sense of intellect he was always able to find some method of gaining expression, and all his portraits bear the impress of this quality. There is at least a glimmer of a soul, and in many of the best of the paintings there is the full development of it, the mind clearly set forth, the power of the artist brought up to that noblest result, delineation of the mind which lies behind the face. We are inclined to give him a higher place in the history of miniature art than belongs to Andrew Plimer, by reason of the absence of that factitious quality of pretence which belongs to some of the finest works of Plimer, and which he derived from the influence of Cosway. Engleheart is not so great a man as Smart, and his work is not completed with the extreme minuteness and the exquisite finish which distinguished the work of that little-known master. There is not the repose about it, the calm dignity, the simplicity, which all characterize the miniatures of Smart. It is more showy than is his work, more noticeable, less unobtrusive, but it is grander in its way, and therefore more impressive. Smart requires to be known and carefully studied to be fully appreciated. His beauties are not so apparent, they are below the surface and require to be looked for and sought out, and his miniatures will then be found full of charm and exquisite in their completeness and marvellous finish. Engleheart's merits are more on the surface, easier appreciated, and more statuesque in their nobility.

The next place below Smart belongs to him by right, and many persons not so fully conversant with the miniatures of Smart would be disposed to give Engleheart the higher place. He is greater than, Plimer because he is truer. He does not idealize his features so much as Plimer does.

The regularity of face is not so marked, the bold showy look of the eye not so forced, and the meretricious quality which is inseparable from the work of Plimer, lovely as most of it is, can hardly be traced in that of Engleheart. The hair, so wiry in Plimer's work, is more natural in that of Engleheart, and the expression of the faces is far truer to life, and

altogether lacks that overbold and overcoquettish fascination which Plimer's ladies so often bear. Above all, the drawing, faulty in Cosway, was far more so in Plimer, and in some of his best works the arms and hands are quite absurd in their inaccuracy.

Engleheart usually signed his miniatures with a simple script capital E, but after his nephew took to painting and exhibiting miniatures George Engleheart added the G to the single initial he had used before, and many of his later works are signed with a G. E., written with the utmost precision in a flowing Italian hand, and often having below them the date of the work.

He was a very expert draftsman in pencil and water-colour, and the examples contained in this volume will reveal him as ingenious in other fields than that of portraiture.

His water-colours of Stonehenge, five in number, one of which appears in this book, are of special interest at the present day, inasmuch as the position of many of the stones has altered since Engleheart made his careful studies of the ruin.

His sketch-books are full of charming work, studies of animals, landscapes in black and white, and in colour, or in bistre or sepia, heads and busts, copies of famous pictures in notable collections, such as the copy of the Rubens head, which we reproduce, and, in fact, everything which took his fancy and pleased his cultured taste. He seems to have known and admired the work of Cosway, and to have on occasion copied some of it ; Meyer, as already mentioned, was his great friend ; Romney and Reynolds he knew well ; but he seems to have had purer taste than any of them, and to have refreshed himself by returning to the fountain of all art knowledge, the study of the work of the ancient Greeks, and in the contemplation of a fine torso, or in the close examination of a gem, and perhaps in the attempt to copy it and acquire its secret of grace and movement, to have obtained his greatest delight. The fruit of all this study is to be found in the fine quality, the definite truth, and the exquisite finish, of the work which he did himself, and by which his name will be ever remembered. He was fortunate in the time in which he lived. The study of classic art was fashionable, and what was so important for the miniaturist was the beauty of the costume which was in vogue, the method of dressing the hair, and the use of that most helpful of all materials for the artist, powder, with all the charm which it gave to the hair, and the softness which it produced in the general effect of the portrait. His nephew, who succeeded him, was not

COLLECTION OF SIR J. GARDNER D. ENGLEHEART, K.C.B.

NORTH FORELAND LIGHTHOUSE.

From a watercolour by George Engleheart.

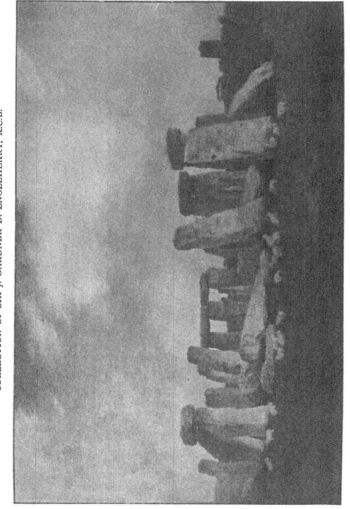

COLLECTION OF SIR J. GARDNER D. ENGLEHEART, K.C.B.

STONEHENGE.

From one out of a series of five watercolours by George Engleheart.

COLLECTION OF SIR J. GARDNER D. ENGLEHEART, K.C.B.

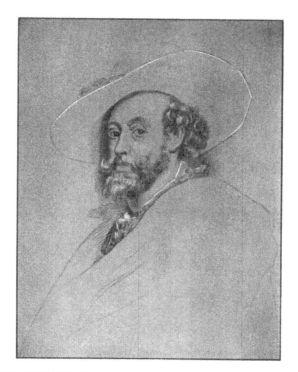

PENCIL SKETCH FROM THE PORTRAIT OF RUBENS BY HIMSELF AT WINDSOR CASTLE,
DRAWN BY GEORGE ENGLEHEART AT THE DESIRE OF THE KING.

so fortunate, and those who have come later on have lost all the advantages which the use of velvet and satin, brocade and silk, rich colour and dainty lace, gave to the men whose portraits the older artists had to paint. The present-day men have no field for their colour sense when a man's portrait is in question, and can only regret that they have so little scope for their ingenuity. Worse than all, the advent of photography has flooded the world with a series of so-called likenesses in which the transient glance of a moment is crystallized into permanence, and the days when an artist really studied his sitter, and gave the world the character of the man in the miniature portrait, garbed in all the rich materials of glowing colours which formed the costume, have passed away, never again to return.

Miniature work now lacks the personal element which gave to the older miniaturists their charm. There is too little study given to the human form, too often the basis is a photograph, instead of an accurate, truthful pencil drawing, and often the artist has no real understanding of the task which is set before him, and but little ability to carry it out with all that his own personal conscience dictates to him as to honesty, truth, and sobriety.

There are exceptions to this general statement, but they are few and notable, one of the cleverest painters of to-day having been mentioned on p. 62, but on the whole the art of the miniature-painter does not yet show that it has entered upon a new lease of life or is likely to make a mark upon the world as it has done in the days of yore.

A GENTLEMAN UNKNOWN.
(*Collection by J. Whitehead, Esq.*)

CHAPTER IX.

A FEW WORDS ON KEW.

IT has been felt that the interest of this volume would be increased by the presence within its pages of a map of Kew, showing the residence of George Engleheart and other members of his family. In his time Kew was so intimately connected with the leading artists of the day, and since that period it has been so much altered and so many of the old houses have been removed, that without such a plan as is here given it is not easy to realize where Engleheart, Gainsborough, Meyer, Zoffany, and their companions resided. The plan will show what a centre of artistic activity the little village at one time was.

Its connection with the Royal Household commenced in 1730, when, having quarrelled with his father and been forbidden to appear at Court, Frederick, Prince of Wales, obtained a long lease of Kew House from the Capel family, took up his abode there, and interested himself in improving the estate.

After his death in 1751 the Princess Dowager of Wales continued the work, and one of the persons who was responsible for the arrangement of the garden was the John Dillman who is mentioned in the first chapter of this book. The ornamental buildings were erected by Sir William Chambers, whose portrait Engleheart so often painted.

After the death of the Princess, which took place at Carlton House in February, 1772, Kew became the frequent residence of her son, George III., who eventually bought of the Dowager Countess of Essex the freehold of the estate, which from that time became an inheritance in the Royal Family.

Here it was that George III. used to come for three months of the year, and here it was that during the winter of 1788 he sojourned for a long time, as the physicians considered the place better adapted for his weak state of health than either Windsor or London.

COLLECTION OF H. L. D. ENGLEHEART, ESQ.

NATHANIEL ENGLEHEART.

JOHN D. ENGLEHEART.

HENRY ENGLEHEART.

COLLECTION OF MRS. ENGLEHEART.

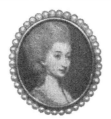

A LADY UNKNOWN.

VICTORIA AND ALBERT
MUSEUM.

COLLECTION OF THE
MARQUIS OF SALISBURY, K.G.

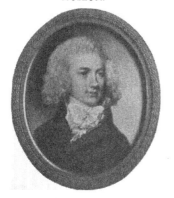

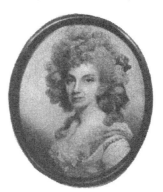

A GENTLEMAN UNKNOWN.

THE FIRST MARCHIONESS OF SALISBURY.

The old palace was taken down in 1803, and a new one erected on its site near by, but the new building was never inhabited by the King, nor ever entirely finished, and its materials were all sold by order of George IV. in 1827.

The house now called Kew Palace was originally called the Dutch House, and is so marked on the map. It was erected about the time of James I., and passed into the possession of Sir Richard Levett in 1697. From his heirs Queen Caroline took a long lease of it, which had not expired when in 1781 the freehold was purchased in trust for Queen Charlotte, and the house used as a royal nursery. Here it was that George IV. was educated, and during the long illness of Queen Charlotte in 1818 it was in this house that she resided, and here she eventually died on November 17 of that year.

The Dillmans and the Englehearts appear to have been very fond of the place, and to have acquired some considerable property around its pleasant green, all of which still remains in the hands of their descendants. The artistic coterie which made its headquarters at Kew must have been an agreeable and interesting one, and the constant residence of the Court near at hand tended to make Kew a place of great attraction and of favourite resort.

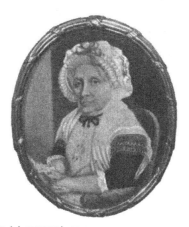

ELIZABETH BROWN (*née* WOOLLEY), WHOSE DAUGHTER BY HER FIRST HUSBAND WAS MARRIED TO J. C. ENGLEHEART, AND BY HER SECOND TO GEORGE ENGLEHEART.

(*In the possession of Mr. George Mackey.*)

M

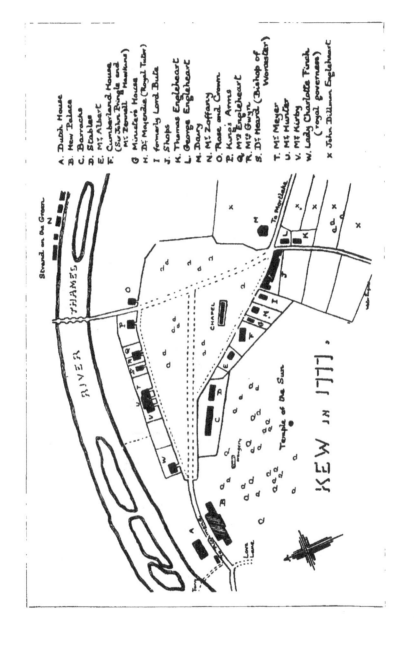

KEW in 1777.

A. Dutch House
B. Kew Palace
C. Barracks
D. Stables
E. Mr Albert
F. Cumberland House
 (Sir John Burgle and
 Mr Zouall Haviland)
G. Minister's House
H. Dr Majendie (Royal Tutor)
I. formerly Lord Bute
J. Shops
K. Thomas Engleheart
L. George Engleheart
M. Davy
N. Mr Zoffany
O. Rose and Crown
P. King's Arms
Q. Mrs Engleheart
R. Mr Gwyn
S. Dr Heard (Bishop of
 Worcester)
T. Mr Meyer
U. Mr Hunter
V. Mr Kirby
W. Lady Charlotte Finch
 (royal governess)
x. John Dillman Engleheart

Appendix I.

List of the Persons who sat to
George Engleheart from 1775 to 1813,
extracted from the Fee-Book.

PENCIL SKETCH BY J. C. D. ENGLEHEART FROM THE PICTURE OF HEBE,
IN PREPARATION FOR HIS COPY OF IT IN MINIATURE.

Appendix I.

List of the Persons who sat to
George Engleheart from 1775 to 1813, extracted from
the Fee-Book, and recorded with the original
spelling, copied as closely as it can be read.

1775.
Ayscough, Capt.
Alexander, Mr., Sen.
Alexander, Mr., Jun.
Arrow, Mrs.
Andrews, Mr. P.
Adair, Mr. (Argyle Street)

1776.
Adair, Miss
Adair, Mr. (a drawing for
 the Pope)
Asp, Mr.
Ayscough, Capt.
Adair, Mr.
Albemarl, Dow. Lady
Atkinson, Miss

1777.
Albemarl, Ld., Copd. for
Albemarl, Ld., for D. L. Alb.

1778.
Aularey, Mrs.
Ayscough, Capt.

1779.
Athill, Mr.
Adair, Miss

1780.
Adair, Mr.
Adair, Mr.

1781.
Ashton, Mrs.
Agnew, Mr.
Agnew, Mr., Senr.
Adair, Mr.
Arbuthnot, Mr.

1782.
Ashton, Mr.
Ashton, Mrs.

1783.
Arden, Capt.
Atherton, Mr.

1784.
Adair, Mr., Jun.
Ainstry, Mr.
Ainsley, Mr.
Arden, Capt. H.

1785.
Arden, Capt.
Atkinson, Miss
Adair, Mr. Sergt.

1786.
Ashton, Capt.
Acton, Mr.
Ascott, Miss

1787.
Acton, Mr.
Anderson, Mr.
Atkins, Mr.
Atley, Mr.
Aston, Lady Jane
Atchinson, Mr.

1788.
Adair, Miss
Adair, Mr.
Adair, Mrs.
Anstruther, Mr.
Astley, Mr.
Austin, Capt.

1789.
Arden, Capt.
Arden, Mrs.
Adam and Eve
Apsley, Lady
Ashton, Col.
Apsley, Lord
Ashton, Capt.
Astley, Lady A.

1790.

Aston, Lady J.
Alexander, Mr.
Ashton, Mrs., Jun.
Ashton, Capt.
Ahmety, Miss

1791.

Amfelt, Baron de
Andrews, Miss
Antrobus, Mr.

1793.

Amber, Miss
Amber, Mr.
Amyand, Mrs.
Acton, Mr., Sen.
Aldershawe, Rev. Mr.
Adams, Col.
Achee, Miss

1794.

Ayres, Col.
Anthony, Miss

1795.

Anthony, Miss
Audrey, Mr.
Aiton, Mr.
Anderson, Mr.

1796.

Ashbrook, Lord
Agassiz, Mr.
Aston, Sir William
Andover, Lord
Ackland, Miss
Anderson, Mrs.

1797.

Adair, Mr., Jun.
Agnew, Mr.
Agar, Mrs.

1798.

Alexander, Miss
Atherton, Mr.
Aislieby, Miss

1799.

Adair, Mr.
Anderson, Mr. David
Apsley, Col.
Aufrere, Mr.

1801.

Alexander, Mr.
Alexander, Mrs.
Austin, Miss A.
Atchinson, Capt.
Andrews, Mr.
Atkins, Rev. Mr.

1802.

Anthony, Mr.
Abercrombie, Mr. Robert
Abercrombie, Sir George
Abercrombie, Mrs. R.
Anthony, Miss
Augusta, Princess (portrait of the Prince of Wales)

1803.

Aspinwall, Mr.
Adair, Mr.

1804.

Arbuthnot, Lord

1805.

Adams, Mr.
Adams, Mrs.

1807.

Anson, Rev. Mr.
Armstrong, Miss
Aylmer, Capt.

1808.

Aboyne, Lord

1809.

Ahmety, Mr.
Ahmety, Mrs.

1810.

A., Miss
Arnold, Miss
Armstrong, Major

1812.

Addams, Mrs.
Anderdon, Mrs. John

1813.

Ahmety, Mr. J.

1775.

Belt, Mr. (Crown Office)
Banks, Lady
Banks, Miss
Bucher, Mrs.
Bucher, Miss
Bristow, Miss
Bulkley, Mrs. (drawing)
Birch, Mr. John (drawing)
Burnewood, Mrs.
Borrowdale, Lord

1776.

Bogue, Mr.
Bunnington, Mrs.
Bardoe, Mr.
Brahe, Count
Baynes, Miss
Barton, Mr.
Barton, Mrs.
Broadhurst, Mrs.
Blake, Mr.
Blake, Miss
Broadhurst, Mr.
Bond, Miss
Blake, Master P.

1777.

Byde, Mrs.
Boldero, Mr.
Brigstock, Mrs.
Brayham, Miss
Bale, Mr.
Beal, Mrs.
Byham, Master
Burdet, Mr. (from India)
Baker, Mr.
Barlow, Mrs. (Essex Street)
Baker, Mr. (City)

1778.

Byron, Mrs.
Birt, Miss
Bassett, Miss
Blake, Mr.
Bradshaw, Mr.
Bradshaw, Miss
Brown, Mr. C.
Blake, Miss
Borridale, Lord

Bradshaw, Mrs.
Biggs, Mr.

1779.

Brown, Mr.
Bradshaw, Mr.
Brown, Capt.
Benyon, Mrs.
Braham, Miss
Blake, Mrs.
Brown, Mrs.
Biggs, Mrs.
Baker, Mrs.
Bond, Miss
Bell, Capt.
Bromley, Master P.
Beech, Miss

1780.

Bassett, Mr.
Blake, Miss
Blake, Mr.
Bromley, Mrs.
Brown, Mr.
Bainy, Mrs.
Bromley, Mrs.(Castle Street)
Bromley, Miss
Bailey, Miss
Bromley, Master C.
Bromley, Master G.
Bridge, Capt.
Bromley, Master P.
Bembrigge, Mrs.

1781.

Bowater, Capt., R.N.
Biggs, Mrs.
Bowater, Miss
Batson, Miss
Beaufoy, Mr.
Beckwith, Miss
Biggin, Mr.
Belford, Capt.
Biggs, Mrs.
Bennet, Mrs.
Brickenden, Mr.
Bardoe, Mr.

1782.

Bent, Mrs.
Belford, Capt.
Brown, Mr.

Bagge, Dr.
Bagge, Mrs.
Brook, Lady
Bedingfield, Mr.
Bloomfield, Rev. Mr.
Belford, Miss
Belford, Mrs.
Belford, Miss A.
Belford, Miss Jane
Belford, Master (above five, all drawings)
Brown, Mr. (Hampton Court)
Biggs, Mrs. (drawing)
Batson, Capt.
Brown, Mr. (drawing)
Brown, Capt.
Brown, Miss

1783.

Bristow, Mrs.
Bright, Mr.
Bristow, Mr.
Bertie, Col.
Bertie, Mr.
Barton, Capt.
Balguy, Mr.
Barter, Mr.
Bucher, Master
Bellingham, Capt.
Bidcock, Mrs.
Bennet, Mrs. (for Lord Feilding)
Balfour, Mrs.
Bradyle, Mr.
Bocket, Miss
Boyce, Capt.
Bird, Mr.
Burnett, Miss

1784.

Beckwith, Mrs.
Biggs, Mrs. (drawing)
Brackenbury, Mr.
Biggs, Mrs.
Brown, Mrs.
Bryant, Mr.
Bennet, Mrs.
Balguy, Mrs.
Brown, Mr.
Binlop, Mrs.

1785.

Bromley, Mrs.
Blunt, Miss
Blunt, Miss L.
Barry, Mrs.
Booth, Sir Charles
Brownrigge, Rev. Mr.
Bolton, Capt.
Bembrigge, Mrs.
Broadhead, Mrs.
Best, Mr. George
Brotherton, Mrs.
Bryant, Mr.
Bowater, Capt.
Bale, Mrs.
Bassett, Miss
Bell, Miss
Brabazon, Capt.

1786.

Boldero, Mrs.
Boldero, Mr.
Brydges, Mrs.
Bromley, Mr.
Bamford, Mr.
Blackburn, Mr. P.
Brook, Miss
Brook, Mrs.
Blackburn, Miss
Brook, Mr. Peter
Bright, Mrs.
Baker, Mrs.
Bembrigge, Mrs.
Beechcroft, Mr.
Bassett, Mr.
Beaumont, Col.
Brook, Mr.
Beechcroft, Mrs.
Blane, Dr.
Barwell, Capt.
Beaumont, Mrs.
Blunt, Lady
Byrne, Mrs.

1787.

Bertie, Col.
Bligh, Mr.
Buckle, Capt.
Byrne, Mrs.
Barwell, Mrs.

88

GEORGE ENGLEHEART.

Beale, Mr.
Brown, Mrs.
Bosanquet, Mrs.
Bosanquet, Mr. W.
Barwell, Mr.
Bracebridge Mrs.
Blunt, Lady
Blunt, Miss
Brooke, Mr.
Brent, Mrs.
Bromley, Miss
Braham, Mr.
Braham, Mrs.
Baker, Capt.
Beale, Mrs.
Bosanquet, Mr. W.
Bisse, Rev. Mr.
Bisse, Mrs.
Baker, Mrs.
Braham, Mr. Sen.

1788.

Baugh, Mrs.
Braddyle, Mr.
Branvine, Mr.
Blair, Miss
Bosanquet, Mr.
Blair, Mrs.
Bicknall, Mrs.
Bosanquet, Mr. Jacob
Branfield, Mr.
Bockett, Mr.
Buller, Mr.
Brooke, Mr.
Bousire, Mr.
Burgoyne, Mr.
Bradshaw, Mr.
Blackwood, Capt.
Billington, Mrs.
Benyon, Mrs.
Blacke, Capt.
Burrows, Mr.
Blacke, Mrs.
Brooke, Mrs.
Baker, Mr.
Brown, Miss

1789.

Biddulph, Miss
Bellasize, Lady E.

Braddyll, Mr.
Brograve, Mr.
Bridgeman, Mrs. F.
Belford, Mrs.
Braddylle, Mrs.
Borser, Capt.
Belford, Mr. W.
Brooke, Mr.
Blaquiere, Sir F.
Blaquiere, Sir J.

1790.

Belcher, Miss
Burnaby, Lady
Barton, Miss
Bate, Rev. Dudley
Bridges, Mr.
Bury, Hon. Mr.
Bhen, Mr.
Braddyll, Mr.
Bosanquet, Mr. H.
Buller, Capt.
Boldero, Mr.
Bannaton, Mrs.
Broughton, Sir Thomas
Bosanquet, Mrs. H.
Basires, Mr.
Bouchier, Capt.
Bosanquet, Mr. J.
Bramley, Mr.
Brown, Mr.
Baugh, Mrs.
Baddely, Dr.
Bonnell, Mrs.

1791.

Brooks, Mrs.
Bonnell, Mr.
Bristow, Master
Burr, Miss
Bishton, Mrs.
Bell, Miss
Buller, Mr. Yard
Bertie, Lady C.
Barnett, Capt.
Brooke, Mrs.
Brooks, Miss
Brooks, Mr.
Bogle, Mr.
Biggin, Mrs.

Bilson, Capt.
Bennett, Capt.

1792.

Byne, Mrs.
Blunt, Lady
Barry, Hon. Mr.
Burr, Miss
Bennet, Mr.
Becke, Mrs.
Birch, Mrs.
Blunt, Mr.
Blunt, Miss
Brooks, Miss

1793.

Blunt, Miss
Blandy, Mr.
Baird, Sir James
Bateman, Mr.
Bateman, Mrs.
Boldero, Mr.
Boone, Mrs.
Boone, Mr.
Bradney, Mr.
Blunt, Miss

1794.

Bredalbane, Lord
Bagot, Hon. Mr.
Blunt, Lady
Bangor, Bishop of
Boyston, Mrs.
Brother of Lord Saltoun
 with Lord S.

1795.

Bowden, Mr.
Bulkeley, Capt.
Boldero, Mrs.
Bosanquet, Master
Bell, Mrs.
Boyton, Mrs.
Blackwell, Miss
Bateman, Miss
Benezet, Miss
Burrard, Miss
Bucannon, Mr.

1796.

Biscoe, Miss
Bagot, Hon. Mr.

Blunt, Miss E.
Byng, Mr. R.
Billington, Mrs.

1797.
Bilson, Capt.
Bowden, Mrs.
Bale, Mr.
Brown, Mr.
Bythesea, Rev. Mr.
Broome, Lord
Bogle, Mr.
Bogle, Mr., Jun.
Blakesley, Mr.
Bulkeley Mrs.
Brown, Mr.
Burridge, Rev. Mr.
Bishton, Mr. T.
Bishton, Mr. J.
Bosville, Mr.
Bosanquet, Mr.

1798.
Blunt, Capt.
Brown, Capt.
Brett, Mr.
Beechcroft, Mrs.
Bensley, Mr.
Beechcroft, Mr. T.
Biscoe, Mrs.
Bevan, Capt.
Bennett, Mr.
Bennet, Mr. J.

1799.
Biscoe, Mr.
Boldero, Mr., Sen.
Battine, Doctor (A Lady)

1800.
Bolton, Mrs.
Barry, Mr.
Bainbridge, Mrs.
Burley, Mr.
Bentley, Mrs.
Burdett, Mr.
Blunt, Miss E.
Bligh, Capt.
Bridges, Sir Brook
Brett, Mr.
Brooksbank, Mr. J.
Basshawe, Mr.

1801.
Bonaparti
Blunt, Col.
Bensley, Mr.
Brown, Capt.
Birt, Rev. Mr.
Brown, Master
Bogle, Mrs.
Bogle, Mr.
Bentley, Mrs.
Braithwait, Admiral

1802.
Brown, Mr.
Brown, Mrs.
Byland, Count
Barnard, Mrs.
Bouverie, Mrs.
Burdet, Capt., R.N.
Brown, Mr. William
Brown, Mrs. William
Buchannon, Miss
Buchannon, Mrs. and Mr.

1803.
Bonham, Mr. H.
Brotherton, Mr.
Blackwood, Sir James
Bouchier, Rev. Mr.
Baring, Mr. T.
Brook, Capt.
Baring, Mrs. T.
Bosanquet, Mr.
Brotherton, Capt.

1804.
Beauchamp, Capt. R.
Beaachamp, Capt. R. (his eye)
Beauchamp, Capt. R. (his left eye).
Beauchamp, Mr. Richard (his eye)
Beauchamp, Mr. Thomas (his eye)
Beauchamp, Miss (her eye)
Baring, Mrs.
Brown, Mr.
Beauchamp, Lady (her eye)
Reauchamp, Sir Thomas (his eye)

Baring, Mr. G.
Baring, Master G.
Baring, Master F.
Baring, Master T.
Baring, Mr. George
Bonham, Mr. H.

1805.
Burton, Hon. Col.
Boyd, Miss
Barwell, Mr. F.
Barwell, Mr., Sen.
Barwell, Mr. C.
Bathurst, Mr.
Brown, Capt. W., R.N.
Briggs, Mr.
Burnett, Mrs.

1806.
Baring, Master John
Bowdler, Mr. C.
Bragge, Mr.
Bedford, Mrs.
Beauchamp, Lady
Barwell, Mr., Jun.
Baugh, Mrs. (her eye)

1807.
Broad, Major
Boyd, Mrs.
Backeley, Mr. G.

1808.
Barbut, Mrs.
Bairy, Mr. T.
Boulton, Miss
Brewer, Miss (her eye)
Burrows, Miss
Brisbane, Lady
Bedford, Mrs.

1809.
Backley, Mr. D. R. (portrait of Mrs. Robinson)
Backley, Mr. Robinson
Brooke, Rev. Mr.
Blagrove, Mr.

1810.
Boynton, Capt., R.N.
Barklay, Mrs.
Barklay, Mr.
Boynton, Mrs.

N

Bourke, Mr.
Bouverie, Capt., R.N.
Barklay, Miss L.

1811.

Brown, Mr. R.
Blosse, Sir Robert
Bulkley, Mrs.
Brisco, Lady (Crofton Hall, Cumberland)
Bristow, Mr.
Buller, Master

1812.

Blunt, Sir Charles
Boulton, Mrs.
Brander, Mrs.
Beddome, Mr.
Bernard, Mr.
Buxton, Miss
Burls, Mr. Charles
Barton, Lieut.-Col.
Burls, Mrs. Charles
Barton, Mrs. Col.
Bradley, Mr.

1813.

Brinkwood, Mr.
Bridge, Mr. James
Bootle, Mr. Wilbraham

1775.

Cornebus, Capt.
Combes, Capt.
Cox, Mr. Bethell
Carr, Mrs. (Old Burlington Street)

1776.

Cox, Mr., Sen.
Chambers, Lady
Christian, Miss
Chasemore, Mr.
Chambers, Mr. J.
Chambers, Master G.
Chambers, Sir William (5)
Chambers, Mrs. John
Chauner, Mr.
Cummings, Mr.
Chambers, Miss Sabina
Chambers, Miss C.

Chaloner, Mrs.
Chambers, Miss L.
Caldicote, Mrs.
Carr, Mrs. (6)
Cuthbert, Mr.
Coney, Miss
Clarges, Sir Thomas
Cornwallis, Mrs.
Charlton, Miss Georgina
Charlton, Mr.
Cummings, Rev. Mr.
Cumming, Miss
Cumming, Mrs.
Cumming, Mrs., Sen.
Cruttendon, Mr.
Cumming, Mr.

1777.

Coltman, Mr.
Coltman, Mrs.
Callogan, Mr.
Cox, Mrs. (as Venus)
Cox, Mrs. B.
Colebrook, Mrs.
Chetwyn, Mr.
Chetwyn, Mrs.
Courtney, Mrs.

1778.

Carver, Rev. Mr.
Churchill, Mr.
Cumming, Miss
Compton, Miss P.
Chisholm, Mr.
Chisholm, Mr. C.
Covert, Miss
Colebrook, Mrs.
Colebrook, Miss L.
Combes, Capt.
Carter, Mrs.

1779.

Colebrook, Mrs.
Campbell, Lord F.
Campbell, Mrs.
Cox, Mrs. R.
Craig, Mr.
Cadogan, Lady
Crozier, Mr.
Carr, Mrs. (a drawing)
Chambers, Mrs.

Carter, Mrs.
Craig, Mrs.
Craig, Miss
Claprosse, Mr
Cox, Mr. B.

1780.

Collingwood, Mr.
Christie, Mr.
Calley, Mrs.
Crowe, Major
Chad, Mrs.
Chamberlayne, Mr. S

1781.

Cresswell, Mr. (Doctors Commons)
Carr, Miss
Campbell, Capt.
Cadogan, Lady
Churchill, Capt.
Caldicote, Mr.
Cobb, Miss (Margate)
Cavenhagh, Mr.
Cox, Mr. Sen.
Chad, Mrs.

1782.

Courtney, Mrs.
Chambers, Sir William
Cox, Master Bethell
Cunliffe, Lady
Churchill, Capt.
Chambers, Mrs. J.
Christie, Master
Cadogan, Lady
Cadogan, Lord
Cobb, Mr.
Cross, Mrs.
Cooke, Miss
Churchill, Mrs.

1783.

Cadogan, Lady
Crowther, Mr.
Cowall, Capt.
Caithness, Lord
Christie, Mr.
Crowden, Capt.
Capstick, Mr.

1784.

Cadogan, Master
Christie, Mrs.
Cergat, Capt. T.
Cox, Mr. (Lincoln's Inn)
Cobb, Mr. (Margate)
Cobb, Mr. (Ireland)
Cains, Capt.
Cunningham, Master
Caldwell, Capt.
Church, Miss.
Crawchey, Mr.
Conway, Capt. G.
Cyler, Miss
Coffin, Mr. T.
Coffin, Capt.
Churchill, Capt.
Clarke, Miss
Chew, Mr.

1785.

Carter, Mrs.
Christie, Miss
Christie, Miss S.
Chambers, Capt.
Chambers, Miss L.
Collyer, Mr.
Clive, Miss
Campbell, Mr.
Cobb, Mr.
Cleveland, Miss
Channing, Miss
Colliton, Mr.
Creighton, Mr.

1786.

Cookson, Miss
Culverden, Mrs.
Colt, Mr.
Coffin, Mr.
Coffin, Miss
Carr, Rev. H.
Cergat, Capt.
Crewe, Mr.
Crespigney, Mr.
Carnivale, Master
Creythorn, Mr.
Cavenhaugh, Mrs.

1787.

Colvin, Mr.
Cookson, Miss

Clarke, Mr.
Crosse, Mrs.
Cox, Mr., Sen.
Compton, Lord
Colville, Mrs.
Crowther, Mr.
Chamberlain, Rev. Mr.
Clavering, Capt.
Clarke, Miss
Cooper, Capt.

1788.

Cumming, Miss
Cale, Miss
Cookson, Mrs.
Crompton, Mr.
Corbyne, Mrs.
Charlton, Mrs.
Crawley, Mr.
Courtney, Mrs.
Curson, Mr.
Cowall, Capt.
Chobbam, Mr.
Church, Mrs.
Crawford, Mr.
Cotton, Capt.
Carter, Rev. Dr.
Clark, Mr.
Clarke, Mr. T.

1789.

Clifton, Miss
Culverden, Mrs.
Campbell, Mrs.
Campbell, Mr.
Crane, Mr.
Chapman, Mrs. (Miss Horsley Whiteman)
Clifton, Mr.
Crespigney, Mr.
Cholmondely, Miss
Colley, Mrs.
Colley, Mr.
Calcraft, Mr.
Carden, Mr.
Crane, Mr.
Colvin, Mrs.
Colvin, Master F.
Clarkson, Mrs.
Caske, Capt.

Chamberlayne, Mr.
Cleves, Mrs.

1790.

Corner, Capt.
Cooper, Rev.
Craven, Mrs.
Curtis, Mr.
Clarke, Miss
Caldicote, Mrs.
Charnock, Mr.
Cotterell, Major
Coleman, Mr. G.
Church, Capt.

1791.

Cage, Mr.
Coltman, Mr.

1792.

Cage, Mr.
Crawford, Mr.
Coffin, Mr.
Cockerell, Mr.

1793.

Cockerell, Mrs.
Cole, Miss
Clarke, Mr.

1794.

Cotton, Mrs.
Christie, Capt.
Campbell, Mr.
Campbell, Mrs.
Church, Mr.

1795.

Cox, Mr.
Cole, Major
Chalmers, Miss
Cockran, Mr.
Coulthurst, Mrs.
Cresswell, Mr.
Campbell, Mrs.
Cresswell, Mr. H.
Campbell, Major
Cree, Mrs.
Christian, Admiral
Cooke, Mrs.
Christopher, Miss

1796.

Clayfield, Mr.
Clayfield, Mrs.
Cathmore, Mr.
Coulston, Miss
Clackie, Capt.
Collins, Rev. Mr.
Currie, Mrs.
Campbell, Mrs.
Cooke, Mr.
Claxton, Mr.

1797.

Cassallis, Lord
Claxton, Mr.
Cox, Mr.
Clarke, Mr.
Coulston, Rev. Mr.
Coulston, Miss

1798.

Carter, Miss
Congreve, Miss
Cardwell, Mrs.
Coulston, Miss J.

1799.

Cherry, Mrs.
Cherry, Master G.
Charnock, Master
Crompton, Mr.
Christie, Rev. Mr.
Corsbie, Mr., Jun.
Clinton, Miss
Charnock, Mrs.
Chester, Lieut.-Col.
Christian, Admiral Sir H.

1800.

Conran, Lieut.-Col.
Colquhoun, Master
Cox, Mr. B.
Clarke, Mr.
Campbell, Capt.
Clayton, Lady
Crompton, Mr. John
Cresswell, Mr. T.

1801.

Cathcart, Capt.

1802.

Coulston, Miss
Chapman, Mrs.
Cambridge, His Royal
 Highness Duke of
Curtis, Mr.
Curtis, Master
Cooper, Miss
Campbell, Mr. John
Claxton, Mrs.
Cotterel, Sir Clement

1803.

Cameron, Capt.
Cale, Sir William
Cale, Mr. George
Clarke, Miss G.
Clayton, Mr.
Craigie, Capt.
Cochrane, Hon. Capt.
Coore, Miss
Clarke, Rev.

1804.

Curtis, Mrs. W.
Coore, Miss
Curtis, Master
Call, Mr. H.

1805.

Curtis, Mr. T.
Cruttenden, Mr. Edward
Cuppage, Col.
Call, Capt.
Claxton, Mrs.
Cummings, Capt.
Cummings, Major
Carnegie, Capt.

1806.

Croasdale, Mr.
Cunninghame, Capt.
Curtis, Mr. C.
Cruttenden, Mr. Edward
Carnegie, Capt.
Carnegie, Mrs.

1807.

Cresswell, Mr. Richard
Collier, Capt.
Cherson, Mrs.
Courthorp, Mr.

1808.

Cooper, Mr.
Cowper, Mr. S.
Coore, Mr.
Cartwright, Mr. John
Coventry, Hon. Mr. T
Constable, Rev. Mr.
Calvert, Capt.
Chamberlayne, Miss
Claxton, Mr., Jun.

1809.

Creed, Mr.
Campbell, General

1810.

Campbell, Mr.
Curties, Mrs.
Curties, Mary
Cavan, Lord
Cartwright, Mr. John
Carter, Mrs.
Collyer, Capt.
Caldwell, Miss
Campbell, Vice-Admiral
Campbell, General
Curties, Doctor

1811.

Constable, Mrs.
Croft, Mrs. T.
Cocks, Capt. T. S.
Cocks, Major S.
Curtis, Capt.
Cocks, Mr. J. S.
Curtis, Mrs. Capt.
Cavendish, Mrs.
Croft, Mr. John
Curran, Col.

1812.

Campbell, Lieut.-Col
Cochrane, Hon. A.
Curtis, Miss M.
Collyer, Col.
Cochrane, Sir Thomas
Cole, Mr. (at Mr. Robin-
 son's)

1813.

Curtis, Mr. Timothy
Constable, Mrs.

1775.

Drummond, Mr. Hay
Drummond, Miss Sophia
Drummond, Miss
Drummond, Mr. Henry
Drummond, Master H.
Dubois, Miss (Smithfield)

1776.

Dempster, Mr.
Dempster, Mrs.
Dillon, Mr.
Duncomb, Miss
Drummond, Master F.
Drummond, Miss
Dubourg, Lady Augusta
Dunlop, Mr.

1777.

Diggle, Rev. Mr. (Esher)
Drummond, Mrs. Sophia

1778.

Dubois, Miss
Darley, Mr.
Day, Lady
Dalrymple, Col.
Drummond, Mr.

1779.

Derby, Lord
Dering, Lady
Dering, Master R.
Dering, Miss
Dawson, Lady Caroline
Dering, Mr. Edward
Dyke, Master
Drummond, Mr. G.
Dawson, Mrs.
Dominica, Miss
Digby, Miss
Daws, Mrs.
Doyley, Col.
Dowdeswell, Col.

1780.

Dod, Mrs.
Dering, Miss·C.
Dalton, Capt.
Dolbon, Mrs.

Drummond, Mr. Henry,
 Jun.
Drummond, Miss
Dyer, Mr.
Drury, Capt.

1781.

Dubois, Mrs.
Dawes, Mrs.
Drummond, Mr. Andrew
Doyley, Mrs. T.
Daley, Mrs.

1782.

Drummond, Mr. G.
Drummond, Mrs.
Dering, Miss
Dalrymple, Mr. H.
Dodsworth, Miss
Dodsworth, Miss M.
Darley, Miss C.
Duay, Capt.

1783.

Dornford, Mrs.
Dornford, Capt.
Darell, Capt.
Drummond, Mr. John
Drummond, Miss G.
Drummond, Mr. H.
Drummond, Mr. Hay
Drummond, Mrs. Hay
Devis, Mrs.
Dehaney, Mr.
Delaney, Capt.
Diggle, Mrs. (Esher)

1784.

Delaney, Col.
Daley, Mr.
Diggle, Mr.
Day, Mr. (a copy)
Drummond, Mr. G. W.

1785.

Drummond, Master G.

1786.

Davis, Mr.
Drummond, Mr. H., Jun.
Drummond, Lady E
Drummond, Miss H.

Drummond, Mrs. H.
Donne, Mr.
Dobree, Mr.
Downshire, Duchess of
Dinnis, Mr.
Dinnis, Mrs.
Dundass, Mr.

1787.

Davis, Sir John
Davis, Lady
Dewar, Mr.
Dawson, Mr.
Dundass, Mr.
Dymock, Mr.
Drax, Miss
Delaney, Miss
Dickinson, Mr.
Duval, Mr.

1788.

Drummond, Miss
Davie, Miss
Douglas, Mr.
Drummond, Mr. John
Drummond, Mr. W.
D'Oyley, Lady
Douglas, Mrs. (Miss Wins-
 low)
Douglas, Capt.
Dundas, Mr.
Devonshire, Duchess of
Devonshire, Duke of

1789.

Duodee, Madame
Duncomb, Miss
Drummond, Mr. Chas.
Dair, Lord

1790.

Dempstre, Capt.
Dempstre, Mrs.
Dundas, Capt.
Dorien, Mr. M.
Dudley, Rev. Bate
Dowdswell, Mrs., Sen.

1791.

Day, Capt.
Dillon, Hon. Mr.

Douglas, Hon. Mr. D.
Denton, Miss
Denton, Mrs.
Darell, Miss

1792.
Dent, Mrs,
Douglas, Mrs,
Dent, Master
Dent, Miss
Dent, Miss Charlotte

1793.
Dawson, Capt.
Dicke, Master Robert
Dobree, Mrs.
Dicke, Master William
Duor, Mr.
Dupuis, Rev. Mr.
Dundas, Major Gen. Thos.

1794.
Dillon, Mr.
Dillon, Mrs.
Dubisson, Mr.
Dobignon, Miss
Drummond, Mrs.
Delaney, Mrs., Sen.
Davis, Miss
Dauncey, Mr. B.
Dundas, Col.

1795.
Dewar, Major
Deffell, Miss
Deffell, Miss A.

1796.
Duggin, Capt.
Dowall, Mr.
Dundass, General
Dupuis, Mr.

1797.
Dubrough, Capt.
Delmer, Mr.

1798.
Downman, Mrs.
Dalton, Mrs.

Donne, Capt.
Delmer, Mr. E. H.

1800.
Delmer, Lady
Dottin, Capt.
Drummond, Capt
Dearsley, Miss

1801.
Dixon, Mr.
Donne, Mr.
Dearsley, Miss

1802.
Davis, Mrs.
Deffell, Miss
Davis, Mr.

1803.
Davis, Lieut.
Downes, Master
Drake, Mrs.
Dunlop, Mr.

1804.
Dick, Capt.
Darlington, Lord

1805.
Deffell, Mr., Jun.

1806.
Donne, General
Daniel, Rev. Mr.

1807.
Delaney, Capt.

1809.
Duckenfield, Capt.
Dick, Mr. Quinton

1810.
Drury, Master
Daniel, Miss

1811.
Davenport, Mrs.
Davenport, Mr.
Dewar, Mr.
Duckenfield, Sir Nathaniel

1812.
Drake, Mr. T. Tyrwitt

1813.
Dalziell, Miss (very ill)
Davison, Mrs.

1775.
Elliott, Mrs.

1776.
Engleheart, Mr. F.

1778.
Estcomb, Mr.
Estcourt, Mr.

1779.
Escott, Mr.
Escott, Mrs.

1780.
Engleheart, Milly D.
Engleheart, G. (my own portrait)

1781.
Ewen, Mr. John
Erskin, Mr.
Eastcott, Miss

1782.
Engleheart, L. D.
Engleheart, Mrs.
Edmondstone, Mr., Jun.

1783.
Elliott, Miss
Elliott, Mrs.
Engleheart, Lucy D.

1785.
Ellis, Mr.

1786.
Engleheart, Lucy D.

1787.
Egerton, Mrs.
Edom, Master
Engleheart, M. D.

1788.

Evatt, Mrs. (a ring)
Engleheart, Mrs. George
 and Emma

1789.

Egerton, Mr.
Engleheart, Mrs. George
 and Emma
Elliott, Miss
Edgar, Miss

1790.

Evans, Mr.
Evans, Mrs.
Evans, Miss
Evelyn, Miss
Engleheart, M. D.
Edward, Prince

1791.

Erskine, Sir William
Engleheart (my son George)
Engleheart, Lucy D.
Engleheart, Mr. D.
Engleheart, Mrs. J. D.
Engleheart (my son Nathaniel)

1792.

Elmer, Mr.

1793.

Egmont, Lady
Ellis, Mr.
Engleheart, G. (my own portrait)

1795.

Elphinston, Mr. C.
Erskine, Col.
Engleheart, Lucy D.
Engleheart, Mill D.

1796.

Erskine, Sir William, Bart.
Evans, Mr.
Eyre, Mr.
Engleheart, Mr. J. D. C.

1797.

Engleheart, Mr. G.
Engleheart, Mr. J. D.

1798.

Engleheart, Mrs. D.
Elphinston, Capt.
Engleheart, Emma
Engleheart, Nathaniel

1799.

Ellis, Mr.
Eyres, Mr.

1800.

Erskine, Col.
Engleheart, M. D.

1801.

Elliot, Lieut.-Col.
Erskine, Mr.

1802.

Eccles, Mr.
Engleheart, George (for self)

1803.

Engleheart, G. (self)
Engleheart, Nathaniel (lost)
Engleheart, Emma
Engleheart, Mrs.
Engleheart, G. (self, for George, lost)

1804.

Erskine, Mr.

1805.

Engleheart, Henry
Engleheart, Emma
Edwards, Mr. Mostyn
Eaton, Mr. R.

1806.

Engleheart, Nathaniel
Engleheart, Emma

1807.

Engleheart, Mrs.
Engleheart, G. (self—two drawings)

1808.

Elphinstone, Capt.

1809.

Engleheart, N. B.
Ewart, Capt.
Ellis, Mr.
Eyle's, Mrs. (eye)

1810.

Engleheart, Emma

1811.

Erskine, Lord (Lord Chancellor)
Erskine, Miss
Edwards, Dr.
Eppes, Mr.

1813.

Engleheart, G. (drawing of self for Mr. Tomkins)

1775.

Fouquier, Mr.
Frazer, Mrs.

1776.

Ferrers, Lord
Faithful, Rev. Mr.
Fordyce, Mr.
Freman, Miss

1777.

Farnell, Mr.
Farrell, Rev. Mr.
Furgusson, Mrs.
Fordyce, Mrs.
Forster, Mrs.
Fortescue, Mrs.
Festing, Mrs.

1778.

Farrell, Rev. Mr.
Frederick, Mrs. (2)
Fotheringham, Mr.
Faucett, General

1779.

Farrell, Miss
Forbes, Mrs.
Forbes, Doctor
Fisher, Miss

96

GEORGE ENGLEHEART.

1780.

Fletcher, Col.
Fyffe, Mr.
Fuller, Rev. Mr. (Clapton)
Fortescue, Hon. Mr.
Fauconberg, Lord (2)
Fitzgerald, Capt.

1781.

Fouquier, Mrs.
Fowlis, Sir Wm., Bart.
Fowlis, Mr. T.
Finers, Rev. Mr.
Forster, Mrs.
France, Miss

1782.

Forster, Mrs. (2)
Fotheringham, Col.
Fryer, Mrs.
Fitzgerald, Miss

1783.

Ferrers, Mrs.
Fraser, Mrs.
Fenn, Mr.
Fenn, Mrs.
Finmore, Mrs.
Fitzgerald, Miss
Feilding, Lord
Fendall, Mrs.
Fraser, Miss
Fraser, Mr. John
Fraser, Capt.

1784.

Fraser, Capt.
Felton, Miss
Frewen, Mr.
Franklin, Mr.
Frederick, Mrs.
Ford, Capt.

1785.

Fernside, Miss
Ford, Mrs. (2)
Ford, Capt.
Franks, Mr. (Teddington)
Fullerton, Mr.
Fraser, Capt.
Fisher, Miss (2)

Fynne, Mrs.
Ferrar, Mrs.
Fendal, Mrs. (2)
Fendal, Miss (3)

1786.

Frankland, Lady
Fendal, Mrs.
Ferrers, Mrs. (her eye)
Fendal, Miss, Jun.
Fisher, Miss (copied)
Ford, Mrs.
Forbes, Lady
Frazer, Capt.
Freeman, Mrs. (3)
Fitzwater, Miss

1787.

Francis, Mr.
Fazakerley, Mrs.
Filmer, Lady
Filmer, Miss
Franks, Mrs.
Franks, Miss
Fuller, Mrs.
Fane, Mr.
Fisher, Mr. John
Freemantle, Capt.
Fitch, Mr.
Forster, Lady E. (3)
Fisher, Mr. T.
Fendall, Miss

1788.

Fisher, Mrs. John (2)
Fitzgerald, Lord Robert
Fletcher, Mr. Richard
Faucett, Capt.
Ferrers, Mrs.
Freemantle, Miss
Fraser, Capt.
Fane, Lady Susan (2)
Forster, Lady E.
Fish, Mr.

1789.

Fisher, Mr.
Fisher, Mr. T.
Freeman, Mr. C.
Fuller, Mr. George
Forster, Mrs.

1790.

Freemantle, Capt.
Fitzherbert, Mrs.
Fortescue, Capt.
Früling, Mr.
Fitzpatrick, Col.
Forbes, Mr.
Forbes, Mrs.
Forbes, Miss
Fitzgerald, Miss
Fane, Lady E. (2)

1791.

Fitzgerald, Lord R.
Ferrers, Mr.
Farren, Miss

1792.

Ford, Mrs.
Furgesson, Mr.
Fisher, Mr.
Foreman, Mr.
Fuller, Mr.

1793.

Field, Mrs.
Field, Mr.
Furgesson, Mr.
Furgesson, Mrs.

1794.

Fitzgerald, Capt.
Flowers, Miss
Foote, Mrs.

1795.

Finch, Miss
Finlay, Capt.

1796.

Foulkes, Mr.
Forbes, Mrs.
Francis, Mrs.

1797.

Fergusson, Lieut.-Col.

1798.

Fuller, Capt.
Freemantle, Sir W. Bart.

1799.

Foote, Miss
Foote, Mrs.
Fittess, Mr.

1800.

Fox, Miss
Field, Mr. George
Field, Miss
Field, Mrs. George
Fuller, Mr. Richard
Field, Mrs.

1801.

Fitzgerald, Mrs.
Forbes, Mr.
Fergusson, Col.
Freeman, Capt.

1802.

Flint, Mr.
Fillot, Mr.
Fitzroy, Rev. Lord Henry
Fish, Mrs.

1803.

Fletcher, Miss
Fletcher, Mr. E.
Fletcher, Mrs. E.
Free, Mr. Peter
Farquharson, Mr.

1804.

Fotheringham, Capt.
Founerson, Mrs.

1805.

French, Miss Bogle

1806.

Fraser, Mr. James
Fleming, Mr.
Farquharson, Mr.
Frazer, Lady (3)

1807.

Forbes, Mr. G.
Frazer, Lady
Fermor, Lieut.-Col.

1808.

Fotheringham, Major
Flint, Mrs.
Flint, Capt. G.

1809.

Fitzroy, Hon. C.
Ferdinand VII. (King of Spain)

1810.

Farrar, Mr.
Frazer, Mr. W.
Frazer, Mrs. Wm.
Frazer, Mrs., Sen.
France, Mrs.

1812.

Forster, Hon. Col.

1775.

Gardner, Master
Gybbs, Mrs.
Gardner, Rev.

1776.

Grant, Master
Grant, Mr.
Gabriel, Angel
Gordon, Duke of

1777.

Game, Mr.
Grile, Mr.
Goodwyn, Mr.

1779.

Gale, Mr.
Gass, Miss

1780.

Grant, Capt.
Gooseting, Mrs.
Glendinning, Capt.
Godfrey, Mr.
George, Rev.
Grimstone, Mrs.
Griere, Mrs. (3)

1781.

Griere, Mr., Sen.
Grove, Capt.
Graham, Miss
Goddard, Mrs.
Grant, Mrs.
Grant, Miss

Guy, Miss
Gibson, Mrs., as Cecilia
Gregory, Mr.

1782.

Griffiths, Mr.
Godwyn, Gen.
Gibson, Mrs.
Gurling, Capt.
Griere, Mr. (4)
Galway, Mrs. Payne
Gildart, Mr.
Gibson, Mr.
Goodyear, Mr.
Grimwood, Mr.
Guy, Mrs.

1783.

Griere, Mrs.
Grigby, Capt.
Gale, Capt.
Gardner, Mrs.
Gordon, Mr.
Garth, Col.
Gardner, Mr.
Goodyear, Mrs.
Geldart, Miss
Griere's, Mrs., niece
Gregory, Mr.

1784.

Gibbons, Lady
Gordon, Mr.
Gamell, Mr.
Gowland, Mr.
Gold, Mrs.
Graves, Mr.
Gray, Capt.
Gale, Mrs.
Gray, Mrs.
Gardiner, Mr.

1785.

Gray, Mr.
Gray, Mrs.
Gregory, Mrs.
Graham, Mrs.
Graham, Miss
Gosling, Miss
Gore, Miss
Gale, Mrs.

O

Goosetrey, Mr.
Gregor, Mr.

1786.
Gildart, Mr.
Gardner, Miss
Gregory, Mrs.
Grant, Capt.
Gersomer, Mr.
Grady, Mr.
Gardner, Rev. Mr.
Greville, Capt.

1787.
Gregson, Mr.
Gausson, Mr.
Gregor, Mrs.
Goodyere, Mr.
Gardner, Mrs.
Gideon, Sir Sampson
Grote, Mrs.
Gosling, Mr.
Gowland, Mr.
Gloom, Miss

1788.
Gregory, Mr.
Grote, Miss
Glover, Miss
Gordon, Mrs.
Grosvenor, Mr. F.
Gosling, Mrs.
Grosvenor, Mr. R.
Griere, Mrs.
Gordon, Mr.
Greathead, Rev.
Greathead, Mrs.
Goodyere, Capt.

1789.
Gregor, Rev. Mr.
Grote, Mr.
Gascoine, Mr. G.
Gauson, Mrs.
Gage, Major
Gregor, Mrs.
Grady, Mrs.
Gibbons, Mr.
Gurley, Master

1790.
Grimstone, Mrs.
Gambier, Mr. C.

Gosling, Mrs., Sen.
Groves, Mrs.
Gerrard, Capt.

1791.
Gregory, Capt.
Gilbert, Miss
Gerrard, Sir Robert
Graves, Capt.
Grote, Miss
Glencairn, Earl
Greene, Mrs.
Gresley, Miss
Goble, Mr.
George, Miss

1792.
Green, Mrs.
Gladwin, Mr.
Gaston, Mr.
Gerrard, Capt.
Garrard, Mrs.

1793.
Green, Mrs.
Gildart, Miss
Gosling, Mr.
Gibson, Miss
Gordon, Capt.
Goddard, Rev.

1794.
Gausson, Miss E.
Grant, Mr.
Gregor, Mr.
Gregor, Mrs.
Grosvenor, Col.
Godfrey, Mr.

1795.
Gilbraith, Miss
Gowan, Miss
Griffith, Capt.

1796.
Green, Mrs.
Green, Rev.
Granville, Mrs.
Granville, Mr. Wm.
Garret, Capt.
Gray, Col. T.
Griffith, Capt.

Gregor, Mrs.
Garrick, Mrs.
Goddard, Mrs.
Gillet, Mrs.

1797.
Gordon, Mr.
Grote, Mr.
Goldthorp, Mrs.
Gray, Col.
Gray, Col. T.

1798.
Georges, Mr.

1799.
Gordon, Capt.
Gillespie, Mr.
Garret, Capt
Gibson, Capt.
Graham, Mr.

1800.
Grey, Sir Charles
Goddard, Mrs.

1802.
Graham, Mr.
Gurney, Mr.
Gordon, Mr.

1804.
Gordon, Mrs. Hope
Graves, Lord Admiral, K.B.

1805.
Grace, Miss
Gosling, Mr.

1806.
Garling, Master (dead)

1807.
Gerard, Col.
Gordon, Mrs. Hesse
Gibbons, Miss
Gordon, Mrs.

1808.
Grove, Mr.
Grant, Mr.

1809.
Gosselin, Capt.
Gordon, Mrs. Col.

Gaillard, Capt.
Georges, Capt.
Germands, Mr.

1810.

Gordon, Mrs. Col.

1811.

Graves, Ad. (Copd.)
Gregory, Capt.
Girdler, Miss
Gregorie, David
Gregorie, Mrs.

1812.

Gregorie, Miss Catherine

1813.

Gregorie, Mr. George
Garry, Mr.

1775.

Harvey, General (Chorland)
Humphreys, Miss
Hale, Mrs.

1776.

Hale, Mrs.
Herries, Mr.
Heathcott, Rev.
Hodgson, Mrs.
Hodgson, Miss
Heathcote, Mr.
Hesse Mrs.
Hobart, Mrs.
Harvey, Mrs.
Hobart, Mr.
Hay, Mr.

1777.

Hays, Master
Herries, Mrs. William
Hodgson, General
Hume, Mr.
Hume, Mrs. (after death)
Hackson, Miss M.
Hackson, Miss
Hogarth, Mr.
Hobcraft, Mr.

1778.

Haverfield, Mr.
Hyde, Mrs. (Mr. J. Whitbread)
Hardinge, Mrs.
Harvey, Mrs. (Marylebone)

1779.

Hankey, Mrs.
Holford, Miss
Harley, Miss
Hennard, Mrs.
Hodgson, Capt.
Hartley, Mrs.
Hilliard, Mr.
Hilliard, Mrs.

1780.

Hume, Mrs. (dead)
Hughes, Major
Hurd, Capt.
Hobart, Miss
Harley, Miss A.
Harley, Miss
Hultz, Col.

1781.

Harley, Miss M.
Harley, Miss J.
Harley, Miss E.
Hodgson, Miss
Hall, Mrs.
Hilliard, Lady
Hale, Mrs.
Holland, Mr. Henry
Herbert, Mrs.
Hardinge, Mrs.
Haynes, Mr.
Hussey, Miss

1782.

Hughes, Miss
Hamilton, Lady Tra
Hamilton, Mr.
Hodson, Mr.
Hardinge, Mrs.
Hughes, Rev. Mr. Q.
Haldane, Capt. H.
Holland, Mr., Jun.
Hardwick, Mr. T.

1783.

Hearn, Miss
Herries, Mr. C.
Hearn, Mrs.
Hall, Miss
Hilliard, Capt.
Harley, Alderman
Hewitt, Miss
Hugill, Capt.
Harrison, Miss
Harley, Miss E.
Harrison, Miss E.
Harper, Mrs.
Harper, Col.
Harper, Miss

1784.

Hale, Sir Edward, Bart.
Hatton, Sir Thomas, Bart.
Hewitt, Capt.
Harper, Mrs.
Harvey, Rev. Mr.
Hallet, Mr.
Hale, Col.
Heath, Capt.
Harvey, Mrs.
Hinde, Rev.
Haywood, Mr.
Hopkins, Mr. Bond
Hill, Capt.
Hill, Mrs.

1785.

Hinde, Capt.
Harvey, Mrs.
Hamilton, Honbl. Mr.
Hilcoat, Capt.
Hallet, Master
Hamilton, Mr.
Hammond, Miss
Hardwick, Mr., Sen.
Hawkins, Mrs.

1786.

Hibbert, Mrs.
Hornby, Governor
Herbert, Mrs.
Hallet, Mr.
Harris, Mr. Q.
Hamilton, Miss

O 2

Hamilton, Capt.
Harvey, Mr.

1787.
Harvey, Mrs.
Hornby, Governor
Hamilton, Capt.
Hotham, Capt.
Holdemand, Sir Frederick
Hornby, Mrs.
Holmes, Mrs.
Hawker, Mr.
Hodgson. Miss
Hill, Mrs.
Hampson, Mr.
Hibbert, Mrs.
Home, Mr.
Hoste, Mrs.

1788.
Haggerston, Lady
Hoane, Mrs.
Hanbury, Mrs.
Harley, Dr. (Bishop of Hereford)
Hasilrygge, Major
Halliday, Mrs.
Hamilton, Capt.
Howard, Rev.
Haines, Mrs.
Halliday, Capt.
Hamilton, Lord W.
Hawkins, Miss
Hambley, Rev. Mr.
Hoare, Mrs.
Harris, Mr.
Harris, Mrs.
Hutchinson, Miss
Hankin, Mr.

1789.
Holford, Mr.
Howard, Lady Elizabeth
Howard, Hon. Mr.
Hallet, Mr.
Hamilton, Rev. Mr.
Hutchinson, Capt.
Heyland, Mr.

1790.
Hoare, Mrs.
Hamilton, Rev. Mr.

Henderson, Mr.
Hepburn, Mr.
Henney, Mr.
Hotham, Miss
Howell, Mr.

1791.
Harper, Mrs.
Harvey, Mr.
Hamilton, Lord A.
Hurst, Mr.
Hawkins, Mrs.
Horneck, Miss
Horneck, Miss E.
Henderson, Mr.

1792.
Hunter, Mr.
Henderson, Miss
Hanson, Mr.
Henderson, Miss G.
Heyton, Miss
Hammet, Lady
Harris, Miss
Howard, Mr.

1793.
Hankey, Mrs.
Hobhouse, Mr.
Hobhouse, Mrs.
Hornby, Mr. N.
Hornby, Miss
Heathfield, Lord
Hyde, Mr.
Hennings, Mr.
Haldane, Capt.
Haldane, Mrs.

1794.
Hankey, Mr.
Hounsome, Mr.
Hankey, Miss
Hankey, Mrs.
Haverfield, Miss
Hornby, Governor
Hamilton, Capt.
Halmaking, Lady
Haywood, Mrs.

1795.
Hall, Capt.
Hammond, Mr.

Humphrey, Rev. Mr.
Hornby, Governor

1796.
Harrington, Miss
Harrington, Miss M.
Howison, Col.
Harvey, Lord
Hooke, Miss
Hull, Capt.
Hotham, Mr.
Haverlocke, Lady
Hounsome, Mr.
Harman, Mrs.
Hagg, Mr.

1797.
Hartley, Mr.
Hyatt, Mr.
Hamilton, Mr.
Hornby, Mr.
Hublon, Mr.
Hesketh, Sir Thomas

1798.
Hay, Capt.
Hotham, Lieut.-Gen

1799.
Hotham, Capt. Henry
Houlton, Capt.
Houlton, Mr.
Houlton, Mrs.
Hay, Capt.
Hamilton, Lord
Hull, Mr.

1800.
Hamilton, Mrs.
Hanbury, Mr.
Hodges, Mr.
Hill, Rev. Mr.
Hamilton, Mr., Jun.
Hamilton, Mr., Sen.

1801.
Hamilton, Lord A.
Higgins, Mr.
Higgins, Mrs.
Hale, Mr.
Hamilton, Mr. J.
Halliday, Capt.

Henry, Mr.
Hoare, Capt.

1802.

Hartley, Mr.
Hoskins, Sir H.
Hill, Mrs.
Hotham, Rev. Mr.
Hoskins, Miss
Hunt, Mr.

1803.

Hoskins, Sir H.
Hamilton, Mr. Augustus
Hamilton, Capt.
Halket, Capt.
Horner, Mr. F.
Hollowell, Mr.
Hamilton, Mrs.

1804.

Hamilton, Mr., Jun.
Hoskins, Lady
Hamilton, Admiral
Henniker, Mr.
Henniker, Mrs.
Hallowes, Capt.

1805.

Hallam, Capt.
Hamilton, Mr. William
Handlay, Master
Hankey, Mr. R.

1806.

Halliday, Mr.
Hereford, Mr.
Harmon, Col.
Hamilton, Mr. A.
Hunsley, Miss
Hare, Mrs.
Harris, Mr.

1807.

Henney, Dr.
Holloway, Mrs.
Holloway, Mr. John
Hebdin, Mr.
Hunt, Mr.

1808.

Hopkins, Capt.

1809.

Hayley, Mr.
Harris, Lieut.-Col.
Hunter, Capt.
Home, Sir Abraham
Haley, Mrs.
Hill, Rev. Mr.
Hutchins, Capt.
Handley, Mrs.
Hale, Mr.

1810.

Handley, Mrs.
Hepburn, Capt.
Hoare, Miss
Hudson, Mr.
Haley, Mr.

1811.

Hoare, Mr. S.
Hale, Mrs.
Home, Mr.

1812.

Holman, Mrs.
Hepburn, Col.
Huntley, Marquis of

1775.

Jones, Rev. Mr. (of Shipston)
Jones, Mrs. (of Shipston)
Irwin, Dr. John

1776.

Irwin, Mrs.
Jefferys, Miss (St. James' Street)
Jennings, Miss
Irwin, Sir John

1777.

Irvine, Sir John

1778.

Jennings, Miss
Innes, Mr.
Innes, Mrs.

1779.

Jackson, Miss

1780.

Irvine, Capt.

1781.

Irvine, Capt.
Iornis, Mr.

1782.

Innes, Mrs.
Immoff, Mr.
James, Rev. Dr.
Jones, Col. J.

1783.

Jackson, Mr.

1784.

Jones, Mr.
Johnstone, Mr.

1785.

Johnstone, Mrs.
Johnstone, Miss
Jones, Col.
Jones, Mr.
Johnstone, Mr.

1786.

Jenkins, Mr.
Immoff, Mr.
James, Dr. (of Rugby)
Jassome, Mr.
Jackson, Capt.

1787.

Johnson, Capt.
Jansome, Mrs.
Johnson, Mr.

1788.

Jelf, Miss
Jordan, Miss
Johnson, Miss

1789.

Jackson, Mr.
Jackson, Mrs.
Jackson, Miss
Johnson, Capt.
Jones, Mr.
Incledon, Mr.
Jeffereys, Miss

1790.
Jackson, Mrs.
Inglis, Mrs.
Jenkins, Mrs.
Irvine, Col.
Johnson, Capt.

1791.
Irvine, Master
Jones, Mrs.

1792.
Image, Mrs.
Jones, Miss

1793.
Innis, Mrs.
Johnson, Hon. Mrs.
Jackson, Miss
Jardine, Rev. Mr.

1794.
Inglis, Master
Jones, Mr.

1795.
Inglis, Miss
Inglis, Miss A.
Joilleux, Mrs.

1795.
Joilleux, Mrs.
Inglis, Mrs.
Johnson, Lady
Johnson, Sir William
Johnson, Miss

1797.
Johnson, Capt.
Jackson, Mr.
Inglis, Mrs.

1800.
Impy, Mr., Jun.
Johnson, Sir William
Johnston, Mr. C.

1801.
Impy, Mr.

1802.
Johnson, Miss
Izard, Mr.

1803.
Jormer, Mr. H.
Joliffe, Mr.
Izard, Mr.

1804.
Jenner, Mr. H.
Joliffe, Mr.

1806.
Inglis, Mrs.
Inglis, Mr.

1809.
Johnstone, Miss

1812.
Jervis, Capt.

1776.
Keen, Miss
Kepple, Mr.
King, His Majesty the

1777.
Kelsal, Miss

1778.
Kerr, Mrs.
King, His Majesty the

1779.
Knatchbull, Miss

1780.
Knatchbull, Mr. Ed.
Kinniard, Mr.
Kinniard, Mrs.
Knatchbull, Capt., R.N.
Knight, Mrs. (Grosvenor Square)
Kinniard, Mr. (from Spain)
Kenn, Miss
Kincaid, Mr.
Kincaid, Mrs.
Kincaid, Mr. (with family)

1783.
King, His Majesty the

1784.
King, His Majesty the

1785.
King, His Majesty the

1786.
Kaye, Master W.
Knatchbull, Mr. Edward
Kaye, Capt.
King, Mr.
King, His Majesty the

1787.
King, His Majesty the
King, Mrs.
King, Mr.
King, Miss

1788.
King, Mrs.
Keate, Doctor
King, His Majesty the

1789.
Knox, Mr. H. W.

1794.
King, Capt.
King, Lady Helena

1795.
Kilderbie, Rev.
Kemp, Miss

1797.
Kemp, Miss

1798.
Keene, Miss

1802.
Kirkman, Mr.
Kensington, Lord
Kensington, Lady

1807.
Kidd, Col.
Knox, Lord George

1808.
Knox, Mr. T.
Kirkpatrick, Capt.

1809.

King of Spain (Ferdinand VII.)
Knighton, Dr.
Knighton, Mrs.
Knighton, Miss
Knox, Hon. Mr. T.

1810.

Kitt, Mr. George

1811.

Kneller, Capt.

1812.

Kneller, Miss
Kitt, Mrs. George
Kneller, Mrs.
Kendrick, Mrs.

1775.

Lyttleton, Lord
Lyttleton, Mrs.
Lovelace, Mr.

1776.

Lemaitre, Mrs.
Lee, Master
Leslie, Capt.
Lillingstone, Miss

1777.

Loyd, Mr.
Lindsey, Lord
Lee, Miss
Leslie, Lady F.
Lyndergreen, Mr.
Leslie, Hon. P.

1778.

Leslie, Lady F.
Lushington, Mrs.
Long, Miss
Layton, Miss

1779.

Leslie, Mrs.
Legg, Mrs.
Lewis, Capt., R.N.
Leech, Miss
Lutwich, Mr.

1780.

Leech, Capt.
Lutwich, Mrs.
Lee, Miss L.
Lumsden, Lieut.
Lisle, Hon. Mrs.
Leightonhouse, Mrs.

1781.

Lennox, Mrs.
Lax, Mrs.
Locke, Mrs.
Lightbody, Miss
Lushington, Master
Long, Miss
Layer, Master Skeffington
Lancy, Rev.
Langley, Mr.

1782.

Lightbody, Mrs.
Lee, Miss
Lewis, Capt., R.N.
Long, Miss
Leslie, Mrs. (Princess Dowager of Wales, for Mrs. Leslie)

1783.

Lawrence, Mr.
Locksdale, Mr.
Lambard, Rev.
Lee, Mr. T.
Lee, Miss
Lindergreen, Mrs.
Lewis, Capt., R.N.
Lapinnodie, Mr.
Leslie, Capt.

1784.

Lowe, Miss
Le Duc, Mons.
Lawrence, Mr. (America)
Lewis, Mrs.
Lewis, Master
Lomer, Duc de
Lee, Mrs.

1785.

Lee, Sir Egerton
Lee, Capt.

Lambert, Mr.
Lambert, Mrs.
Locksdale, Mr., Jun.

1786.

Long, Mr. C.
Lowther, Mr. J.
Lucas, Miss
Long, Mr. William
Lee, Mr. Richard

1787.

Long, Mr. Chas.
Law, Mr.
Long, Mr. Dudley
Law, Mrs.
Loxdale, Miss
Long, Miss
Lightbody, Miss
Long, Mr. Samuel

1788.

Long, Mr.
Lloyd, Mrs.
Luders, Mr.
Lowndes, Mr.
Lowndes, Miss
Long, Lady Jane
Loxdale, Mr.
Long, Mrs.

1789.

Long, Lady J.
Latouche, Mrs.

1790.

Law, Mr.
Lindsay, Mrs.
Leicester, Sir John
Lloyd, Mrs.
Lee, Mr.

1791.

Llewellyn, Mr.
Legh, Mr.
Lane, Rev. Mr.
Law, Dr.

1792.

Langford, Mr.
Lloyd, Mr.

1793.
Lindsay, Capt.
Larkins, Capt.
Latouche, Mr.

1794.
Lee, Miss
Lynch, Mrs.
Law, Mr. T.
Lockhart, Mrs.

1795.
Lovaine, Mr.
Ladbrooke, Mr. F.
Laughman, Mr.
Long, Mrs.
Lewis, Mrs.
Lord, Master

1796.
Lowe, Mr., Sen.
Lyon, Mr.

1797.
Lynch, Mrs.
Latham, Mr. Ashby
Lyon, Mr.
Lynch, Mr.
Loudon, Mr. Price
Leicester, Mr. Ralph

1798.
Lewis, Miss F.
Lambert, Mr. D.
Lorne, Lord
Loughman, Mr. A.
Lafroy, Mr.

1799.
Lathom, Mr.
Lefroy, Mr.
Lawrence, Mr.

1800.
Loxdale, Mrs., Sen.
Laugham, Mr.

1801.
Loxdale, Mrs., Sen.
Loxdale, Mr.
Lyne, Capt.

1802.
Long, Rev. Mr.

1803.
Le Mesurrier, Major
Lewis, Major
Lowe, Mrs.
Lovett, Rev. Mr.

1804.
Lucas, Mr.

1805.
Lloyd, Mr.
Lowall, Mr. T.
Lygon, Capt.
Lygon, Mr.
Lucas, Mr.
Leslie, Lord William

1806.
Le Mesurrier, Mr.
Little, Miss
Little, Mr.
Liphott, Rev. Mr.

1807.
Lowall, Mr.
Levet, Rev. Mr.

1808.
Limpster, Lord
Le Mesurrier, Mrs.
Le Mesurrier, Miss
Lauderdale, Lord

1809.
Le Mesurrier, Miss
Leicester, Mrs.
Levett, Rev.
Liblane, Capt.
Le Cocq, Miss
Little, Mr. James

1810.
Lower, Mr.
Leicester, Miss

1811.
Leake, Mr.
Le Mesurrier, Alderman
Le Mesurrier, Capt.

Le Mesurrier, Mr. Benjamin
Leake, Mrs.
Lower, Mr.
Lauderdale, Lord
Lillycrap, Capt., R.N.
Lavinge, Sir Richard

1812.
Little, Major

1813.
Locke, Mrs.
Leach, Mrs.

1775.
Meadows, Mr. C.
More, Miss
Meyrick, Mrs.

1776.
Mitchell, Miss
Milbanke, Mr.
Milbanke, Sir R.
Mayne, Capt.
Milbanke, Mrs.
Morse, Mr. (Conduit Street)
Merridue, Miss
Miller, Mr.
Majesty, His (see King)
Molesworth, Miss
Morant, Miss
Morris, Miss

1777.
Morton, Mr.
Mahon, Mrs.
Mahon, Master

1778.
Molesworth, Miss
Morgan, Col.
Marriet, Miss
Metham, Sir George

1779.
Meadows, Mr.
Marriot, Mr.
Martelli, Mr.
Muir, Mrs.
More, Miss
More, Master G.
Metcalfe, Miss

Mahon, Mrs.
McLeod, Mrs.
Milbanke, Miss (dead)
Mackay, Master
Mayne, Master
McVeach, Capt.

1780.

Moseley, Mr.
Mulgrave, Lord
Miller, Mr.
Mills, Mrs.
Morgan, Mr. (Litchfield)
Mulgrave, Lord
Morthland, Mr.
Minicowe, Mr.
Mitchell, Major
Maw, Mr.
Mahon, Mrs.
Mackenzie, Mrs.
Morris, Mr.

1781.

Mathias, Mr., Jun.
Matthias, Miss
Mason, Miss
Mayne, Mrs.
Mutge, Mr.
Mathias, Mr. W.
Mathias, Master
Mutge, Mrs.
Mott, Mr.
Mills, Mr.
Moyle, Capt., R.N.
Mahon, Mrs.
Minicowe, Mr.
Moody, Mr.
Morson, Mrs.
Marsh, Mrs.

1782.

Mure, Mrs.
Monkton, Lieut.-Gen.
Mackenzie, Capt., R.N.
Monro, Mr.
Mahon, Mrs.
Mure, Mr. G.
Maxwell, Mrs.
Marriot, Mr.
Mathias, Miss V.
Mathias, Miss C.

Mann, Capt., R.N.
Mitchell, Capt.
Mathias, Mr. Gabriel
McDonall, Capt.

1783.

Mahon, Master
McDonall, Capt.
Mahon, Mrs.
Myers, Master
Mossman, Mr.
Macbeth, Mr.
Mackenzie, Miss
Manners, Lady L.
Murray, Capt.
Mure, Mrs.
Mills, Mrs.
Mason, Miss (for Capt. Stewart)
Mathias, Capt.
Minot, Mrs.
Mackie, Mr.

1784.

Mackenzie, Master
Mackenzie, Mrs., Sen.
Martin, Mrs. Byan
Molleson, Mr.
Mathias, Mrs.
Mathias, Miss
Mackrell, Miss
Mathias, His Excellency Mr.
Mackenzie, Mrs., Jun.
Mackenzie, Mr.
Mackenzie, Mrs.
Mitchell, Capt.
Manners, Lady L.
Maitland, Mr.
Mackenzie, Capt.
McLeod, Mrs.
Mathias, Mr., Sen.
Madan, Rev. Mr.
Mahan, Mrs.
McLeod, Mr.
Maule, Major.

1785.

Mason, Mr.
Mathias, Mr.
Mackenzie, Col.
McDonald, Capt.

McDonald, Mrs.
Mee, Mr.
Mackrett, Mrs.
Muirhouse, Mr.
Mathews, Miss M.
Mathews, Miss
Mathias, Mrs. G.
Mathias, Miss
Mackenzie, Mr. Humbre
McDonald, Major

1786.

Mills, Mrs.
Mannington, Mrs.
Mills, Mrs. (Old)
Mannington, Mr.
Mann, Miss
Mann, Mr.
Moxon, Mr.
Mann, Mrs.
Monro, Mrs.
McLeod, Mrs.
McLeod, Mr.
Morseman, Mr.
Maynard, Lady
Miller, Miss

1787.

Miller, Miss
Manners, Lady L.
Mason, Miss
Masterman, Mr.
Masterman, Miss
Matcham, Mrs.
Moody, Mr.
Montgomery, Master
Molleson, Mrs.

1788.

Mure, Mrs.
Moffatt, Mr.
Morris, Mr.
Mitchell, Mr.
Maxwell, Col.
McVee, Major
McDonald, Capt.
Maxwell, Mr.
Murrey, Mr.
Maxwell, Governor
Maitland, Lady
Motteaux, Mr.

P

1889.

Martindale, Mr. (a Lady for)
Moffatt, Miss
Milner, Miss
Masterman, Mr.
Masterman, Miss
Morant, Mr.
Mahon, Mrs.
Mackenzie, Capt.
Martin, Miss
Maitland, Mr.
McLane, Miss

1890.

Mackinnon, Capt.
Mackenzie, Mr.
Mackrett, Mr.
Minicowe, Mr., Sen.
Mansfield, Mrs.
Molesworth, Rev. Mr.
Milner, Lady
Mansfield, Miss
Meares, Major
Metcalf, Miss
Marshall, Mr.
McMahon, Capt.
Minicowe, Mr. Chas.

1791.

Matthews, Mr.
Matthews, Miss
Mortlock, Mr.
McDonald, Capt.
Majoribanks, Capt.
Martin, Mrs.
More, Mr.
Millett, Capt.
Monro, Mr.
Murray, Capt.

1792.

Melbourne, Miss
Maitland, Major
Mitchell, Miss
More, Mr.

1793.

Methold, Rev. Mr.
McDonald, Mrs.

Murray, Lord Charles
Metcalf, Miss
Masters, Miss
Moyle, Miss
Moyle, Mrs.
Moffatt, Miss

1794.

Mitchell, Mrs.
Mitchell, Miss E.
Marriot, Mr.
More, Major
Mason, Mr.
Maule, Mr.
Molesworth, Master
Metcalf, Miss P.
Metcalf, Miss

1795.

McTavish, Capt.
McDonald, Mrs.
Murray, Major
Morgan, Mrs. (a portrait of Mrs. Brown)
Manby, Mrs.
Manby, Capt.
Mieux, Mr. Henry
Metcalf, Miss
Maxwell, Capt.

1796.

Morant, Mr. H.
Macknab, Capt.
Mosses, Count de
Maconica, Miss
Maconica, Mr.
Maule, Mr.
Meaux, Miss
Morgan, Mr. Arthur
Mitchell's, Mrs. (eye)
McDonald, Mrs.
McDonald, Mr.

1797.

Mathias, Mr.
Maud, Mrs.
Marriott, Miss
Mitchell's, Mrs. (eye)
Maxwell, Mrs.
McDonald, Mrs.
McDonald, Miss

1798.

Mackay, Capt.
Mitchell, Mrs.
Meadows, Mrs.
Metcalf's, Mrs. (eye)
Metcalf's, Miss (eye)
Masters, Mrs.
Murray, Mrs.
Murray, Mr.
Martin, Major-General
Morse, Mr.
Minshull, Mr.
Maud, Mr.
Metcalf's, Mr. Jun. (eye)
Majoribanks, Mrs.
Majoribanks, Mr.
Monson, Mrs. (her eye)
Mackay, Mrs.
Maude, Mr.

1799.

Mills, Mr.
Motreux, Miss
Motreux, Miss L.
Meaux, Miss
Montague, Capt.
McDonald, Capt.
McDonald, Lieut.

1800.

Maitland, Capt.
Metcalf, Mrs. (her eye)
Metcalf, Miss
Murray, Capt.

1801.

Murray, Capt.
Miller, Rev. Mr.
Moir, Mrs.
Moir, Mr.
Mandenburgh, Mr.
Miller, Mrs.
Manby, Mr.
Martin, Miss J.
Mackrell, Mr., Jun.
Murray, Mrs.
Montague, Capt.

1802.

McDonald. Capt.
Murray, Mr.

Mandenburgh, Mr.
Midford, Mr.
Maitland, Mrs.
Mandenburgh, Mr.

1803.
Mackenzie, Mr.
McDonald, Mr. (of Staffa)
Murray, Capt.

1804.
Montgomery, Capt.
McDonald, Capt.
Money, Miss M.
Murray, Capt.

1805.
Maitland, General
Murray, Mrs.
Monro, Mr.
McDonald, Mr., Sen.
Munden, Miss Hesta
Munden, Mr.

1806.
Meaux, Mr. T.
Maxwell, Mr.
Malcolm, Capt., R.N.
Malcolm, Capt., Jun.

1807.
Money, Miss Emma
Malcolm, Capt.
McCall, Mr.
Morrison, Mrs.
Munn, Mr. Paul
Moffatt, Mr.
Melville, Mr.

1808.
Mowbray, Mr.

1809.
May, Master Joseph
Metcalf, Miss T.
Martin, Miss
Moseley, Lieut.
Mortlock, Capt.
Major, Mr.
Majoribanks, Mrs.

1810.
McMurdoe, Mr.
Meyrick, Mrs.
Merreweather, Rev. Mr.
Murray, Mrs. John
Maitland, General
Morris, Master

1811.
Metcalf, Mr. Theo
Mills, Miss
Malcolm, Capt. C., R.N.

1812.
Mcdonald, Mrs. (of Staffa)
Marshall, Mr.

1813.
Millet, Mr., Jun.
Masters, Rev. Mr.
Masters, Mrs.

1775.
Newton, Master

1776.
Nixon, Mr.

1780.
Nash, Capt.
Nares, Rev. Mr.
Nicholes, Rev. Dr.
Nash, Mr. C. (a Lady for)

1781.
Nicholas, Mrs.
Newport, Mr.

1782.
Newnham, Mr.
Neville, Mrs.
Nares, Mrs.

1783.
Nailor, Mrs.
Neatsmith, Sir James
Neave, Mrs.

1785.
Nason, Major
Nason, Mrs.
Nichols, Mr.
Nesbitt, Major

1786.
Northington, Lord
Newland, Mr.

1787.
Nichols, Dr.
Newton, Mrs.
Northington, Lord

1788.
Newton, Rev. Mr.
Needham, Col.
Newnham, Mrs.

1789.
Nichols, Mrs.
Nuns, Mr.

1790.
Neville, Miss

1791.
Nash, Col.

1793.
North, Master

1796.
Neville, Mrs.

1797.
Neville, Mrs.
Nilson, General

1801.
Nesbitt, Mr.

1803.
Newman, Miss
Nesbitt, Mr. (his eye)
Newman, Mr. (his eye)

1806.
Nesbitt, Lord

1807.
Nesbitt, Mrs.

1810.
Neal, Rev. Mr.
Nore, Mr.

P 2

1811.

Nicholls, Miss

1812.

Nares, Rev. Mr. E.

1780.

O'Connell, Capt.

1782.

Otley, Miss
Oxley, Mr.

1783.

O'Callahan, Capt.
Ogle, Mr. (Ireland)
Ord, Governor
Obyrn, Rev. Mr.

1784.

O'Callahan, Capt.

1785.

O'Hara, General

1787.

Oliver, Mr.

1788.

Oliver, Mr.
Oliver, Mr. (a Lady for)

1789.

Ord, Mr.

1790.

Oakes, Mr. C.
Oakes, Capt.
Oxford, Lord

1791.

Ord, Mr.
Oliver, Mr.
Oxford, Lord

1793.

Owen, Mr. Owen Smith

1794.

Oxford, Lord
Oswald, Capt.

Oswald, Mrs.
Ord, Sir John
Ord, Capt.
Ogilvy, Miss
Ord, Major

1795.

Ord, Capt.

1798.

Osborn, Mr.
Oliver, Mr. R.

1799.

Offley, Mr. Chas.

1803.

Offley, Mrs. J.

1804.

Otter, Rev. Mr.

1805.

Orr, Col.

1807.

Offaney, Major

1808.

O'Brien, Capt.

1809.

Osborne, Capt.

1812.

Oxford, Lord

1775.

Pitt, Mrs.
Prole, Mr.

1776.

Pugh, Mr.
Powell, Mr. (St. James'
 Street)
Pelly, Capt.
Pinson, Mrs.
Paulet, Mr.
Paulet, Mrs.
Pierson, Miss
Pierson, Mrs.

1777.

Pierson, Mr.
Pearson, Mrs.

1778.

Petrie, Miss
Pelham, Mr.
Palmer, Mrs.
Pennington, Mr.
Parsons, Miss
Pearson, Miss J.

1779.

Plastow, Mr.
Potter, Mrs.
Polhill, Mr.
Pinton, Mrs.
Payne, Mr.
Parker, Mrs.
Payne, Miss F.
Payne, Miss E.
Pigott, Mr.
Pigott, Mrs.

1780.

Phipps, Col.
Potter, Mr. P.

1781.

Pott, Miss
Pigott, Mrs. (Kew)
Pott, Miss E.
Petre, Mr., Jun.
Petre, Miss
Petre, Mr., Sen.
Petre, Mrs.
Percival, Lady M.
Pulleyne, Miss
Pennant, Mrs.
Pears, Mrs.
Pott, Miss
Payne, Mr. J.
Ponsonby, Miss
Prescott, Mrs.
Phillips, Mrs.
Patterson, Master

1782.

Patterson, Mr.
Payne, Lady

Portre, Miss
Paget, Lady

1783.

Payne, Mr. Edward
Porter, Rev. Mr.
Pigott, Mrs. (Kew)
Payne, Mr. T.
Peareth, Mr.
Peascott, Mrs.
Page, Capt.
Patton, Capt.

1784.

Phipps, Capt.
Pinyer, Miss
Paine, Miss
Payne, Mrs.
Payne, Sir Ralph
Page, Sir Thomas
Plank, Mr.
Polhill, Master

1785.

Patrick, Mrs.
Patrick, Mrs. (her sister)
Patrick, Mrs. (her sister C.)
Platt, Miss
Pym, Mr.
Pope, Mr. A.
Plank, Mrs.
Payne, Miss
Payne, Miss M.
Payne, Miss F.
Phillips, Mr.
Pearce, Miss
Pearce, Miss M.

1786.

Purchase, Mrs.
Pigott, Mrs. (Kew)
Palmerston, Lady
Penrose, Mr.
Pott, Mr. (a ring)
Pott, Mrs. (a shirt-pin)
Pulteney, Miss
Parker, Mr.
Parker, Mrs.
Powell, Mr.
Plowden, Mrs.

1787.

Prescott, Miss
Prescott, Mr.
Pearce, Miss
Pearce, Capt.
Polhill, Miss
Pearce, Miss M.
Peony, Miss

1788.

Plowden, Mrs.
Packham, Miss
Pym, Mrs.
Pinckney, Miss
Pearson, Mr.
Paruther, Mr.
Peshall, Miss
Planta, Mr.
Paxton, Mrs.
Peak, Mrs.

1789.

Palmer, Mrs.
Patterson, Mr. J.
Palmer, Mr.
Parker, Mr.
Percival, Mr. L.
Price, Mrs.

1790.

Phillips, Mr.
Phillips, Mrs.
Parker, Mr.
Parker, Mrs.
Pitt, Mrs
Pratt, Mrs.
Parsons, Mr.
Peacock, Mrs.
Petrie, Mr.
Phillips, Miss
Papillon, Miss

1791.

Peachall, Master
Peachall, Master H.
Petre, Mr.
Penny, Mr.
Purdy, Mr.
Pelham, Miss
Papillon, Mr.

1792.

Pattison, Mrs.
Paxton, Mrs.
Phillips, Mr.
Pattison, Mrs., Jun.
Parker, Mr., Sen.

1793.

Phillips, Mr.
Popkins, Mr.
Palmer, Mrs.
Payne, Miss
Plampin, Miss
Petre, Capt.

1794.

Parker, Mr.
Prescott, Mr. R.
Phillips, Miss

1795.

Paget, Capt.
Paget, Capt. W.
Partridge, Mrs.
Praed, Mr.
Pery, Rev. Mr.
Parker, Mr.
Pattison, Miss
Parker, Master
Pyne, Capt.
Ponsonby, Mr.

1796.

Pattison, Mr. (a Lady for)
Pattison, Mr. (another Lady for)
Popham, Mrs.
Pemberton, Dr.
Palmer, Miss
Pope, Mrs.
Parsons, Mr.

1797.

Parry, Mr. (Oakden)
Pogson, Capt.

1798.

Paget, Hon. A.
Porter, Mr. W.
Pym, Mr.

1799.

Plowden, Mr., Jun. (his eye)

1800.

Purton, Mrs.

1801.

Place, Mrs.
Place, Mr.
Paget, Capt. C.
Postlethwait, Mr.

1802.

Penfold, Lady M.
Paget, Col. Ed.
Pryor, Mr.
Patton, Mr.

1803.

Paget, Capt. O. (his eye)
Prothero, Mr.
Paget, Hon. Col.
Paget, Col. (his eye)

1804.

Purvis, Capt.
Paget, Capt. Berkeley
Pickwood, Mr. A.
Pickwood, Mrs.

1805.

Parke, Mrs.
Paget, Lord
Paget, Capt. C. (his eye)

1806.

Parsons, Sir Lawrence
Plowden, Mr. Trevor
Plowden, Mr. William
Plowden, Mr. William (his eye)
Pollock, Mr. A.
Phillimore, Mr. T.

1807.

Pinckard, Alderman
Plowden, Mr. Trevor (his eye)
Plowden, Mr.
Plowden, Mrs.
Price, Capt. T.
Payne, General

1808.

Petty, Lord Henry
Paget, Sir Arthur

Plowden, Master Ch.
Patterson, Mr.
Prothero, Mr.
Prothero, Mrs.
Pope, Mrs.

1809.

Pickman, Mr.
Pickwood, Mr. R.
Prothero, Mr.

1810.

Pickwood, Mr. R.
Persian Ambassador (a portrait of the Queen for)
Pickford, Mr. William
Perkins, Mr.
Perkins, Mrs.

1811.

Pelly, Capt.
Price, Mr. F. R.

1812.

Paris, Mrs.
Poulett, Hon. Capt.
Phelps, Rev. Mr.

1776.

Quick, Mr.

1780.

Quarrington, Mrs.

1783.

Quarrington, Mrs.
Quarrington, Mrs. (her eye)

1810.

Queen, Her Majesty the

1811.

Quin, Hon. Mr.

1775.

Russell, Miss (Piccadilly)
Roles, Miss (Richmond)

1776.

Ross, Mrs.
Ross, Mr.
Rouse, Mrs.

Roebucke, Mr.
Ridge, Miss

1777.

Rushbrook, Mr.

1778.

Rigby, Mr., Jun.
Riddle, Mr. (of Bath)
Riddle, Mr., Jun.
Riddle, Mr., Sen.

1779.

Reed, Mr. James
Reed, Mr.
Rochford, Mr.
Richmond, Miss

1780.

Robertson, Mrs. (Great George Street)

1781.

Raymond, Mrs.
Robertson, Mrs.
Rutter, Mrs.
Reed, Miss
Riggs, Mrs.
Rodney, Capt.
Rouplett, Capt.

1782.

Robinson, Capt., R.N.
Robertson, Mrs.

1783.

Reed, Mrs.
Richardson, Mrs.
Richardson, Mr.
Rouplett, Capt.

1784.

Rumbold, Miss
Rodney, Master
Roberts, Capt.
Ralph, Mrs.
Ross, Mrs.

1785.

Ramsden, Mr.
Robertson, Capt.
Robbins, Mr.
Ross, Miss

1786.

Reed, Mr.
Ryan, Mr.
Robinson, Mrs.
Rearley, Miss

1787.

Roles, Capt.
Rogers, Mr.
Robinson, Mrs.
Ring, Mr.
Ring, Mrs.
Ring, Miss

1788.

Ring, Miss
Ring, Mrs.
Robertson, Mr.
Rochford, Mr.
Rowley, Capt.
Ross, Mrs.
Rest, Marquis Du
Rougement, Mr.
Ralph, Mrs.
Robertson, Mrs.
Robertson, Mrs. (her eye)
Robertson, Capt.
Roles, Mr.

1789.

Reed, Mr.
Robertson, Miss
Roles, Mr.
Roles, Mrs.
Ross, Capt.
Reed, Col.
Rain, Miss

1790.

Roles, Mr.
Robertson, Mrs.
Reed, Mr.
Reed, Mrs.
Rolleston, Mrs.
Rolleston, Mr.
Robertson, Capt.
Reed, Mrs. J.

1791.

Rougemant, Mr.
Roles, Mr.

Ruddle, Miss
Ryecroft, Sir Nelson
Reed, Master
Reed, Miss
Reed, Master George
Reed, Master F. (last four
 all drawings)

1792.

Reed, Master Thomas
 (drawing)
Ramsay, Mr.
Ramsay, Mr., Jun.

1793.

Ross, Mrs.
Ruddle, Mr.
Ross, Capt.
Reed, Master
Randall, Miss
Reid, Mrs.
Redman, Mrs.

1794.

Rowe, Mr.
Rowley, Major

1795.

Rose, Mr.
Richardson, Mr., Mrs., and
 Thomas (in one)
Roberts, Miss
Rattray, Mrs.
Rattray, Miss
Rieve, Capt.

1796.

Reid, Mr.
Reid, Mrs.
Reid, Mr. John
Romaine, Rev. Mr.
Ravenscroft, Mr., Jun.
Richardson, Mr.
Reynolds, Mr. E.
Raine, Miss
Read, Mr.

1797.

Read, Mr.
Rush, Miss

1798.

Riggs, Miss M.
Riggs, Miss
Ross, Miss
Robinson, Mrs. G., and
 Child
Riddle, Mrs.
Robinson, Capt. G.
Robinson, Capt.
Redmond, Mrs.
Revell, Mr. S.
Redman, Mr.

1799.

Randall, Mrs.
Randall, Mr.
Riddle, Mr. J.
Redhead, Mr. George
Reid, Miss
Readhead, Mrs.
Rose, Mrs.
Redhead, Mr.
Russell, Mr.

1800.

Robertson, General
Robertson, Lieut.-Col.
Rice, Mr.

1801.

Ruddle, Mr. George
Ross, Mr. H.
Ross, Mrs. H.
Roberts, Mr. J.
Russell, Lady W.
Robertson, Mr.
Rendle, Mrs.

1802.

Redhead, Mr. (a Lady for)
Rodney, Capt.
Robinson, Mr., Jun.
Robinson, Miss
Redman, Mrs.
Readhead, Mr. T.
Redhead, Mr.
Rhodes, Mr.

1803.

Roberts, Mr., Jun.
Russell, Mr.

Rawson, Mr.
Rawson, Mrs.
Rash, Mr.
Rumbold, Lady

1804.

Russell, Mr.
Russell, Mrs.
Reed, Miss
Randall, Miss

1805.

Richards, Mrs.
Robarts, Capt.

1806.

Roope, Capt.

1807.

Roebuck, Mrs.
Ruthven, Mr.

1808.

Roden, Mr.
Ross, Col.
Richardson, Mr.
Rosslyn, Lord
Robertson, Miss
Robbins, Capt.

1809.

Robinson, Mrs. (for Dr. Backley)
Rundel, Mrs., Sen.
Rogers, Mr.
Ramsay, Capt.

1810.

Rice, Mrs.
Rawson, Mrs.
Rawson, Mr.

1811.

Rouse, Capt.
Robinson, Sir Christopher
Robinson, Mrs. George
Rundell, Miss Harriet
Rundell, Mrs. Edmund
Rundell, Mr. Edmond
Routh, Mr.
Ronalds, Mrs.

1812.

Robinson, Lady
Rendlesham, Lady
Rendlesham, Lord
Robinson, Mr. George

1813.

Ruckson, Mrs.

COPIES OF PICTURES BY REYNOLDS.

1776.

March 21, Miss Palmer, from Sir. J. Reynolds
November 1, Miss Ridge, from Sir J. Reynolds

1777.

October 25, Little Thief, from Sir J. Reynolds
October 27, Link Boy, from Sir J. Reynolds for Mr. Scawen

1778.

April 30, Cupid, from Sir J. Reynolds
June 1. Old Head, from Sir J. Reynolds
June 7. Ditto
June 21. Samuel, from Sir J. Reynolds
September 7. Schoolboy, from Sir J. Reynolds
September 22. Boy at Study. Sir J. Reynolds
October 23. Pensive Girl. Sir J. Reynolds
December 5. Laughing Boy. Sir J. Reynolds

1781.

January 8. Madame Scheldlering, from Sir J. Reynolds

1782.

September 3. Laughing Girl. Sir J. Reynolds

1786.

August 18. Lord Northington, from Sir Joshua

1775.

Slater, Mr.
Smith, Capt. (Woolwich)
Smith, Mrs. T.
Sloan, Miss

1776.

Stables, Miss
Smith, Mrs. T.
Stables, Mr.
Swinburne, Sir Edward
Strutt, Master
Scawen, Mrs.
Scawen, Mr.
Scawen, Mr., Sen.
Stewart, Mr. J.

1777.

Stewart, Mr.
Standen, Mr.
Smith, Mrs.
Smith, Mrs. T.
Sclater, Mr.
Smith, Mr. P.
Smith, Miss.
Stephenson, Mr.
Stephenson, Mr., Jun.
Saumerez, Mrs.
Skeffington, Col.
Scawen, Mrs.

1778.

Stephenson, Mr.
Smith, Mr. Benjamin

1779.

Sleigh, Mrs.
Scawen, Mrs.
Scottowe, Mr., Sen
Stewart, Hon. Mrs.
Scottowe, Capt.

1780.

Scottowe, Miss
Scottowe, Mr., Jun.
Saunders, Master
Saunders, Miss
Scottowe, Miss
Scott, Rev. Mr.

1781.

Scottowe, Miss
Stapleton, Master
Straitfield, Master
Sutherland, Mr.
Stone, Mr. (Lombard St.)
Skeffington, Master
Stewart, Mr.
Stewart, Mrs.

1782.

Standen, Mr.
Spackman, Mr.
Simpson, Mr.
Spackman, Miss M.
Simple, Capt.
Simpson, Mrs.
Simpson, Mr.

1783.

Scawen, Mrs.
Sims, Col.
Scott, Mrs.
Stewart, Mrs.
Stewart, Mr. (Ireland)
Stewart, Capt.
Sharp, Mr. (for Mrs. Wilson)
Swaby, Mr.

1784.

Smith, Mr.
Stewart, Mrs.
Stewart, Mr.
Southby, Miss
Smith, Mrs.
Stewart, Sir J.

1785.

Sister of Mrs. Patrick
Shepherd, Mrs.
Smith, Capt.
Sawyer, Commodore
Stepney, Mr. T.
Scott, Col.
Swinfin, Mrs.
Stanhope, Mrs. Spencer
Stapleton, Lady
Sawyer, Mr. John
Scott, Mrs. D.

Starkey, Mr.
Sandby, Mr.
Shepherd, Miss
Strickland, Col.
Speed, Miss

1786.

Squires, Miss.
Scott, Mrs. Fenton
Sellwall, Mrs.
Scott, Mr. Fenton
Stapleton, Lady
Smith, Mr. Drummond
Stewart, Mr.
Shadwell, Capt.
Skreath, Miss
Smith, Mr.
Shippey, Mrs.
Scott, Miss A.

1787.

Sutton, Mr. (a Lady for)
Scott, Mr. (a Lady for)
Simpson, Mrs.
Symmonds, Sir Richard
Smith, Mrs.
Smith, Miss
Smith, Master Edmond
Sampson, Miss
Symes, Mr.
Smyth, Mr. O. (a Lady for)
Shiffner, Mr.

1788.

Shiffner, Mr. George
Smith, Mr. Owen
Spooner, Mrs.
Snead, Miss
Stewart, Sir James
Skinner, Mr.
Shore, Mr., Jun.
Spooner, Miss
Sandby, Mr., Sen.
Smith, Mr. C. (a Lady for)
Searle, Mr.
Smith, Mrs. George
Sullivan, Master
Sullivan, Miss
Sclater, Mrs.

1789.

Shiffner, Mr. G.
Stileman, Rev. Mr.
Shepherd, Miss
Shepherd, Mr.
Slater, Mr.
Stead, Mrs.
Staples, Mr.
Starting, Mr.
Starkey, Capt.
Sewell, Mrs.
Shears, Mr
Savage, Mrs.
Sewell, Mr.

1790.

Shepherd, Mr.
Scott, Mr.
Snow, Mr.
Sandby, Mr., Jun.
Salisbury, Lady
Smith, Mrs. J.
Smith, Mr. Thomas
Seton, Mr.
Scott, Capt.
Sparkes, Master
Smith, Capt. T.
Smith, Miss
Sparkes, Mr.
Smith, Miss

1791.

Smith, Mrs. George
Stainsforth, Mr. R.
Sibbald, Mr.
Sutton, Capt.
Seton, Mr., Jun.
Scott, Mr.
Stirling, Capt.
Spilsbury, Mr.
Swan, Mrs.
St. Julian, Madame
Silk, Mr.
Sugeson, Capt.

1792.

Skeffington, Sir William
Smith, Madame St. Julian
Swaby, Mrs.
Saunders, Mr.

Q

Stephens, Mr.
Staunton, Master
Staunton, Lady
Staunton, Sir George

1793.

Scott, Miss
Sutton, Sir Richard
Smith, Capt.
Smith, Mr.
Steed, Mrs.
Steed, Mr.
Shergold, Miss Harriet
Shergold, Mr.
Soto, Miss
Shergold, Mrs.
Shergold, Mrs. Samuel
Spence, Mr. George

1794.

Scott, Miss
Sharp, Miss
Swaby, Mrs.
Stopford, General
Saltoun, Lord (the Brother of)

1795.

Sackville, Lord
Shergold, Miss
Shergold, Miss E.
Small, Mr.
Storie, Rev. Mr.
Scott, Miss
Scott, Miss J.

1796.

Soilleux, Mrs.
Scott, Mr. T.
Scott, Mrs. J.
Stovin, Major
Swinton, Capt.
Schroiter, Mrs.
Sparkes, Mrs.
Schnarkie, Mr.
Stovin, Capt.
Saunders, Miss
Schiffner, Mr.
Smith, Miss
Scudamore, Mrs.
Simpson, Mr.

1797.

Sutton, Mr.
Smith, Mr.
Smith, Rev. Mr. T.
Smith, Miss
Steed, Mr.
Shiffner, Mr.
Scott, Mr.
Spooner, Miss

1798.

Sandys, Mrs.
Sawkins, Mr.
Scudamore, Mrs.
Smith, Rev. Mr. T.
Seton, Miss C.
Salmond, Mrs.
Salmond, Capt.
Seton, Mrs.
Seton, Mr. (Harley Street)
Scott, Mr. David
Seton, Miss
Seton, Miss Anna
Seton, Miss H.
Scott, Mrs. David
Sloper, General
Scott, Miss Diana
Scott, Mr. David, Jun.
Sykes, Rev. Mr.

1799.

Salt, Mr.

1800.

Saolleux, Master
Swinburn, Lady
Swan, Mrs., Jun.
Salt, Mrs.
Sykes, Mr. (a Lady for)
Stephens, Mrs.
Stephens, Mr.
Stewart, Sir John
Sawkins, Mrs.
Sabine, Capt.
Sherriden, Mr. Thomas

1801.

Scott, Mrs. Robert
Scott, Mr. Robert
Stracey, Mr.
Scott, Mrs. D.

Swaine, Mr. Walter
Stewart, General
Sweedland, Mr.

1802.

Samson, Mr., Jun.
Stephenson, Miss
Seton, Miss Anna
Sculthorp, Miss
Struth, Mr.
Samson, Mr., Jun.

1803.

Samson, Mrs., Sen.
Samson, Mrs., Jun.
Stead, Mr.
Stewart, Mr. C. F.

1804.

Sandford, Mr.
Sheddon, Mr. R.
Sealey, Miss
Sheddon, Mrs. R.
Samson, Mr. H.
Stenhouse, Lieut.
Stewart, Mr. S. H.

1805.

Stewart, Mr.
Saltram, Mrs.
Saltram, Mr.
Shawe, Mr.
Seton, Miss H.
Sandford, Mrs.
Salvine, Major

1806.

Scott, Mrs. H.

1807.

Stewart, Mr. Michael
Sloper, General
Stewart, Mr. M.
Stewart, Miss
Sanders, Capt.

1808.

Sheldon, Mr.
Sale, Capt.
Stoddart, Dr.
Sitwell, Mr. F.
Salmond, Mr.

1809.
Stewart, Lieut.-Col.
Stirling, Mr. Walter
Samson, Capt.

1810.
Sabine, Mrs.

1811.
Schranke, Mr.
Smyth, Sir Henry
Savile, Capt.

1812.
Swan, Mrs.
Slater, Miss
Slater, Mr.
Schnell, Mrs.

1813.
Salmond, Master
Salmond, Mrs.

1775.
Treeves, Mr.
Thynne, Mrs.
Treves, Master
Townshend, Lady (*N. B.
Engleheart did six the
same month of this lady*)
Thompson, Dr.

1776.
Taylor, Miss
Treves, Mrs.
Turner, Miss
Tyson, Miss
Talbot, Mrs.
Tyrconnel, Lady
Tongue, Mr.
Tongue, Mrs.
Treves, Mr.
Trotter, Mr.
Trotter, Mr., Jun.
Tahourdin, Mr.
Tahourdin, Mrs.

1778.
Thurley, Mr.

1779.
Taylor, Mr. J.

1780.
Theobalds, Mrs.
Trollop, Capt., R.N.
Thompson, Capt., R.N.
Treves, Mr.

1781.
Townshend, Miss A.
Thompson, Mrs.
Townshend, Mr.

1782.
Tarrant, Mrs.
Taylor, Capt.
Townshend, Lady
Townshend, Miss C.
Thomas, Miss

1783.
Townshend, Capt.
Townshend, Miss C.
Townshend, Miss
Townshend, Miss A.
Townshend, Lady
Towns, Mrs.
Townshend, Mr. John
Townshend, Miss E.
Talbot, Rev. Mr.
Towers, Mrs.
Taylor, Mr.

1784.
Thornhill, Mrs.
Topham, Capt.
Treeves, Mr. (a Lady for)

1785.
Tighe, Mr.
Towers, Mrs.
Todd, Capt.
Thoits, Mr.

1786.
Townshend, Hon. John
Trelawney, Miss (a Rev.
 Gentleman for)
Trelawney, Miss
Tate, Mr.
Trelawney, Col.
Tatnell, Mrs.
Tryon, Capt. (dead)

1787.
Towers, Mrs.
Todd, Miss
Travell, Miss
Talbot, Capt.
Troward, Mr.
Tilliard, Mr.
Taylor, Miss

1788.
Theed, Mr.
Theed, Mrs.
Theats, Dr.(a Gentleman at)
Tennant, Mrs.
Towers, Mrs.
Trotter, Mr. Alex.
Twisden, Mr.

1789.
Talbot, Hon. J.
Tempest, Mr.
Townshend, Rev. Mr.
Tyrwhitt, Mr.
Twisden, Lady
Tollemash, Lord

1790.
Townshend, Capt.
Talbot, Mr. (a Lady for)
Thelusson, Mrs.
Thelusson, Mr. G.
Tritton, Mr.
Trotter, Mr.

1791.
Tempest, Mr.
Tweedale, Lady
Tattersall, Rev. Mr.
Tweedale, Marquis

1792.
Torriano, Major
Trotter, Capt.
Torriano, Mr., Jun.
Tobin, Mr.

1793.
Taylor, Capt.

1794.
Trotter, Mrs.
Treves, Mrs., Jun.

Thorp, Capt.
Torriano, Major

1795.

Torphachen, Lord
Tennant, Master F.
Tempest, Sir H. V.
Thorp, Mrs.
Talbot, Major
Torriano, Mrs., Sen.
Topham, Mrs.
Topham, Miss

1796.

Treves, Miss E.
Treves, Master H.
Treves, Miss H.
 (Above three all in one
 picture)
Treves, Miss H.
Trench, Col.
Tinney, Mr.
Talbot, Mr.
Torriano, Major
Turner, Nancy (Mrs. Windsor)

1797.

Thornton, Mrs.
Todd, Mr.
Tomkins, Mr.

1798.

Talbot, Col.
Taylor, Mr. Jos.
Tennant, Mr.
Tennant, Mrs.
Turner, Mr.
Thompson, Capt.

1799.

Thompson, Capt. B.
Torriano, Major
Tennant, Mrs.

1800.

Thornhill, Mrs.
Tippet, Mrs.

1801.

Todd, Mrs.
Todd, Mr., Jun.

Taswell, Mr.
Thornton, Mr.
Taylor, Miss
Tod, Mr.
Tarlton, Mrs.
Tarlton, Mrs. (her sister)
Todd, Capt.

1802.

Tamworth, Lord
Thompson, Lady
Taswell, Mr. George

1803.

Thomas, Mr., Jun.
Tennant, Mrs.
Tucker, Miss

1804.

Taylor, Mr.
Twining, Mr., Jun.

1805.

Turner, Mr. J., Jun.
Tod, Mr. G.
Tod, Miss
Turquand, Mr.

1806.

Trotter, Miss
Trotter, Mr. T.

1808.

Thornton, Mrs. J.
Trotter, Mr. John
Trotter, Mr. John (a Lady
 for)

1812.

Treweeke, Rev. Mr.
Trower, Mr. Hutches
Turner, Mrs. Samuel, Jun.

1813.

Thomas, Mr. J.

1782.

Unwyn, Miss

1791.

Urmston, Mrs.

1800.

Uxbridge, Lord
Urmston, Mr.

1805.

Uthoff, Mr.

1806.

Uthoff, Mr.

1807

Upton, Capt. Clotworthy

1775.

Valentia, Lord

1777.

Vernon, Mr. Richard
Vauxmeister, Count

1781.

Valentia, Lord

1782.

Vachell, Capt.
Valentia, Lord

1784.

Vachell, Miss
Vietz, Mrs. de
Vachell, Mrs.
Vilat, Rev. Dr.

1785.

Vann, Mrs.

1788.

Vane, Sir Frederic
Vane, Mr.
Vane, Miss
Vane, Miss M.
Vansittart, Mr.
Vansittart, Master

1791.

Vaughan, Miss

1793.

Vanheulen, Mrs.

1795.

Vezey, Major

1796.
Vezey, Mrs.
Veal, Mr.

1797.
Vaughan, Mrs.

1799.
Villiers, Col.
Vaughan, Mr.
Vaughan, Mrs.

1801.
Vezey, Col.

1802.
Vernon, Mrs.
Vernon, Mr.

1809.
Vorst, Mr. Van
Vorst, Mrs. Van
Vernon, Mr.

1811.
Villebois, Mrs.

1812.
Veriker, Hon. Col.
Vane, Mr.

1775.
Webster, Miss (Newman Street)
Warner, Miss
Williams, Miss
Wilton, Miss

1776.
Warre, Mr. J.
Wilton, Miss
Walpole, Mrs. E.
Warre, Mr.
Wynne, Mr.
Wynne, Mrs.
Wilson, Mr. (at Mr. Dunlop's)
Webb, Master

1777.
Webb, Master W.
Webb, Master

Webb, Miss Maria
Wilton, Miss
Webb, Miss M.
Wilmot, Miss
Winterton, Lord
Walrond, Mr.

1778.
Winterton, Lord
Walrond, Mr.
Walrond, Mrs.
Winterton, Lady
Warre, Mr., Jun.
Warre, Mr., Sen.
Wilcocke, Mrs.
Watkin, Dr.
Witaker, Mrs.
Williams, Mrs.

1779.
Williams, Mrs.
Whitfoord, Master
Wells, Mrs. Sally
Webb, Capt.
Wise, Mrs.

1780.
Waring, Mr.
Wallace, Lady
Wynne, Col.
Wallis, Mr.
Winstanley, Mr.

1781.
Waring, Mr.
Weight, Mrs.
Wale, Miss
Webb, Capt.
Wynne, Mrs.
Walpole, Mrs.
Wynne, Col.
Williams, Mr.
Wynyard, Capt.
Westcott, Mr.
Wylden, Mrs.
Whitefoord, Master
Whitefoord, Sir John
Wadkis, Mr.
Wadkis, Mrs.

1782.
Wake, Miss
Wentworth, Mrs.
Warr, Mrs.
Williams, Mr.
Wynne, Master
Wynne, Master W.
Williams, Mr.
Wilson, Miss
Wiston, Mr.
Williamson, Col.
Wentworth, Mrs.
Wilson, Mrs.
Williamson, Mrs.
Webb, Capt.

1783.
Willis, Mrs.
Wilton, Miss
Wilson, Mr.
Williams, Miss
Wishart, Mrs.
Whaley, Miss
Ward, Mrs.
Westcott, Rev. Mr.
Ward, Mrs., of Ireland
White, Miss (for Mrs. Woolley)
Wentworth, Mr.
West, Miss
Wilson, Miss
Watson, Capt.

1784.
Wilks, Mr.
Winter, Rev. Mr.
Wolff, Miss
Waldren, Mrs.
Wentworth, Capt.
Wilcocke, Mr.
Wilson, Mrs.
Windsor, Mrs.
Wynch, Capt.

1785.
Wilkinson, Miss
Windsor, Mrs.
Wright, Miss
Whateley, Mrs.
Wilcocke, Mr.
Wilder, Mrs.

1786.

Watson, Mr.
Whitworth, Miss
Webb, Miss
Wise, Capt.
Watson, Hon. Mrs.
Wilson, Mr.
Windham, Mr. G.
Wigston, Mr.
Windsor, Lady J.
White, Capt.
Wynch, Mrs.
Wynch, Miss
Wentworth, Mr. N.
Waddle, Mrs.
Waddle, Master
Williams, Capt.

1787.

Waddle, Master
Wilkinson, Mr.
Witaker, Capt.
Wheat, Capt.
Woolley, Miss

1788.

Williams, Capt.
Walpole, Mrs.
Wigglesworth, Mr.
Wyatt, Mr.
Wickham, Miss
Wilson, Sir John
Wright, Major
Westmoreland, Lord
Woodford, Col.
Webb, Capt.
Wortham, Capt.
Welby, Miss
Wemyss, Col.

1789.

Watley, Mr.
Wale, Mr.

1790.

Webb, Mr., Jun.
Walker, Mr.
Williams, Mr. H.
Williamson, Mrs.
White, Rev. Mr.

Wooley, Mr.
Westmoreland, Dowager
 Lady
Warren, Miss
Wale, Mr. Gregory
Weston, Mrs.
Watson, Mrs.

1791.

Wraughton, Mr.
Warden, Master
Woodford, Master Alex.
Woodford, Master John
Whitcomb, Mrs.
Warden, Miss
Wharton, Mrs.
Worthington, Mr.
Watson, Mr.
Wood, Mr.
Walpole, Mr.

1792.

Walbank, Mr.
Wilson, Miss
Watson, Mr.
Watson, Mr. (a Lady for)
Wheeler, Mrs.
Whitfield, Dr.

1793.

Wedgewood, Mrs.
Wedgewood, Mr.
Wentworth, Mr. A.
Wise, Capt.
Woods, Mr.
Williams, Mr.
Wilson, Mr.
Wynyard, Lady Matilda
Watson, Capt.
Wakefield, Mr.
Walsh, Mrs.
Webster, Mrs.
Webster, Mr.

1794.

Watson, Capt.
Webb, Mr.
Wedgewood, Mr.
Williamson, Master

Wraughton, Mr.
Wallace, Commissioner
Wynyard, Col.
Wallace, Mr.
Wise, Mrs.

1795.

Walpole, Mr., Jun.
Wyndham, Capt.
Williams, Mrs.
Westmoreland, Lord
White, Miss
Wise, Mrs.
Wedgewood, Mr.
Whitfield, Mrs.
Wedderburn, Mr.
Wemyss, Col.
Warren, Rev. Mr.

1796.

Winter, Mr.
Westmoreland, Lord
Wallace, Mrs.

1797.

Welby, Miss
Welby, Miss M.
Weeks, Miss
Walmsley, Mr.
Watts, Mr.

1798.

Walpole, Mrs.
Wilkinson, Mrs.
Warnford, Rev. Mr.
Wyndham, Mrs.
Weyland, Miss S.
Walton, Mr.

1799.

Weyland, Mrs. S.
Williams, Lord
Wimberley, Mr.
Winter, Mr.
Willadvice, Capt.
Wright, Mrs.
Wedderburn, Mr.
Wilson, Mr.

1800.

Williams, Mr.
Woodcocke, Rev. Mr.
Whitmore, Capt.
Watson, Commodore
Worsley, Sir Richard
Wemyss, Capt.
Wynyard, Capt. M.

1801.

Wood, Mr.

1802.

Watson, Admiral
Wise, Capt.
Wood, Miss
Wales, Prince of

1803.

Wilkes, Mr.
Webster, Miss
Webber, Mr.
Whitehead, Rev. Mr.
Walton, Miss
Walsh, Mrs. B.
Wauchope, Capt.
Walsh, Mr. B.
Walsh, Mr., Sen.
Wyer, Mr.
White, Mrs. Henry

1804.

Woodcock, Mr.
Williamson, Miss

1805.

Wardlaw, Capt.
Willett, Mr. Willett

1806.

Wardlaw, Capt.
Warner, Mr. A.
Watts, Mr.

Waddington, Mr.
Whitehead, Mrs.
Wilson, Mr.

1807.

Williams, Mr., Jun.
Wood, Mr. Alex.
Wood, Mrs. Alex.
Wilder, Mr. F.

1808.

Walsh, Master
Webber, Mr.
Wise, Miss
Wheatley, Capt.
Webber, Mr. (a young Lady
 for)
Walbank, Capt.

1809.

Wardlaw, Capt.
Wilson, Mrs.

1810.

Ward, Mr.
Ward, Lady A.
Wheatley, Col.
Wiseman, Sir William, R.N.
Welford, Miss Harriet
Walpole, Rev. Mr.

1811.

Wardlaw, Capt.
Warre, Major
Warburton, Major
Wolstonholme, Capt.

1812.

Warton, Lord
Warton, Lady
Winter, Miss
Ward, Mr.
Weymouth, Lieut.

1813.

Wickham, Mr., Jun.

1778.

Yeo, Mrs.
Yates, Mr.

1779.

Young, Capt.

1780.

Yeo, Capt., R.N.
Yeldham, Mr.
Yeldham, Mr. Thomas

1781.

Yeldham, Mr. Moses

1782.

York, Col.

1783.

Yates, Mr.

1784.

Yeldham, Mr. T.
Young, Miss

1786.

York, Mr.
Yeldham, Mr. T.
Yeldham, Mrs.

1787.

Yeldham, Mrs.

1795.

York, Hon. Mr.

1807.

Young, Mrs.

1808.

Yates, Rev. Mr.

Appendix II.

The Works exhibited by each member of
the Engleheart family at the Royal
Academy, Suffolk Street Gallery, and British
Institution, extracted from the
original catalogues.

Appendix II.

The Works exhibited by each member of the Engleheart family at the Royal Academy, Suffolk Street Gallery, and British Institution, extracted from the original catalogues.

WORKS EXHIBITED AT THE ROYAL ACADEMY BY THOMAS ENGLEHEART, WITH THE ARTIST'S ADDRESS AT THE TIME OF EXHIBITION.

1773. *Little Carrington Street, Mayfair.*
96. Bust of Thomas Fuelling of His Majesty's Board of Works.
1774. 84. A bust, a model.
85. Three models in wax.
1775. 4, *Old Bond Street.*
115. Three portraits models in wax.
1776. 100. Two portraits in wax.
1777. 119. A medal in wax.
120. A small bust in wax.

1778. 102. A small bust in wax.
103. Three medallions in wax.
1779. 28, *St. James's Street.*
89. A model in wax.
1780 294. A Lady in wax.
295. A Gentleman in wax.
1786. *Richmond, Surrey.*
370. A Portrait in wax.
Twenty in all. Mr. Graves' List puts twenty-one, but that is an error.

WORKS EXHIBITED AT THE ROYAL ACADEMY BY GEORGE ENGLEHEART, WITH THE ARTIST'S ADDRESS AT THE TIME OF EXHIBITION.

1773. *Kew Green, Surrey*
94. View of the Royal Villa, late the Princess Dowager's, at Kew.
95. Portrait of a child (miniature).
362. Landscape and Castle.
1774. *Shepherd Street, Hanover Square.*
82. Portrait of Lady Viscountess Townsend (miniature).
83. Portrait of Sir Roger Mostyn (miniature).

1775. 116. A Gentleman (miniature).
117. A Gentleman (miniature).
118. A child in the character of Cupid.
1776. *Princes Street, Hanover Square.*
101. A Family in miniature.
1777. 118. A Lady (miniature).
1778. 104. A Fancy Picture (? Adam and Eve).
1783. 4, *Hertford Street, Mayfair.*
295. Frame with three Portraits.

333. Frame with three Portraits.
1784. 262. Frame with three Portraits.
277. Portrait of a child whole length.
1786. 293. Frame with six miniatures.
A note in contemporary hand on catalogue says " Very Good."
1788. 304. A Lady.
321. A Gentleman.
329. A Young Lady.
1789. 313. His Majesty.
1790. *Miniature Painter to His Majesty.*
304. A Gentleman (Mr. Bate Dudley).
1794. 505. Portrait of a Lady and her two Daughters.
1798. 345. A Young Gentleman.
407. A Gentleman.
499. A Young Lady.
737. A Young Gentleman (*J. E. in catalogue*).
1799. 491. Capt. Sir T. B. Thompson of the *Leander*.
1806. 668. Admiral Hamilton, Mrs. R. Shawe, Capt. W. Brown, Mr. J. Fraser, Mr. A. Warner, Mr. Lucas, Mr. Munden, Mr. W. Plowden.

1807. 831. Six Portraits, Mr. Plowden, General Don, Mr. G. Wilson, Mr. F. Barwell, Mr. H. Barwell, Mr. C. Barwell.
1808. 805. Col. Kyd, Bengal Engineers, Lord Aboyne, Hon. E. Cowper, M.P., Lord H. Petty, M.P., Mr. J. Holloway, Rev. Mr. Dallaway, Mr. P. S. Munn, and Mr. Walsh.
1809. 610. A young Gentleman.
633. Rev. Mr. Yates.
635. A young Gentleman.
1810. 613. Mr. Barclay, Dr. Knighton, Mr. Rogers, and three Gentlemen.
1811. 599. Lord Erskine (Lord Chancellor), Mrs. Curties, Master Morris, Sir Christopher Robinson, Vice-Admiral Campbell, M.P., Hon. Mr. Quin, M.P., Mr. Perkins, Hon. Capt. Cocks, 14th Light Dragoons.
1812. 568. Miss Johnson, Hon. Capt. A. Cochrane, R.N., Capt. Lillicrap, R.N., Capt. Kneller, Mrs. Rucker, Mr. C. Raikes, Rev. Dr. Curties, Mr. E. Rundell.

Eighty-five in all.

WORKS EXHIBITED AT THE ROYAL ACADEMY BY C. D. ENGLEHEART, WITH THE ARTIST'S ADDRESS AT THE TIME OF EXHIBITION.

1801. *Hertford Street, Mayfair.*
455. A Lady.
783. A Gentleman.
1802. *13, Shepherd Street, Hanover Square.*
586. A Gentleman.
824. A Lady and Gentleman.
1804. 793. Portrait of an Artist, Mr. R. Young and Miss Engleheart.
1805. 397. The four Sons of J. Wolley, Esq., of Birmingham.
418. Rev. H. White of Lichfield.
1806. 667. Rev. J. Smith of Birmingham.
767. Mrs. Marten.
1807. 848. D. Engleheart, Esq.
866. A Gentleman.

1808. 88, *Newman Street, Oxford Street.*
786. Lord Blayney, Miss Price, the Children of — Collard, Esq., of Cowley, near Cheltenham, Rev. Sir C. Anderson, Bart., and L. Reilly, Esq.
1809. 704. Infant Daughter of Lieut.-Col. Gordon, W. Albert, Esq., W. F. Gardner, Esq., Mrs. R. Robinson, C. Seager, Esq., and the celebrated Miss J. Cramer in the character of Cheerfulness from Collins' " Ode on the Passions."
1810. 596. D. Britten, Esq., and W. Miller, Esq.

678. Hon. Mr. and Mrs. Fitzroy Stanhope, W. France, Esq., E. Du Bois, Esq., and an allegorical subject.

1811. 615. A Lady.

617. A Lady.

626. Miss H. Cresswell, E. H. Baillie, Esq., J. Madox, Esq., a Lady and Psyche borne by zephyrs from the mountain.

1812. 560. B. Hobhouse, Esq., M.P., Miss Salvin, Mrs. Britten, Mr. F. B. Grant, Mr. Harrington, Mr. J. Purton, a Lady, and a Gentleman.

1813. 476. Mr. Tighlman, Rt. Hon. Viscount Jocelyn, Mrs. Fisher, Mrs. Stewart, Dr. Lathom, Mrs. Russell, and R. de Lisle, Esq.

"Then April with her sister May,
Shall drive him from the bow'rs,
And weave fresh garlands every day,
To crown the smiling hours."
"April and May, Winter Retiring,"
Cowper's "Invitation to the Country."

1814. 377. The Comte d'Alais, son of Duc de Castries, Miss Hall, Count Rios, brother to His Excellency the Spanish Ambassador, Miss Bulkeley, A. Baillie, Esq., H. Verelst, Esq., Lt.-Col. King, 82nd Regiment, and G. Engleheart, Esq.

1815. 550. Hon. Miss Curzon, E. Walpole, Esq., a Son of Sir C. Morgan, Bart., and the Daughter of Herodias.

724. Hon. T. Erskine, Mrs. H. Johnstone, a Lady in the costume of Rubens' wife, and Miss Gresley.

1816. 628. Mrs. Huntly, G. Tuffnell, Esq., Coldstreams, Hon. Mrs. Westby, and a Lady.

634. E. Peters, Esq., 7th Hussars, Hon. Mrs. Fitzroy Stanhope, J. Britten, Esq., and Capt. P. Turner.

1817. 670. Rev. H. Hutton, Hon. T. Coventry, F. Page Turner, Esq., and three Ladies.

1818. 682. — Denny, Esq., Mrs. Keane, and a group of children.

824. Major and Mrs. Govenham, and a Lady.

1819. 917. P. Delabaud, Esq., Miss Benyon, — Parkes, Esq., J. Tyrrell, Esq., Maj.-Genl. Sir J. Keane, K.C.B., Hon. Pleydell Bouverie, and a Lady.

1820. 692. J. Wrench, Esq.

735. J. G. Children, Esq., of the British Museum.

783. Major By.

795. Mrs. Wrench.

802. Mr. Macready of Covent Garden Theatre in the character of Richard III.

"The murder's doing."
Act iv., Scene 3.

813. — Cherry, Esq.

827. Charles Barker, Esq.

856. Mrs. By.

1821. 70, *Berners Street.*

645. Three Sisters.

675. F. Baker, Esq., and Family.

685. H. Hoddie, Esq.

688. Rev. Dr. Frewin.

889. Mrs. David Barclay.

891. A Gentleman.

1822. 640. Mrs. Alexander Baillie.

653. J. Orde, Esq.

654. A Lady.

663. — Campbell, Esq.

675. Mrs. Campbell.

676. D. Barclay, Esq.

1823. 714. Lady Elizabeth Drummond.

750. Mrs. Devon.

802. C. Hoare, Esq.

806. A Gentleman.

848. Lady Granville Somerset.

859. H. Porcher, Esq., M.P.

894. C. Devon, Esq.

908. A. R. Drummond, Esq.

1824. 583. Hon. Mrs. Milles.

683. A Gentleman.

738. Mr. Macready of the Theatre Royal, Drury Lane.

728. Hon. G. J. Milles.

GEORGE ENGLEHEART.

729. Mrs. T. Perry.
739. A Lady.
768. A. H. Eyre, Esq.,
754. T. Perry, Esq.
 65, *Berkeley Street, Portman Square*.
589. The Earl of Carysfort.
610. George Lucy, Esq., M.D.
625. Rev. Archdeacon Eyre.
653. Countess of Carysfort.
639. Rev. Dr. Fisher.
742. The Lady of G. Lucy, Esq., M.P.
772. The Lady of C. B. Curtis, Esq.
802. C. G. Graves, Esq.
600. F. W. T. Drake, Esq.
609. Mrs. Wall.
747. A Peeress.

752. Alexander Reid, Esq., Bengal Civil Service.
768. The Lady of T. B. Stirling Benson, Esq.
771. Henry Dawes, Esq.
774. A Lady.
1827. 710. Two Daughters of Jesse Watts Russell, Esq.
712. Miss Jennings.
714. Hon. Mrs. Proby.
831. Hon. Granville Leveson Proby, Capt., R.N.
846. A Lady.
1828. 7, *Mortimer Street, Cavendish Square*.
755. F. Lyttelton Hollyoak, Esq.
157 *in all.*

EXHIBITS AT THE ACADEMY OF OTHER MEMBERS OF THE ENGLEHEART FAMILY.

J. Engleheart, Foot Lane, Richmond.
A Portrait in wax.

1801. W. F. S. Engleheart, 7, Shepherd Street, Mayfair.
758. A Lady.

ENGRAVINGS EXHIBITED BY FRANCIS ENGLEHEART AT SUFFOLK STREET.

2, *Bayham Street, Camden Town*.
592. From Don Quixote, Engraving.
641. Six Don Quixote Engravings.
645. Robert Pope, Esq., Engraving.

749. Five from Don Quixote, Engravings.
1826. 539. Rev. J. Yates.
1828. 847. Duncan Gray after Wilkie, Engraving.
Six in all.

MINIATURES EXHIBITED BY J. C. D. ENGLEHEART AT THE BRITISH INSTITUTION.

88, *Newman Street*.
38. A Study, miniature.

1810. 21. Cheerfulness, miniature, 1-0 × 0-9.

Appendix III.

Manuscript Lists of Works executed by
John Cox Dillman Engleheart.

Appendix III.

Manuscript Lists of Works
executed by John Cox Dillman Engleheart.

MEMORIAL OF PICTURES FROM THE TIME I FIRST WENT TO MY
UNCLE'S IN HERTFORD STREET.

1798 : November—Hertford Street ...	A Head of Seneca, in India ink, from plaister.
	A Head of Sappho, ditto.
	A Head from a portrait of Romney's.
1799 : February 6—Hertford Street ...	Samuel, half-length only, given to Miss Burgoyne.
„ 13—Kew	Mr. C. Nisbett, a drawing.
„ 14—Kew	Mr. Newton, a drawing.
March 9—London	Weeping Girl, from Sir Joshua Reynolds.
„ 29—London	Laughing Girl, ditto.
April 12	An Old Head, ditto.
„ 20—Kew	Mr. J. Haverfield, a drawing.
May 1	An Old Head, from Sir Joshua.
„ 9—London... ...	Copied Capt. Ashley's picture, for my uncle.
„ 15	Mr. Redhead's, ditto.
„ 22	Admiral Christian's, ditto.
June 7	Mrs. Charnoch, ditto.
July 6	Samuel, whole-length.
„ 27	Mr. Rice, ditto.
„ 29—Kew	My Father, a drawing.
August 6	Miss Oborne, ditto.
„ 7	Lucy, copied from my uncle, ditto.
„ 22	Mrs. Schnell, a drawing.
September 7	Mr. Morgan, the first miniature portrait I did.
„ 28	Mr. C. Stevens, miniature.
October 7—Pentonville ...	Mrs. Cooper, a drawing.
„ 15—Kew	Mr. Meyer, ditto.
„ 19	Mrs. Planta, ditto.
	Miss Mary Mayer as Hebe, a miniature from a full-length picture painted by Sir Joshua Reynolds, and in the possession of Mrs. Meyers (*sic*) at Kew.
„ 30	Mrs. Planta, copied from the other.

1799: November 5	Mr. John Elmslie, drawing.
„ 7	Miss Del Sotto, drawing.
„ 9	Mr. Montague, ditto.
„ 9	Mrs. Newton, a miniature.
„ 15	Mr. Gardner, a miniature.
„ 20	Mrs. C. Hayes, a drawing.
„ 26	Mr. Brown, a drawing.
December 10	Mr. Rice, miniature.
„ 31—Hertford Street	...			Mr. Freemantle, a copy from one of my uncle's.
1800: January 3	Mr. W. Albert, a drawing.
February 1—Kew	Mrs. R. Haverfield, a drawing.
„ 11—Hertford Street		...		Sleeping Cupid, from my uncle's.
„ 22	Copied a picture by Pine, for my uncle.
March 7	Copied a picture of a Gentleman, for my uncle.
„ 21	A drawing of Lucy, from my uncle's.
„ 28	Sleeping Boy, from my uncle's.
April 18	An Old Admiral, for my uncle.
„ 21	Ditto.
„ 24	Boy with a Portfolio under his Arm.
May 19	Copied a Gentleman, for my uncle.
„ 23	Reading Boy.
„ 28	Copied Mr. Stevens, of Ealing, for my uncle.
June 3—Hertford Street		...		Copied a Gentleman, for my uncle.
July 2—Kew	Mrs. Fulling.
„ 5	My Grandmother.
August 6	Colonel Erskine, for my uncle.
„ 9	Lady Strathmore, for my Aunt W.
„ 15	Ditto ditto.
„ 19	Mr. Cooper, miniature.
„ 23	Lady Strathmore, for my aunt.
September 2	My Father, drawing.
„ 14	My Mother.
October 24—Condery Farm		...		Anne Paterson.
„ 25—Condery Farm		...		William Paterson.
November 14—Eton	Mrs. John Roberts, drawing.
				Mrs. Swainson.
„ 17	Mrs. W. Roberts, drawing.
„ 20	Miss Briggs.
„ 24	Mrs. Battiscombe.
„ 26—Kew		Mrs. Paterson.
December 2	Mr. Paterson.
				Miss Paterson, a drawing.
„ 13	My Aunt, copy from my uncle's.
				Miss Zachary.
1801: April 4—Hertford Street		...		Miss F. Burgoyne, whole-length drawing.
„ 6	My Uncle.
„ 17	Mrs. Gardner.
May 6	My Grandmother, drawing.
June 3	My Aunt Wooley, drawing.
„ 5	Emma, whole-length drawing.

1801 : June 7—Kew My Aunt Wooley, from my uncle's.
 ,, 15 Mrs. Best.
 July 20 Lucy.
 August 10 Mrs. Pritchard, drawing.
 Mrs. Wright, drawing.
 ,, 20 Mr. John Turner.
 September 21 Miss H. Nisbett.
 October 16 Mrs. Day.
 November 16—Hertford Street... Mrs. Hoggins.
 ,, 26—Kew Mrs. Haverfield.
1802 : January 8 Mrs. Stonehouse.
 February 12—Hertford Street ..: George Engleheart, drawing.
 April 9 Miss Engleheart.
 July 10 Lady Strathmore, copy.
 ,, 14 Michael Turner, as a cherubim.
 August 11 Mrs. Edmeads.
 ,, 13 Master and Miss Turner.
 ,, 14 Mrs. Nicholls.
 Ditto, copied.
 October 24 Admiral Thornborough.
 December 11 A Gentleman, a friend of Jno. Turner.

COPIED FOR MY UNCLE.

1801 : January 2—Hertford Street ... Copied a Lady, for my uncle.
 ,, 10 Copied a Gentleman.
 ,, 21 A Lady.
 February 11 An Indian picture of Lady ——.
 ,, 18 Mr. Locksley, Town Clerk.
 March 2 Mrs. Alexander.
 ,, 13 Mr. Hercules Ross.
 May 21 Mrs. Place.
 June 3 Capt. Paget.
 ,, 23 Mrs. Taswell.
 August 24—Kew A Lady, by Cosway.
 October 8 A Little Boy with a Dog, from a painting in crayons.
 ,, 12 A Gentleman.
 November Capt. Dotting.
 December 1 Background of Gentleman.
 ,, 5 Mrs. Swedeland.
 ,, 8 Background, Capt. Tod.
 ,, Mrs. Bentley.
 ,, Mrs. Hoare.
 ,, Gentleman.
 ,, 29 ,, Mr. Stacey.
1802 : January 1 Background.
 ,, 4 Admiral Braithwaite, background.
 ,, 5 French Lady, ditto.
 ,, 7 Master Greentree, ditto.

1802 : January 11	Lord Tamworth, background.
„ 15	Background, Capt. Mitchell.
			„ Miss Stephenson.
			„ George Engleheart.
„ 26	„ A Young Lady.
February 12	„ Mr. Lubbock.
„ 15	Copied Miss Coulston's picture.
„ 16	Background of Miss Seton's.
„ 17	„ Capt. Rodney's.
March 5	„ Mrs. Robinson.
„ 17	Copied an Old Lady.
„ 22	Background of Admiral Watson's.
„ 30	„ Mrs. Anthony.
April 2	„ a Young Lady.
„ 6	„ a Gentleman.
„ 9	„ Mr. Sampson.
„ 10	„ a Lady.
May 3	Copied Lord Kensington.
„ 5	Background of a Gentleman.
„ 10	Copied Mr. Hardenborough.
„ 15	Copied Sir Robert Abercrombie.
„ 22	Ditto ditto.
June 7	Colonel Erskine.
„ 29	Count Byland.
July 5	Mr. Redhead, copied.
„ 12	Background of a Gentleman.
„ 13	„ Mr. Redhead.
„ 14	„ a Lady.
„ 21	Copied a Lady.
„ 22	Background of a Young Lady.
„ 29	Outline of a black profile, Miss Coulston.
„ 30	Background of a Lady.
August 3	Background, Mr. Curtis.
October 28	Copied a picture of Cosway's, H.R.H.T.D.O.W.
November 8	Copied a picture of H.R.H. the Duchess of Würtemberg.
December 2	Copied an enamel, by Zincke.
„ 16	Copied Mr. Sansom senr.
1803 : March 8	Mrs. Roberts.
„ 30	Background to a Gentleman.
„ 31	Ditto ditto.
June 6	Background, Mr. Baring.
„ 11	Copied Mr. Baring.
			Ditto ditto.
„ 20	Copied a Gentleman.
July 5	Copied a Gentleman, small picture.

N.B. The above are the only lists in the writing of J. C. D. Engleheart which can be found.

Appendix IV.

The Will of George Engleheart and the
Inscriptions from the Family Vault.

Appendix IV.

The Will of George Engleheart
and the Inscriptions from the Family Vault.

I, GEORGE ENGLEHEART late of East Bedfont otherwise of Church Bedfont in the county of Middlesex but now of Park House Blackheath in the County of Kent (being of sound mind and memory) Do make this my last will and Testament in manner and form following (that is to say) I direct that my just debts and Funeral and Testamentary Expenses shall be paid by my Executor hereinafter named by and out of my personal Estate as soon as conveniently may be after my decease And as to and concerning my Freehold Messuage or Tenement and Land thereto adjoining or belonging (being part Freehold and part Copyhold) situated at East or Church Bedfont aforesaid and late in my own occupation AND ALSO my Freehold Land containing Sixteen Acres more or less situate in the Parishes of Feltham and East or Church Bedfont aforesaid in the County of Middlesex late in my own occupation with all and every the Hereditaments Rights Members and Appurtenances to the said Messuage and Land belonging or appertaining I do hereby give and devise the same unto and to the use of my eldest son George Engleheart now a Major in the second Regiment of Native Infantry in the Honorable the East India Company's Service on the Bengal Establishment and the heirs of his Body lawfully begotten or to be begotten And in default of such issue of my son George then from and after his decease without issue I give and Devise all my said Messuage Land and Hereditaments before mentioned (Subject nevertheless to be charged with the Annuity or yearly sum by me given or bequeathed to the Wife of my said Son George in the event hereinafter expressed) Unto the Use of my second son Nathaniel Brown Engleheart his heirs and assigns for ever AND I do hereby accordingly charge and make chargeable All the said Messuage Land and Hereditaments at Feltham and East or Church Bedfont herebefore described from and after the decease of my said Son George without issue as aforesaid with the payment of the yearly sum or Rent charge of Two hundred Pounds of lawful Money of Great Britain for the benefit of Eliza the now Wife of my said Son George in case she shall survive him to be paid and payable to her by four equal quarterly payments in every year during the remainder of her natural life or until she shall marry again and the first quarterly payment thereof to be made at the end of three Calendar months next after his decease the said annuity or yearly rent charge nevertheless to be accepted and taken by her the said Eliza Engleheart in lieu and full satisfaction of all Dower or Thirds or other Claim which by Common Law or by Custom or otherwise she may have or would be entitled to as the Widow of my said eldest Son out of or upon all or any the hereditaments or other real Estates which he may become seized of or entitled to under this my Will or as my Heir at Law AND in case the said Eliza Engleheart shall after her

<div style="text-align:right">

Net annual
Produce
or
Value

about

£250 furnished
£160 unfurnished.

£15.

</div>

said present husband's decease marry again then I do hereby will and direct that the said Annuity so given to her as aforesaid shall therefrom and from and after such marriage cease and be no longer payable AND I do hereby Give and Devise my Freehold Messuage or Tenement and Hereditaments with the Appurtenances situate in Rupert Street Golden Square in the parish of Saint James Westminster in the said County of Middlesex now on lease to Mr. Sneesum Carpenter and Builder unto and to the use of my said Son George Engleheart and his heirs of his Body lawfully issuing and in case he shall die without issue as aforesaid then I give the same unto my third Son and youngest Son Henry Engleheart and his heirs for ever I also give and devise to my said Son George Engleheart my leasehold house and premises (No. 19) in Queen Street May Fair in the parish of Saint George Hanover Square in the said County of Middlesex now on lease to the late Mrs. Catherine Berens and all my Term and Interest in the said premises discharged of any Annuity or other Incumbrance now subsisting thereon and subject only to the Covenants to be paid observed and performed under the lease which I hold thereof but if my said son George shall happen to depart this life without lawful issue as aforesaid then I give the said leasehold Messuage and premises in Queen Street unto my said Son Henry Engleheart his Executors Administrators and assigns absolutely AND as to and concerning All that my leasehold Messuage and premises situate in Curzon Street May Fair in the parish of Saint George Hanover Square aforesaid now on lease to John Balfour Esquire and also my leasehold messuage or tenement and premises in Market Street May Fair on lease to Mr. Francis Romart now in the occupation of his daughter Mrs. Ireland And also my leasehold messuage or tenement in Shepherd Street May Fair on lease to Mr. Pugh Dairyman but now in the occupation of Mr. Bean (Butcher) together with all and every the Appurtenances to the said Messuages and premises belonging I do hereby Give Devise and Bequeath the same unto my Executor and Trustee the said Nathaniel Brown Engleheart Upon trust that he his Executors and Administrators Do and Shall by and out of the Rents and profit thereof pay to Mary Engleheart the widow of my late brother Thomas Engleheart One Annuity or clear yearly sum of Eighty Pounds for and during her natural life free from Legacy Duty and all other Deductions whatsoever And the same Annuity or yearly sum to be taken in lieu and satisfaction for a like Annuity of Eighty now payable to the said Mary Engleheart as aforesaid and charged on my aforesaid Leasehold Messuage and premises in Queen Street May Fair heretofore devised to my said Son George Engleheart as aforesaid and in Exoneration of the said last-mentioned premises accordingly And of all other my leasehold or other property now charged with the said Annuity And to be paid and payable Quarterly by even and equal portions on the same days and times as has always been paid the first payment thereof to be made on such of the said days as shall happen next after my decease and subject to and after payment of the said Annuity or yearly sum of Eighty pounds I direct that my said Trustee shall pay all the rents and profits of all my said leasehold premises in Curzon Street Market Street and Shepherd Street hereby respectively devised to him as aforesaid In Trust for my daughter Emma Engleheart and for her whole and sole use and benefit But in case my said daughter Emma Engleheart shall happen to die without leaving issue of her Body lawfully begotten then I do hereby Give and Devise my leasehold house and premises in Curzon Street aforesaid now in the occupation of John Balfour Esquire to my eldest Son George Engleheart for all the remainder of my term therein And if he shall die without lawful issue then to my youngest son the said Henry Engleheart his Executors Administrators and Assigns this house and premises subject always to pay the said Annuity to the said Mary Engleheart Widow of my brother Thomas Engleheart during her life And I do hereby further give Devise and bequeath unto my said son Nathaniel Brown Engleheart my freehold messuage or tenement hereditaments and premises situate in Golden Square and

my freehold messuage or tenement and premises in Brewer Street both in the parish of Saint James Westminster aforesaid and in the respective occupations of Archibald Patterson Esqr. and Mr. Watson Surveyor And also my leasehold land held of the Corporation of Windsor and situate at the bottom of Peascod Street and called the Spittal near the town of Windsor and County of Berkshire And also my two shares and three fifths of another share in the Richmond Waterworks in the County of Surry And also my two shares in the Iron Railway called the Merstham Railway in the said County of Surry To hold all the said Messuages or Tenements Land and hereditaments and other premises Unto and to the use of my said Son Nathaniel Brown Engleheart his heirs executors administrators and assigns according to the nature or quality thereof for ever But nevertheless as to such part of the said premises as may be in mortgage or Security Subject to be charged at the time of my decease with such mortgage or mortgages or other incumbrance as may be then subsisting thereon And I do hereby give and devise unto my youngest son the said Henry Engleheart his executors administrators and assigns All that my leasehold house and premises situate in Curzon Street May Fair now on lease to Robert Frankland Esquire discharged of the mortgage now subsisting thereon for the sum of Nine hundred and sixty pounds and interest which I have hereby provided and directed to be paid off by and out of other part of my estate as hereafter mentioned And I also give devise and bequeath unto my said Son Henry Engleheart his heirs executors administrators and assigns All my Freehold and Copyhold house lands and hereditaments at Kew in the County of Surry including the Messuage or tenement with the land attached to the same situate on the north side of Kew Green and now in the occupation of Mrs. Schnell and also the two messuages or tenements and premises on the south side of Kew Green and in the respective occupations of Mr. Richard Barns and Mrs. Betty Graham with all and every the Rights Members and Appurtenances thereunto and especially belonging And also my leasehold messuage and premises with the appurtenances situate in Kew Road leading to Richmond in the County of Surry aforesaid now in the occupation of Mr. Mudie And I do hereby give and devise all that my Freehold and Tythe Free Farm with the Buildings Land and hereditaments thereunto belonging situate in the parish of Harmondsworth in the said County of Middlesex And also two Acres of land more or less in the parish of East or Church Bedfont allotted to me by the late Enclosure Act and adjoining and leading to the said Farm with the appurtenances unto and to the use of my said Son Nathaniel Brown Engleheart his heirs and assigns UPON TRUST nevertheless that he or they do and shall as soon as conveniently may be after my decease sell and dispose of the said Farm and premises either together or in parcels by public Auction or by private Contract at such time or times and in such manner in all respects as he or they shall think best or most advantageous and do and shall pay and apply the monies arising from such sale (subject to the payment of all costs attending the same) in satisfaction and discharge of all the aforesaid mortgage debt of Nine hundred and sixty pounds (which was borrowed by me of the Honble. Mrs. Sophia Jarvis Daughter of the late Mr. Vincent) on my said house and premises in Curzon Street May Fair aforesaid heretofore devised to my son Henry Engleheart and in full exoneration of the said premises and of the devise so made to him as aforesaid And also in satisfaction and payment of the sum of One thousand pounds borrowed by me of my late deceased friend Mr. John Cooper of New Bond Street London together with all interest which may be due on the said sums respectively at the time of my decease And I will and direct that all the surplus or residue which shall remain of the monies so to arise or to be produced by such sale or sales as aforesaid shall sink into or become part of my residue and personal estate And it is my Will and I do hereby further direct that all the fixtures furniture and other chattels and effects which may be in or about my house and premises at Bedfont aforesaid shall go to and become the property of my Son George Engleheart except such articles as may belong

T

£100.
£60.
£4.

£25; uncertain.

Mortgaged for £1,000.

£290.

£44; Freehold or Copyhold.
£50; Do. Do.
£-5; 10 years unexpired.

Worth about £2,500.

£100 p. ann. Much in arrear and will not be paid.

Worth about £250.

to my Daughter Emma and to my Son Henry and of which I believe they have a list in my handwriting and except also as is hereafter mentioned And as to all my plate linen and china I give and bequeath to my Daughter Emma and my Son Henry share and share alike and all my books books of prints and drawings bookcases and cabinets with all the contents contained therein and household furniture which may be in my present residence at Park House Blackheath at my decease I give and bequeath to my Son Henry Engleheart except my miniature pictures which I desire may be equally divided between my Daughter Emma and my three sons George Nathaniel and Henry And as to all the rest residue and remainder of my estates and property whatsoever and wheresoever whether freehold copyhold leasehold or personal and of what nature or kind soever I do hereby Give Devise and Bequeath the same to my Son Nathaniel Brown Engleheart for his own absolute use and benefit and I appoint him SOLE EXECUTOR AND TRUSTEE of this my last will and testament And I hereby fully authorise and empower him my said Son Nathaniel Brown Engleheart his executors and administrators at my decease to collect receive and get in the rents issues and profits of such my messuages lands and tenements as I have heretofore devised to my Son George Engleheart during his absence from this country and to enter and distrain for the same when in arrears in due course of law he the said Nathaniel taking the usual and customary allowance for his trouble and after deducting such compensation or allowance and the expenses of repairs taxes and insurance and all other necessary outgoings to lay out and invest the surplus monies or any other monies which may come to his hands under this my will in the Government or Parliamentary stocks or funds or on good mortgage securities and the same or any other stocks funds or securities to alter change and transfer when'and as often as he or they shall see occasion and to give sufficient receipts and discharges for any monies that may come into his or their hands which receipts shall exonerate all purchasers or other persons paying such monies from seeing to the application thereof And I hereby further authorize and empower my said Son Nathaniel Brown Engleheart his executors or administrators to grant leases of all or any part of my estate so devised to my son George Engleheart as aforesaid when and if occasion shall require for any term not exceeding fourteen years in possession at the best rents that can be reasonably obtained without taking any fine or premium for the same and generally to manage all the estates and property hereinbefore by me given and bequeathed in such manner as he or they shall see best or most advantageous for the benefit of himself and other my children who may respectively become entitled under this my will And I further declare that my said Executor and Trustee shall be allowed all reasonable costs and expenses which may occur in performing the directions herein contained And that he shall not be answerable for any more monies Estate or effects than what shall actually come to his hands nor for any loss or damage which may happen to my Estate or any part thereof without his wilful default AND HEREBY REVOKING all former and other wills by me at any time made I declare this only to be my last will and testament IN WITNESS whereof I have to this my will contained in three sheets or six folios of paper set my hand and seal that is to say my hand to the first two sheets and my hand and seal to this the last sheet thereof the twenty eighth day of October in the year 1828.

<div align="right">GEORGE ENGLEHEART. </div>

SIGNED SEALED AND PUBLISHED by the Testator as and for his last will and Testament in the presence of us who in his presence and at his request and in the presence of each other have hereunto subscribed our names as witnesses.

<div align="right">JOHN ALLEN.
WM. BROWN.
GEO. LEES.</div>

To prevent any doubts respecting the division of the miniature pictures amongst you my dear children I wish to leave them as under :

To my Dr. Son GEORGE ... Lady with sparrow. Miss Palmer. Boy with book. Laughing Girl. Pensive Girl. Mr. Barretti. Lady Thomond. Studious Boy.

To my Daughter EMMA ... Mrs. Gardner. Mellicent Engleheart. Eliza. Maj. Engleheart. Young Cupid. Laughing Boy.

To my Son NATHANIEL ... Mrs. Biggs. Little Thief. Young Hymen. Mrs. Robinson. Madam Schindleim. The three Miss Montgomerys.

To my Son HENRY ... Reubens. Sir Joshua Reynolds. King George the Third. Samuel. Hugolino. Pope Bavarius.

THE PICTURES are named at the back so as to be very readily divided.

THERE are many necessary papers in a mahogany box* at the bottom of *my Closet* the key of which as well as many other keys belonging to Closets at Bedfont hangs up *immediately* under the shelves in the *same Closet* there are also many receipts &c &c in a well at the top of the Shell Cabinet as also a great many receipts &c &c &c in the iron chest at Bedfont, perhaps necessary, if not destroy them. There is also a *concealed* Closet between the bow window'd Drawing Room and (East) Front Bedchamber over the door leading to the Bedchamber containing many pictures &c &c Emma knows the closet I mean. The key is written on Private Closet it is papered over completely. The contents of the Concealed Closet for my Son George. All the necessary keys are labelled.

The contents of Closet leading to Iron Chest are for my Son Henry except what may belong to his sister.

OUR TOMB is on the left entering the Church porch at Kew and may be very easily distinguished being a large stone raised on about 9 or 10 course of brick work. The way into it is by the left side of Front towards the Chestnut Trees in front of Church. It is my wish to be buried as near your dear Mother as may be and in the same manner the particulars of which may be known by referring to Bill settled and paid in the year 1817. I fear the Bill is among others now in the Iron Chest at Bedfont but may be got at by leave from the Duchess of Manchester.

N.B. A Codicil to this will was subsequently executed by George Engleheart, making a different disposition of part of his property; but as it does not refer in any way to his works it is omitted here.

INSCRIPTIONS ON THE FAMILY VAULT IN THE CHURCHYARD OF KEW.

IN MEMORY of *Francis Engleheart* of this Hamlet, who died February the 3rd, 1773, aged 60 years.

ALSO *Ann* Wife of Thomas Engleheart, died the 16th April 1779, aged 26 years.

ALSO Mrs. *Elisabeth* Wife of Mr. George Engleheart, died 29 April 1779, in the 26th year of her age.

ALSO Mrs. *Ann Engleheart* Wife of the above named Francis Engleheart. She died September 3rd, 1780.

* In this Mahogany box is a circular box sealed up in white paper directed for Major Engleheart if he should not come home it is intended for my son Nathaniel Brown Engleheart.

ALSO Mrs. *Ursula Sarah* Wife of the above Mr. Geo. Engleheart, died 16th October, 1817,
 in the 57th year of her age.

ALSO of the above Mr. *George Engleheart* who died the 21st March 1829, aged 78 years.

ALSO the body of *Mary* Widow of the above Thomas Engleheart, who died Aug. 4th, 1831,
 aged 75 years.

ALSO the remains of *George Engleheart Esq.* late a Lieut. Colonel on the Honorable East
 India Government's Bengal Establishment. Son of the abovenamed George and
 Ursula Engleheart, who died May 28th, 1833, aged 46 years.

ALSO the remains of *Mary Jane* the beloved wife of Nathaniel Brown Engleheart. She died
 March the 9th, 1859, aged 64 years.

NOTE BY THE REV. HENRY ENGLEHEART AS TO ABOVE.

In the Inscriptions the death of Francis Engleheart is stated to have been in 1775;
and the death of Ann, his Widow, in 1786. The above dates are correct. The figures on
the slab which formerly covered the vault, having some years since become very nearly
illegible, a new slab was substituted, and such errors arose from the decayed state of the
originals. Probate of Francis Engleheart's will was granted February 19, 1773, to Ann, his
widow; and a further grant was made September 18, 1780, reciting that she was then dead.

H. E.

Appendix V.

List of Miniatures by George Engleheart
known to be in Existence, with the
Names of their Owners.

—

Appendix V.

List of Miniatures by George Engleheart known to be in Existence, with the Names of their Owners.

BABER, MISS, (? address).

BARNETT, MRS., Stratton Park, Biggleswade.

BATHURST, EVELYN, COUNTESS, 41, Lowndes Square.

BEVAN, MRS., (? address).
BLAKISTON FAMILY, A MEMBER OF THE.

BRICKDALE, FORTESCUE, ESQ.
COCKS, THOMAS SOMERS (exhibited S. K., 1865).
COLE, FITZROY, ESQ.
CLITHEROE, MRS. STRACEY, 20, Park Square E., Regent's Park.
CRIPPS, W., ESQ., Cripps Mead, Cirencester.
CROCKER, MRS., 7, Sussex Place, Hyde Park.

CURRIE, THE LADY, The Embassy, Rome.

Mr. Creswell.
Mrs. Creswell.
Colonel Gregory.
Mrs. Gregory (*née* Grote).
George Barclay.
Rebecca, his wife.
George, their son.
Mrs. George Barclay (*née* Boulton).
Mrs. Boulton.
Mrs. Halliday (*née* Mosseley).
Lady Imhoff.
Lady Seton.
Hon. Anna Bruce.
Dorothy Fletcher.
Sir Burrell Blunt.
Anna Sophia Blunt.
Louisa Dent.
Mr. Fortescue.
Mr. T. G. Vernon.

Major Cole.
Lord Uxbridge.

Mrs. Inglis (*née* Johnson).
Mary Pyne (*née* Engleheart).
Lucy Gardner (*née* Engleheart).
Lord Montjoy.
The Lady Headley (*née* Blennerhassett).
Mrs. Fisher.
A Lady of the Abdy Family.

CURRIE, THE LADY—*continued*.

DENBIGH AND DESMOND, THE EARL OF, Newnham Paddock, Lutterworth.

DOUGLAS, GREVILLE, ESQ., 27, Wilton Crescent.

DRAKE, HENRY, ESQ., 23, Upper Phillimore Gardens.

EDGCUMBE, SIR ROBERT, Sandye Place, Beds.

EGERTON OF TATTON, EARL (exhibited S. K., 1865), St. James's Square.

ENGLEHEART, SIR J. GARDNER D., K.C.B., 28, Curzon Street, Mayfair.

Portrait of a Lady.
Portrait of another Lady.
Mrs. Powis.
Viscount Feilding.
Rt. Hon. Charles Yorke, First Lord of the Admiralty.
Miss Sutherland.

Mr. Grote.
Mrs. Grote.
William Egerton of Tatton, 1789.

The Artist (paper, 2).
His Wife Ursula (paper, 2).
His Wife Mary.
His Son George, a baby.
His Son George, ætat fourteen.
His Son Nathaniel (paper).
His Son Henry (paper).
His Daughter Emma (paper).
Another of the same.
John D. Engleheart and Jane his wife.
Jane Engleheart (*née* Parker).
Elizabeth.
Melicent.
Lucy.
Mary (paper).
John Cox D. (paper).
Elizabeth (Mrs. George Engleheart, junior).
Francis (paper).
King George the Third, presented by His Majesty.
Madonna and Child, after Caracci.
Lady seated by a Vase, holding her Hand to her Face, a Dog lying at her Feet.
Lady, unknown. Replica in Wallace Gallery.
Lady, unknown.
Peltro Tomkins, the Engraver.
Miss Horneck.
Miss Horneck, sister of the above.
A Gentleman's right eye.
A Lady's right eye.
Four unfinished miniatures.
Napoleon Bonaparte in uniform of First Consul.
Man in a brown coat.
 „ dark blue.
 „ light blue.
 „ green.
 „ red.
 „ red and blue.

ENGLEHEART, SIR J. GARDNER D., K.C.B.
 —*continued.*

Man in a red and yellow coat.
Mr. Plowden.
Mr. Stewart.
Mrs. Stewart.
Mrs. Woolley.
Mrs. Bowes.
A Girl asleep.
 „ drawing.
 „ reading.
 „ with very light hair.
 „ in a turban.
 „ in a mob-cap.
A Lady, profile to the right.
 „ „ „ left.
 „ with a necklace of pearls.
 „ in a white dress (Empire).
 „ in a white dress (Empire).
Sir William Skeffington.
Nathaniel Brown.
Elizabeth Brown (*née* Woolley).
Girl in a high-waisted white dress.
Lady.
Mrs. Powell.
1 case of 9 miniatures, unnamed.
Another case of 9 miniatures, unnamed.
40 sepia drawings of antiques in Buckingham
 Palace.
Drawing of a bust after Thomas Engleheart.

*Also the following copies in miniature of
works by Sir Joshua Reynolds :*

Sir Joshua Reynolds in Doctor's robes.
Infant Samuel.
Joseph Barretti.
The Laughing Girl.
The Studious Boy.
The Laughing Boy.
Miss Theophila Palmer.
The Banished Lord.
Ugolino.
Pope Pavarius.
The Pensive Girl.
Lady Thomond.
The Studious Girl.
The Schoolboy.
Young Cupid.
Lady with a Sparrow.
Mrs. Baddelley.
A Negro.

U

ENGLEHEART, HENRY L. D., ESQ., Holbecks Park, Suffolk, and Bedfont Lodge, Middlesex.	The Artist (paper).
	Nathaniel Engleheart (paper).
	Henry Engleheart (paper).
	John Dillman Engleheart.
	Lucy D. Engleheart, a drawing.
	Lucy, Mrs. Gardner (*née* Engleheart).
	Farnell Gardner.
	Mr. Moffat, 1807.
	Lady in a kerchief.
	Mary Pritchard and Ann Pritchard (*G. E.'s god-daughter*).
	Melicent D. Engleheart, a drawing.
	A Girl's Head, a drawing.
	A Man's Head, an enamel.
	Two Cherubs, an enamel.
	Venus after Titian.
ENGLEHEART, MRS., Holbecks Park, Suffolk.	Mary Pye, daughter of the Poet Laureate.
	A Lady in a green dress.
ENGLEHEART, MISS.	Melicent Engleheart.
	John Cox D. Engleheart ætat eleven.
	Emma Engleheart, full-length, spinning.
	Lucy D. Engleheart, full-length, reading.
ENGLEHEART, MAJOR E. L., 6, Charles Street, Berkeley Square.	Lucy D. Engleheart.
ENGLEHEART, VICTOR F., ESQ., 28, Curzon Street, London.	Mary Engleheart.
ENGLEHEART, REV. GEORGE HERBERT, F.S.A., Clarendon, Tisbury, Wilts.	Nathaniel Engleheart.
	Mary Jane (*née* Curteis), his wife.
FANE, SIR SPENCER PONSONBY, K.C.B., St. James's Palace.	John, tenth Earl of Westmorland.
	Lady Hampson.
	Lady Westmorland.
GLADSTONE, HON. MRS. W. H. (exhibited S. K., 1865), Hawarden Castle.	Mrs. Neville.
HASTINGS, LORD, Melton Constable.	Sir Jacob Astley.
HOLDEN, MISS, The Grove, Saffron Walden.	Mrs. Payne-Gallwey.
ILCHESTER, THE EARL OF, Holland House, London, W.	Lord Wycombe.
	Lady Holland. (*This may possibly be by G. Engleheart.*)
KENNEDY, S. E., ESQ., 24, Upper Brook Street.	A Lady in a hat and feather.
KING, MISS, 11, Queensberry Place, S.W.	Sir Charles Cotton.
	Lady Cotton.
MACKEY, MR. G., 70, New Street, Birmingham.	Price Price Pritchard (paper).
	Mary Pritchard.
	Ann Pritchard.
	Elizabeth Pritchard.
	Elizabeth Brown (*née* Woolley).
	Hester Woolley.
	A Girl, unknown.
MAYO, LORD, 3, Stratford Place, Oxford Street.	Mr. Caulfield.
	Mrs. Caulfield.

MORGAN, J. PIERPONT, ESQ., Princes Gate. Mrs. Kensmith.

The Misses Berry (a pair), once in the possession of Sir J. Goldsmid.

Mrs. Robinson.

Admiral Lord Rodney.

Lady E. Walpole.

Lady Piggott.

Miss Sainthill.

Lady Mary Harvey.

The Honourable Mrs. Needham (afterwards Lady Kilmorey).

Lady Walpole.

Mrs. Wentworth.

Miss Gwyn (daughter of Colonel Gwyn).

Miss Newcombe (afterwards Lady Gardner).

Sir John Hope, Bart.

Lady Hampson.

A Lady, unknown.

PONSONBY, HON. GERALD, 3, Stratford Place. Captain Lygon.

William, first Earl Beauchamp.

John, first Lord Hutchinson.

Sir Ralph Abercrombie.

PONSONBY, MISS JULIA, 4, Wilton Crescent. Lord Bathurst.

READ, F. T. (exhibited B.F.A. Club, 1889). Charles Mordaunt.

RODWELL, MRS., Eaton Square. Mr. Francis Gosling.

Barbara, his wife.

SALISBURY, THE MARQUIS OF, K.G., Hatfield. The first Marchioness of Salisbury

SETON, SIR BRUCE, BART., Durham House, Chelsea. Sir Charles Blunt.

Lady Burrell Blunt.

Miss Elizabeth Blunt.

Miss Louisa Blunt.

SPOONER, CHARLES, ESQ. (exhibited S. K., 1865). Fortescue, Master of the Rolls.

SPRINGETT, MRS., 5, Salter's Hall Court, London. George Baring.

STOKER, SIR THORNLEY, 8, Ely Place, Dublin. A man's portrait said to represent Edmund Burke.

TAYLER, MISS. Lady Fraser.

TAYLOR, REV. MONTAGU (exhibited S. K., 1865). Admiral Sir H. Hart.

TOMKINSON, MICHAEL, ESQ., Franche Hall, Kidderminster. Richard Sheridan.

TRIGG, MRS., 60, Cleveland Park Avenue, Hoe Street, Walthamstow. A Bishop, name unknown, painted July, 1815 ; see inscription on reverse.

VICTORIA AND ALBERT MUSEUM. Portrait of a Gentleman, unknown.

WALLACE GALLERY. Portrait of a Lady.

WALPOLE, HON. MRS. FREDERICK (exhibited S. K., 1865). Miss Felton.

WHARNCLIFFE, EARL OF, Wortley Hall, Sheffield. Mrs. Fitzherbert.

Capt. Faulkener.

WHITEMAN, MISS.

WHITEHEAD, J., ESQ., Newstead, Wimbledon.

WILLIAMSON, MRS. G. C., The Mount, Guildford.

WOOLLCOMBE, MRS., Biggleswade.

Mrs. Chapman.

Mr. Coleman.

5 portraits of Gentlemen.

1 Gentleman's eye.

Gregory William, 11th Baron Saye and Sele.

Miss Grote, 1788.

Appendix VI.

List of Miniatures by
John Cox Dillman Engleheart known to
be in Existence, with the Names
of their Owners.

Appendix VI.

List of Miniatures by John Cox Dillman Engleheart known to be in Existence, with the Names of their Owners.

BARKER, CHARLES M., ESQ. (? address).

Edgar Barker.

BLACK, C. E., ESQ. (? address).

Mr. and Mrs. Black.

CROCKER, MRS., 9, Sussex Place, Hyde Park, W.

Mr. Pyne.
Mary Pyne (*née* Engleheart)
John Dillman Engleheart.
Lucy Gardner (*née* Engleheart).
Melicent Engleheart.

DRAKE, HENRY, ESQ., Upper Phillimore Gardens.

Miss Netherland.

ENGLEHEART, SIR J. GARDNER D., K.C.B., 28, Curzon Street, Mayfair.

The Artist.
The Artist's Wife and her Sister as April and May in Cowper's 'Invitation to the Country.'
John Dillman seated in a chair.
Mary.
Lucy.
Melicent.
John D. Engleheart and Jane his wife.
George Engleheart.
Miss Cramer as L'Allegro.
Miss Slater.
Miss Dally as Past, Present and Future.
Mrs. Charles Barker and Child.
Macready as Richard III.
Prudence cutting the wings of Cupid.
David with the head of Goliath.
Portraits of Two Girls.

ENGLEHEART, MISS.

The Artist, 1821.
William IV.
The Duke of Wellington.
The Duke of York, 1824.

ENGLEHEART, MISS—*continued.*

Countess Howe, sister of the Earl of Cardigan.
Louise, Queen of Prussia.
The Salutation, after Guercino.
The Laughing Girl, after Reynolds.
The Studious Boy „ „
The Sleeping Cupid „ „
Melicent Engleheart.
Lucy, Mrs. Gardner (*née* Engleheart).
Mary, Mrs. Pyne (*née* Engleheart).
Mary Engleheart (afterwards Mrs. Hennen).
Melicent Engleheart.
Mrs. Charles Barker.

ENGLEHEART, HENRY L. D., ESQ., Holbecks Park, Suffolk, and Bedfont Lodge, Middlesex.

The Artist.
John Dillman Engleheart.
Jane Engleheart.
George Engleheart.
Mary Engleheart.
Miss E. Reynolds.
Mr. Charles Barker.
Lord Russell.
Lady's head.
The Studious Boy, after Reynolds.
The Pensive Girl „ „
Mary Meyer as Hebe „ „
King Lear.

ENGLEHEART, MAJOR E. L., 6, Charles Street, Berkeley Square.

King Lear.
Zephyr.

ENGLEHEART, VICTOR F., ESQ., 28, Curzon Street.

Head of a Girl, a drawing.

MACKEY, G., MR., 70, New Street, Birmingham.

Miss Ann Pritchard (*George Engleheart's godchild*).

MORGAN, J. PIERPONT, ESQ., Princes Gate.

A Lady, unknown.

PARSONS, EDWIN, & SONS, MESSRS., Brompton Road.

Portrait of a Lady.
Portrait of a Lady.

SPENCER, LADY SARAH, St. James's Place, S.W.

Margaret, first Countess Spencer.

THOMPSON, H. YATES, ESQ., Portman Square, W.

Richard Sheridan.

TURNER, MRS. FÜLLING.

Cupid.
Lucy D. Engleheart.
Michael Turner as a cherub.
The Banished Lord, after Reynolds.
An Old Lady.

VICTORIA AND ALBERT MUSEUM.

Portrait of a Gentleman (No. 1,363).

Appendix VII.

List of Engraved Works by
George Engleheart.

Appendix VII.

List of Engraved Works by George Engleheart.

TITLE.	ENGRAVER AND DATE.
Mrs. Mills.	J. R. Smith.
Cecilia (Mrs. Estcourt; ascribed to Thomas Engleheart).	F. Bartolozzi, 1783.
Mrs. Robinson.	R. Stainer, 1788.
Mr. Tomkins.	L. Schiavonetti, 1807.
Captain Thompson.	F. Engleheart.
Robert Pope, M.D.	F. Engleheart, 1824.
Sir P. B. V. Brooke, Bart., R.N.	H. R. Cook.
T. James.	Mathæus Haughton.
Lieutenant-General Sir Alexander Camp-bell, Bart., K.C.B., Colonel of 80th Regiment of Foot.	C. Penny.
Unnamed Gentleman.	Gully.
Unnamed Gentleman.	W. Wood junior.
Unnamed Gentleman.	T. Collyer.
Lady Betty (from a miniature now be-longing to Mr. Kennedy).	D. A. Wehrschmidt.

Appendix VIII.

A Memorandum of Certain Miniatures
recently sold at Christie's.

Appendix VIII.

A Memorandum of Certain Miniatures recently sold at Christie's.

LOT.	DESCRIPTION.	WHEN SOLD.	PRICE.
	Sir J. Green.	November, 1893.	
91.	A Daughter of Sir Horace Walpole.	June, 1896.	
102.	Comtesse de Montesquieu.		
86.	A Boy in a blue dress, holding a rosebud, and leaning on a balustrade—a large oval (only the head and coat is by G. E.).	February, 1894.	
90.	A Lady in pink and white dress, seated in a chair, holding a child in her lap, with another child seated at her feet (only the faces were by G. E.).	February, 1894.	
187.	Portrait of a Lady, unknown.	June, 1895.	
85.	Portrait of a Gentleman in black dress.	February, 1894.	
7.	Portrait of a Lady, 1784.	May 14, 1902.	£135.
100.	Lord Robert Fitzgerald.	February 25, 1902.	£189.
7.	Lord Uxbridge.	February, 1902.	£120.

Appendix IX.

Exhibition of Portrait Miniatures at
South Kensington Museum, June, 1865,
with Notes by Henry Engleheart,
Son of the Artist, as to the
Miniatures Exhibited.

Appendix IX.

Exhibition of Portrait Miniatures at South Kensington Museum, June, 1865, with Notes, within brackets, by the Rev. Henry Engleheart, Son of the Artist, as to the Miniatures exhibited.

403. A Lady, about 1780. [A copy.] Lent by the Earl of Lucan.

449. A Lady. [By George E.] Lent by Mr. Hargreaves.

531. Admiral Sir H. Hart. [By Geo. E., done Nov. 17, 1812, as Capt. Hart.] Lent by Rev. Montague Taylor.

598. Miss F. Felton. [By Geo. E., done June 21, 1784.] Lent by Hon. Mrs. Fred. Walpole.

625. A Lady, ascribed to Geo. E. [Doubtful.] Lent by Sir T. W. Holburne, Bart.

657. Lord Hutchinson. [By G. E., done May 7, 1805.] Lent by Hon. Gerald Ponsonby.

658. Earl Beauchamp. [By Geo. E., done May 24, 1805, as Capt. Lygon.] Lent by the same.

886. Mr. Fortescue, Master of the Rolls. [By Geo. E., done April 4, 1780.] Lent by Mr. Chas. Spooner.

891. James G. Vernon. [By Geo. E., done either Dec. 10, 1802, or Oct. 3, 1809.] Lent by Mr. Thomas Somers Cocks.

1026. Mrs. Neville. [By Geo. E., done either Jan. 6, 1796, or March 23, 1797.] Lent by Rt. Hon. W. E. Gladstone.

1039. A Lady. [A copy; original in my own possession.] Lent by George Richmond, R.A.

1041. A Lady. [The same.] Lent by the same.

1044. An Officer. [By Geo. E.] Lent by the same.

1070. Sir R. I. Murchison, 1818. [By J. C. D. E.] Lent by Lady Murchison.

1423. A Gentleman. [A copy.] Lent by Rev. James Beck.

1864. Mr. Black. }
1865. Mrs. Black. } [By J. C. D. E.] Lent by C. C. Black.

2481. William Egerton of Tatton. [By G. E., done March 25, 1789.] Lent by Lord Egerton.

2502. Jane, Countess of Oxford. [By Geo. E., done in 1809.] Lent by Lady Frances Harcourt.

2522. O. P. Meyrick, Esq. [By Geo. E., early.] Lent by O. F. Meyrick, Esq.
2726. Duchess of Devonshire and Child. [Copied by Geo. E., July 10, 1788.] Lent by Hon. Ashley G. Ponsonby.
2843. The Third Baron Henniker. [By Geo. E.] Lent by Lord Henniker.
2844. Mary, his wife. [By Geo. E., done Dec. 5-21, 1804.] Lent by the same.
2927. Sketch for 2502. [By Geo. E.] Lent by Lady Frances Harcourt.
2937. Mary North. [By J. C. D. E.] Lent by Miss Ouvry.

A SKETCH OF THE PEDIGREES OF THE ARTISTS IN THE ENGLEHEART AND RICHMOND FAMILIES.

Index.

Index.

BILLING AND SONS, LTD., PRINTERS, GUILDFORD.

Printed in October 2021
by Rotomail Italia S.p.A., Vignate (MI) - Italy